PICTURING
THE COSMOS

IINA KOHONEN

TRANSLATION Albion Butters and Tiina Hyytiäinen | GRAPHIC DESIGN Jyri Konttinen
Published with the support of Aalto ARTS Books

PICTURING
THE COSMOS

A VISUAL HISTORY OF EARLY
SOVIET SPACE ENDEAVOR

intellect Bristol, UK / Chicago, USA

CONTENTS

FOREWORD

n January 2009, at a conference on Soviet "space enthusiasm" in Basel, Switzerland, I saw a huge, blow-up photo of an untied shoelace projected on the screen. The offending shoelace belonged to Yuri Gagarin, walking to meet the Soviet leader Nikita Khrushchev upon a triumphal return to Moscow after his pioneering space flight. In her talk, Iina Kohonen used this picture – one of the most ridiculous and at the same time symbolic images of the Space Age – to make a point about a touch of humanity in the idealized representations of cosmonauts by the Soviet propaganda machine.

Previous studies of the visual record of the Soviet space program focused on more obvious issues, such as the retouching of cosmonauts' group photos to erase perished or expelled candidates, or the elimination of cosmonauts' photos with Khrushchev after the embattled Soviet leader was ousted in 1964. Such studies addressed the questions of secrecy or immediate political expediency.

Kohonen's approach is different: she looks at smaller details and bigger context. She studies the photographic record of the Soviet space program not for the sake of finding vanished cosmonauts, but to detect the embedded ideological messages – in other words, to compile the grammar of Soviet visual propaganda.

In this book, each space picture is truly worth a thousand words – Kohonen's analysis reveals not only the explicit intentions of the media, but also the underlying assumptions of the Soviet visual discourse. Photos of heavenly bodies and depictions of space technology convey the message of conquest. Shades of color and grayness in space paintings display a range of conflicting emotions, from awe to escapism. Typical imagery of Soviet space heroes in public and in private evokes a fairytale script. Representations of humans and machines are blurred in utopian technological visions.

This book shows that neither documentary photos nor artwork can ever be reduced to a single meaning. A slow study of visual images, like slow reading, uncovers what a fast glance often misses – the expressions on the faces of villagers watching a just-landed cosmonaut, or the ordinary details of cosmonauts' daily lives that undermine conventional stereotypes of masculinity.

The ambivalence of cosmonaut roles – as heroes or ordinary people, as models of masculinity or family men, as emotional humans or extensions of technology – shines through many images in the book. They encapsulate

the contradictory essence of Soviet space mythology – an attempt to build a propaganda campaign around a highly secretive program, to prove the superiority of socialism while stressing the peaceful and international character of the space enterprise, and to mobilize mass enthusiasm for space exploration while reaffirming domestic family values.

My interviews with Soviet space program veterans and the study of personal diaries and archival materials suggest that cosmonauts did not easily identify with their own visual iconography. While the government decreed that a bust of each flown cosmonaut should be erected in his or her home town, Alexei Leonov, the first "spacewalker," objected to the installation of his monument, which thus had to remain in the sculptor's studio for 28 years. When Gagarin's mother asked him for a photo, he did not give her any of his iconic images, instantly recognizable around the world. Instead he found the photographer who had taken a casual picture of him before the historic flight, when Gagarin was still a young, unknown pilot. This photographer told me in an interview that Gagarin wanted to give his mother precisely that old photo, where he was not famous yet, a photo that was not endlessly reprinted in the media, a photo that had captured his humanity before he was turned into a visual symbol of the Space Age. Gagarin, the most recognizable icon of the time, did not see himself as an icon.

Whether flipping through glossy pages of popular magazines or thumbing through dusty old photos in archives, Kohonen brings to life the immediate visuality of Soviet space experience and slices off layer after layer of meanings. Whether you are a seasoned space historian, a space buff, or a casual reader, familiar space images will never look the same to you after you read this book.

Slava Gerovitch

Historian, Massachusetts Institute of Technology

Author of *Soviet Space Mythologies: Public Images, Private Memories, and the Making of a Cultural Identity* and *Voices of the Soviet Space Program: Cosmonauts, Soldiers, and Engineers Who Took the USSR into Space.*

ACKNOWLEDGMENTS

While doing this research, I was very lucky to be able to work in three very different academic milieus: at the School of Art Design and Architecture at Aalto University, at the University of Tampere and at the Aleksanteri Institute at the University of Helsinki. I want to express my gratitude to everyone at these institutions for all of their support. My very special thanks go to Professor Merja Salo of Aalto University and Dr. Sari Autio-Sarasmo of the Aleksanteri Institute, who always encouraged me to dig deeper and to fly higher. Thank you! I am also deeply grateful to Professor Natalia Baschmakoff and Dr. Johanna Frigård and Professor Hannu Salmi: your wise and critical comments on this work were encouraging and very helpful, and to Dr. Slava Gerovitch for his kind words in the foreword. I am also greatly indebted to my dear friends, peers and colleagues at the three universities. I have greatly benefited from numerous inspiring discussions with you. Still, all errors and misinterpretations are mine.

This study has received financial support from several sources. Work and travels to Russia were funded by Academy of Finland, the Alfred Kordelin Foundation, the Ella and Georg Ehnrooth Foundation, the Niilo Helander Foundation, the Patricia Seppälä Foundation, the Finnish Concordia Fund, and the Finnish Association of Non-fiction Writers. The translation of this book from Finnish was kindly funded by The Finnish Centre of Excellence in Russian Studies – Choices of Russian Modernisation and the graphic design by the Aalto University, School of Art Design and Architecture.

I am also very grateful to Dr. Albion M. Butters and Tiina Hyytiäinen, who translated the Finnish version of this book into English, and to the graphic designer Jyri Konttinen, who made the book as beautiful as it is. Without your contributions, this book would not have been possible.

I am also very thankful to the RGANTD-archive for giving me a permission to publish the photographs from their collections and to the Bonestell LLC for the use of *Nightfall of Montes Leibnitz* by Chesley Bonestell. My very special thanks goes to Cosmonaut Alexei Leonov for kindly allowing me the use of his painting *Selenodezity* in this book.

Finally and most importantely, I wish to thank my dear friends, who were very talented at keeping me from worrying too much, and my loving family: to my mother– without you caring for the whole family this project would not have been possible; to my father, who taught me to be curious, look carefully,

and never stop wondering; and to Anna and Akseli for being both a sister and a brother, but also peers in the academic world. My deepest gratitude goes to my husband Uula and to my lovely children Unni and Toivo for their love.

This book is a translated and edited version of my doctoral dissertation published in Finnish in 2012. This English language version was made possible with the support of Aalto ARTS Books, to whom I am very grateful.

About the Author

Iina Kohonen has a degree in cultural anthropology and a doctorate in photography (2012) from the School of Art Design and Architecture at Aalto University, Helsinki, Finland. Her recent publications address the visual history of the Soviet space program.

INTRODUCTION

CHAPTER 1

Flying, actual, potential, and dreamlike, has always implied more than a mechanism for overcoming gravity.

(Siukonen 2001: 11)

I n an archived photograph, we can see a woman in the middle of space debris. The landing capsule has hurtled into a field; it is charred and lying slightly on its side on the ground. The woman – I know that she is Valentina Tereshkova, the first woman to just return from space – is sitting, looking confused and gathering things in an open bag. On the ground next to her is an open newspaper on top of which a bottle of milk and eggs have been placed. The spacesuit lies in a heap next to these and there is also a lot of other unidentified stuff around. A crowd surrounds the cosmonaut and the landing capsule, children with bare feet and grandmothers with scarves, looking solemnly at the miracle that has come from space (RGANTD 0-878). (**FIGURE I**)

The people around Tereshkova are very close to her. How is it possible? Wasn't the landing of a cosmonaut a state secret? Yes, it was. The surrounding technology was top-secret, but still the people could approach very near, even touch their hero. How was this possible? The image is full of clues, like bits of a plot. These details are heavily loaded with meaning. However, outside of its original context, the photograph remains mute to me, a viewer from another culture and time.

In order to understand this single photograph, to be able to mine its meanings, we have to look further, to other photographs and stories, to the whole of the culture that once surrounded it. The image was born in a specific historical context and is bound with that time and place. The cultural geographer James R. Ryan (1997: 19) has used the term "visual history" to describe the research perspective that aims to examine how photographs or images function as part of a particular historical situation, as part of distinct mechanisms of power and control. The standpoint stems from the basic perspective of visual culture research, according to which images not only reflect reality but also actively produce it. As the French philosopher and cultural critic Roland Barthes put the idea, "In an initial period, photography, in order to surprise, photographs

the notable; but soon, by a familiar reversal, it decrees notable whatever it photographs" (Barthes 1985: 40). What is it that this particular photograph is trying to make notable?

Taking this one shot as a starting point, this book is an analysis of images like it, which were provoked by the Space Age. The photographs that we are about to study in the following pages are both boldly heroic and, as we will see, commonplace yet romantic, strikingly picturesque and sometimes – paradoxically perhaps – very earthbound. The arguments of this book will explore these contradictions.

The research material includes photographs, illustrations, paintings, and films produced in the Soviet Union between 1957 and 1969. The main focus is on photographs found in the press, as the photos published in newspapers and magazines brought space and its conquerors into people's everyday lives. The analysis centers particularly on two interpretative contexts: the conquest of outer space, and the multiple facets of heroism connected to the cosmonauts in the Soviet Union of the late 1950s and the 1960s. (The reader should not worry: even though we will see many pictures and photographs, our space heroine will not be forgotten. Toward the end of this book, we will pick up with her again.)

"The Current Generation of Soviet People Will Live Under Communism"

The images illustrating this book were born as part of the Soviet Union's Cold War propaganda machine and, if published, they followed the official party line, as publishing could not be done legally outside of official channels. The period examined begins with the first Sputnik in 1957 and ends with the mission to the Moon by the United States in 1969. From the perspective of the Soviet Union, therefore, the story proceeds from victory to defeat. During this long decade the world lived in a Space Age, at least on the pages of glossy magazines. In Soviet Union, television had not yet replaced magazines as the primary form of visual media, and the photographs published in popular magazines played an important role in recording, illustrating, and producing the Space Age. In the words of a contemporary photographer, "As photojournalists, we write the history of our time. Our part is to do it through the method of our art; truthfully, clearly, convincingly" (Korolev 1957: 19).

The main publishing channel of the photos was the press, by means of which they circulated through an efficient, state-run publishing network. Technological advances in printing made possible an unprecedented appearance of photographs in the press. In terms of visual culture, times were in flux. In previous decades parades shown in media had been grand, paintings were full of marvels, and photos depicted the construction of a giant country into an even greater one. After the death of Stalin in March 1953, the situation changed – not with a bang, but gradually. At the 20th meeting of the Soviet Party Congress in 1956, Stalin's successor, Nikita Khrushchev, had condemned Stalin's purges and his personality cult. This "Secret Speech" by Khrushchev was followed by the so-called Thaw era[1], which was characterized by a partial relaxation of censorship, careful optimism and belief in a revival of the political system. Socialist realism[2] retained its place as the official trend of the arts, but photographers observed that they had slightly more room to move.

Space grew to be the symbol of modern life and the future. Mankind seemed to be on the threshold of a new era, and belief in the possibilities of science and technology was strong. "Our country was the first to create an orbital spaceship, the first to reach outer space. Is this not a brilliant demonstration of the genuine freedom of the freest of all free people on earth, the Soviet people!" claimed Khrushchev in his speech (1961a) in Red Square two days after Yuri Gagarin's flight. Through the power of technology, everything appeared to be possible. The smiling cosmonauts were the people of the future. The central themes were modernization, "modernity" (sovremennost), a belief in man's omnipotence before nature, and the glorification of scientific and technological progress.

The optimism of that era is shown clearly in the Communist Party's new program (Programma KPSS), the so-called Third Party Program, which was formed in 1958–1961. The program was published in Pravda on July 30, 1961. The basic idea of the Party's program was to build a transition from Socialism to Communism over the next twenty years. "In the Soviet Union, the material and technical foundation of Communism will be created in two decades. That is the most important economic task of our Party, the foundation of the main line of our Party" (Khrushchev 1961b: 201). The program promised that Communism would be achieved in two stages: during the first decade (1961–1970), the Soviet Union would surpass the United States in agricultural and indus-

trial production. The Third Party Program also promised a dramatic rise in the standard of living: growth in housing construction, increased consumer goods, and reduction of working hours to be the lowest in the world. In the second phase (1971–1980), the material-technical foundation of Communism would be created, and Soviet society would achieve the Communist objective of allocating commodities to people on the basis of need. The promise "the current generation of Soviet people will live under Communism" was repeated in the program (*Programma* кpss 1961: 65–66, 142). Communism was no longer a far-off dream, but a fact. This was partially proven by winning the Space Race, as underlined in a humorous picture published in *Ogonyok* in 1961 (**FIGURE 2**). "Illusion! Utopia! Slander!" shout the capitalists, powerless in front of the program. Next to the picture is a quote from Khrushchev: "The program of the Communist Party can be compared to a three-stage rocket" (*Ogonyok* 45/1961). Even before its actual implementation, the Third Party Program received great proof of its success with space achievements. Never before had utopia had such a clear timetable, a concrete point in the future.

Secrecy and Spotlight

What best defines the space-related imagery in its entirety was a strange connection in which meticulous censorship and excessive propaganda were linked. The censorship, which was very strict in general, was particularly vigilant when it came to anything associated with the space program. Created in the top-secret atmosphere of the military-industrial complex, illustrations or photos related to the space program were not circulated to the public without cautious consideration. It is precisely this balancing act that makes these photos an interesting subject of study: every published photo was significant, every detail left in place was meaningful – especially if appearing more than once. In the following pages, we shall see how media managed to negotiate scientific accomplishments and the demands of censorship: how to illustrate as much as possible without accidentally leaking secret technical data?

One simple solution was the practice of heavy retouching. During the whole of the 1950s and 1960s, retouched or otherwise doctored photos could be seen in the press. The photos in *Ogonyok* magazine, for instance, were quite often colored by hand, and this practice was not questioned at any stage during

that era. *Sovetskoe Foto*, an important publishing channel for photo enthusiasts and professionals, even shared instructions with its readers on how to combine negatives, as well as other methods of manipulation and montage (e.g., Bespalov 1964: 36). In a sense, the practice of coloring photos and using other types of manipulation did not lessen their relationship to reality: sometimes retouching was simply a technical and aesthetic matter, not taken as tampering with the photos' authenticity. The method was not very different from the digital retouching of photos in advertisements routinely done today. This is shown in **FIGURES 3 AND 4** for example, where we can see how a hero has been made beautiful by painting on top of the photo. At other times, however, it was much more than that.

Material Used in the Book

This book is based on photos, illustrations, and paintings published in the Soviet Union. The core data was collected from the complete volumes of *Ogonyok* magazine from between 1957 and 1969. Included are images involving the topic of space from that period.

The magazine *Ogonyok*, which came out once a week, had the third largest circulation of the Soviet Union magazines at the turn of the 1950s and 1960s.[3] The magazine existed even before the Revolution, and even then it was already focused on photojournalism. It began circulating in its Soviet form in 1923. While published weekly on Sundays, it could take a month for new issues to reach the eastern and northernmost parts of the Soviet Union. The magazine defined itself as "a weekly socio-political, literary art magazine." It was printed on what in those times was good-quality paper, and it included many photos, illustrations, and articles on science, sports, and Soviet life in general. In 1945, the magazine was expanded and was reintroduced with colored pictures. At that time, its circulation started to climb, and by the 1960s it ran to two million. Its price was affordable, as the magazine was aimed at the general public. Right from the outset, its contributors included the most prominent Soviet authors, scientists, and artists. At the turn of the 1950s and 1960s, many talented photojournalists were working for the magazine, such as Vsevolod Tarasevich, Dmitri Baltermants, Alexei Gostev, and Isaac Tunkel. In addition to having its own photographers, *Ogonyok* also acquired photos from photo

agencies. For example, only carefully chosen photographers had the right to be present at the launches or photograph the landings of the cosmonauts.

Images in *Ogonyok* depicting space were not consistently distributed over the years. From **TABLE 1**, one can note that space images were most concentrated between 1961 and 1963. On the basis of the quantity of images, it is easy to see that space-related news coverage was at its peak during those years.

Table 1. The total number of space-related images in *Ogonyok*.

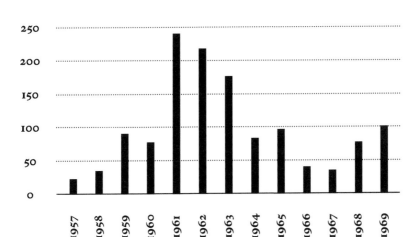

In 1961, when the peak number of images was reached, the Soviet Union won the most meaningful round of the Space Race at that time: on April 12, Yuri Gagarin became the first human to fly into space. The following years were a celebration of manned flights by the Soviet Union, and this is reflected in an abundance of images until 1963. After that point, the number of images dropped significantly, so that by 1967 the topic of space was almost completely absent in the magazine. Reasons for this decline in images were linked to the space program itself. In 1966, the chief engineer of the space program, Sergei Korolev, passed away. This was a heavy hit to the space program. In 1966, the Soviet Union only managed to launch two lunar probes, both of which were extensively reported on by *Ogonyok* (6–7/1966; 15/1966). Yet, not even one manned flight was sent into space by Soviets, and space-related images were

almost completely absent in the magazine: over the course of the whole year, only 37 space-related images were published. The following year the magazine concentrated even less on the subject of space: only 30 images connected to the space program were published in the magazine. Moreover, instead of focusing on celebrated heroes, for the first time ever the magazine reported on an accident that took the life of a cosmonaut, when Vladimir Komarov was killed during a failed descent of his Soyuz I spacecraft. The accident was publicly acknowledged because the flight was already known about (*Ogonyok* 18/1967). The only other newsworthy space-related event reported by *Ogonyok* that year was the successful arrival at Venus of the Venera 4 probe (*Ogonyok* 43/1967).

The year 1968 also started with sad news when the first cosmonaut, Yuri Gagarin, died in a flight accident. This was also widely reported on in *Ogonyok* (15/1968), which led to a jump in the number of space-related images. At the end of 1968, after a long hiatus *Ogonyok* again reported on a manned spaceflight (*Ogonyok* 45–46/1968), and the following year *Ogonyok* introduced many new space heroes through successful Soyuz flights (*Ogonyok* 3–4/1969). There were, however, hints of other new heroes in the images: throughout 1969 we can see, among the familiar faces of the cosmonauts, glimpses of astronauts from the US Apollo program (see, for example, **FIGURE 51**) (*Ogonyok* 1/1969, 22 /1969, 30/1969, 32 /1969).

The images published in *Ogonyok* were primarily directed at a Soviet audience. The magazine was the primary publishing platform of the images that form the material of this book, but it was not the only one. The centralized publishing machine and the copyrights associated with it led to a situation in which multiple versions of a single photo could be in circulation at the same time.[4]

FIGURE 5 shows a young man in an Air Force uniform, looking past the camera with a slight smile on his face. The person in the photo is "Cosmonaut No. 2," Gherman Stepanovich Titov, the second man to orbit the Earth, only three months after Yuri Gagarin. After his spaceflight, this photo became well known. **FIGURES 6–13** (see also **FIGURE 71**) show how the same image was used as press photos, book covers, postcards, posters, and badges. This was a typical practice. Space technology and images of the first cosmonauts were quickly turned into a kind of basic corpus, which was refreshed again and again in slightly different ways, and retouched and cropped.

The photos published in *Ogonyok* were often manipulated, as colorization and other forms of retouching were a common practice. In order to see what

kinds of cropping and changes were made to the photos, I decided to look for their originals. The photo archives of *Ogonyok* itself have disappeared, but most of the space-related images ended up in the Russian State Archive of Scientific and Technical Documents (*Rossiisky gosudarstvennyi arkhiv nauchno-tekhnicheskoi dokumentatsii*, RGANTD) in Moscow. From this archive, I collected extensive background material, a collection forming a total of over 4,000 photos.

The material produced by the Soviet Union's space program has been collected in the archive since 1974. The collection includes correspondence by the cosmonauts, recordings, film clips and technical drawings, memoirs, and a range of scientific and technical documentation. The collection has been built by different parties involved in the space program, as well as media and private people. In terms of this book, the most interesting part of the archive was its photo collection, the largest one in Russia to concentrate solely on the space program, consisting of approximately 92,000 photos. I went through the areas of the collection that were accessible to researchers, examining index cards that included small black-and-white proofs and information about the photo's provenance: the photographer, a description of the location, information about the event or people depicted in the photo, and possible cropping done to photos that were published. The attached proof was often reversed. I used dates as my selection criterion, as I sought to collect photos between the years of 1957 and 1969 as comprehensively as possible.

In addition to the collection of archived material, my research also includes other visual material produced in the era, such as films, art, popular booklets, biographies of the cosmonauts, and trading cards. Together these provide background and create a context for the images of the research. Other visual material, however, remains background material. For instance, I do not separately analyze the narration of films.

Roland Barthes has written about problems that one may confront when trying to make generalizations on the basis of a single photo. As Barthes sees it, photography mechanically repeats something that cannot ever again existentially be repeated. If one wants to understand something broader by means of photos, one encounters a problem, which Barthes calls the "tireless repetition of contingency" (Barthes 1985: 10–11). By this, he seeks to express the contradiction that arises when one attempts to make generalizations based on a single photo. The photohistorian Alan Trachtenberg sees this analogous

to historical research: how can one fit the random and fragmented details of everyday life into a sensible whole without losing the rich detail of life itself? (Trachtenberg 1989: xiv). What aspect of photos is essential when doing research on them? Thousands of tiny details draw any single interpretation into different directions. How to generalize that "endless repetition of coincidence" without losing the coincidence itself?

When I went through the larger corpus of material, I noticed that the imagery, in fact, was not at all accidental. The cosmonauts received the same flower bouquets and medals again and again, and they trained and spent their free time in similar conditions. What was repeated in *Ogonyok* was also repeated in the archive. Subjects of photos and gestures and positions continually recurring in almost the same way leads one to wonder why certain details or themes repeat themselves from one magazine to another, or from one photo to another. I decided to make this repetitiveness one of the objects of my analysis. I approach the imagery by paying less attention to individual visual narratives and instead concentrating on analyzing recurring themes that I have located in the imagery. What recurs and why?

The Structure of the Book

The book is divided in such a way that the premises of the study are presented in an introductory chapter (Chapter 1). The introductory chapter examines the empirical and theoretical background of the study and introduces the methodological preferences. Research material is treated in six analytical chapters. Each of these contains its own specific and exclusive collection of material, along with the essential methodological emphasis that is germane to the research questions of that chapter. The common goal of these analytical chapters is to situate the images in terms of their larger historical, political, and cultural context.

Chapter two considers the space-related images that appear in this book. This imagery includes photos of space, satellites, and the Moon taken from Earth, photos taken by probes in space, and stylized illustrations of rockets launched into space. Soviet cosmic propaganda strongly drew from the idea of outer space's immensity and the rhetoric of conquest and exploration. The purpose of this chapter is to show how this was done via visual representa-

tions, and its basic argument is that the cosmic imagery was, in practice, very imperial by nature. The chapter takes the early Soviet Luna program – the first three robotic spacecraft missions sent to the Moon by the Soviet Union in 1959 – as a case study.

Chapter 3 concentrates on a peculiar sub-genre within the canon of post-Stalinist Socialist Realist art: the cosmic landscapes that appeared so widely in the pages of *Ogonyok* and other popular media. An interesting point of departure for this topic is an artist whose works were frequently published in popular magazines, a cosmonaut himself: Alexei Leonov, the man who performed the first "spacewalk" in March of 1965. The works drew their influence from Stalin's gigantic industrial scenes, which celebrated man's unlimited power to bend nature to his will. But like all dream images, they were ambivalent: in the colorfulness of these paintings, one also finds murkier shades and almost escapist tendencies.

Chapter 4 provides context for the cosmonaut as a new type of hero in Soviet history. This chapter introduces different elements of the visual narratives of the cosmonauts, and it reflects on their meaningfulness in the context of the Soviet Union of the 1960s. In its analysis of the homecoming ritual of the cosmonaut hero, the chapter discusses Vladimir Propp, the researcher of classical structuralist narratology. In the spirit of Propp, the following chapters look at imagery as a narrative that gets its meaning vis-à-vis themes connected to heroism and the modernization of everyday life and humanity.

Chapter 5 contextualizes the hero in the Khrushchevian discourse of ideal citizenship. Over the course of the 1960s the focus turned from outer space to the Earth's surface. The theme of conquest was increasingly replaced with more earthbound subject matter related to the cosmonauts, and the emphasis was on the commonplace, quotidian qualities of the cosmonaut heroes' personal lives.

Chapter 6 demonstrates how the photographs representing early Soviet cosmonauts associated outer space with the discourse of modernity, good taste, and the aesthetics of the everyday. Particularly, the male cosmonaut as a representative of his gender can be seen as having more latitude than men previously had in general in Soviet media.

Chapter 7 focuses even deeper on the human side of the technological utopia. In the midst of Cold War policies and the technological utopianism so closely linked to the Space Race, the photographs in this book clearly show that,

visually speaking, it was not the *machine* that was celebrated – it was the man who had broken the barriers of Earth's gravity and had survived, the cosmonaut, both utopian hero and modern man. This chapter shows how the border between man and machine was blurred in the discourse of cybernetic society.

The concluding chapter (Chapter 8) summarizes the arguments of the main chapters, then assesses the overall implications of their content for both Soviet history and photographic theory.

A SLASH ACROSS THE HEAVENS

MAPPING AND NAMING SPACE

CHAPTER 2

*To sharpen the gaze, reach out one's
hand to develop fingers and a sense
of touch, so that according to our own
discretion we can move the smallest
building blocks of the microcosmos –
so that man can overcome the gravity
of the Earth and shoot wise seeds
through vast space.*

(Leonov 1961: 5)

I n the poor-quality press photo, one can barely recognize a white line crossing over the surface of the black photo. The photo was published in *Pravda*, and it is one of the first published photos of Sputnik 1, the first artificial Earth satellite. It is so vague that it is almost indecipherable. The photo shows a dimly shining stripe on a night sky. It was taken with a long exposure, and it displays the route of the satellite in the sky.[5] The dim stripe left by the satellite is like a slash across the heavens, mankind's track in infinite emptiness. **FIGURE 14** depicts the same theme in *Ogonyok*, as "photographed by the Englishman Alan Morris" (*Ogonyok* 1/1958).

In this chapter, I explore the broader themes that this little photo opened up, examining photos as an aspect of different means of conquering space. The idea of monitoring, controlling, even capturing an object has been linked to photography since its invention (Ryan 1997; Tagg 1988: 23–24, 66–102). After its discovery, photography was immediately adopted as a tool for possessing space. Early nineteenth-century expedition photos were capable of representing targets with millimeter precision. With the help of those photos, it was possible to gauge and comment from afar on the nature and landscape of distant countries; it was viable to classify and categorize landscapes by means of science. The photos produced by the new instrument also interested the audience in an unforeseen way. The photos transformed the abstract symbols of a map into physical places. They produced a sort of imaginary geography,

and they brought distant places within reach (Schwartz 1996: 16–45; Tracht-enberg 1989: 155).

Racing into Space

The Space Race between the Soviet Union and the United States was closely linked to weapon and missile technology. Engineering and technology were key terms in the space program. In the material examined, technology appears as physical and technical equipment, such as different apparatuses and machines. In addition, technology and technical equipment are connected with different mechanisms of control and assuming possession. In this book I define technology largely on the basis of how the concept was used in the Soviet Union in connection with the scientific–technical revolution: the complete electrification of the whole country, the advancement of technical and technological methods across all levels of the economy, the automation and full mechanization of production processes, the use of new energy sources, the full exploitation of natural resources, and the linking of science and technology to all production (*Programma KPSS* 1961: 66).

The belief in technological progress was not typical of the Soviet Union only. For example, the term "scientific–technical revolution," which was much used in the Soviet Union, originated in the United States at the end of the 1950s to describe the swift technological development of the era and those changes that this development brought about. In the 1950s, the belief in modernization, as well as a strong rise in standards of living through science and technology, was a phenomenon that transcended nations and political camps. In the context of the Cold War, the two competing superpowers were both trying to control natural resources, human behavior, and technological development, but through different means (Autio-Sarasmo 2011: 135–137; Westad 2000: 556).

An Earth-orbiting satellite had been the aim of both superpowers from the beginning of the International Geophysical Year.[8] Both doubted, at least in theory, that the other had the necessary technologies to launch an "artificial moon." In the West, however, it was not completely understood, at least publicly, how far the plans of the Soviet Union had actually advanced. When the Soviet Union achieved success, it was a shock to the United States. From the point of view of a superpower, it was humiliating. In particular, the United States

focused on the small satellite's powerful booster rocket, which could enable the delivery of an intercontinental missile. This realization caused self-reflection in the United States about the loss of technological dominance. The Cold War publicly shifted into a new phase, and the United States' tone of technological optimism grew darker (Gorin 2000: 11–42; Peoples 2008: 55–75).

A more serious undertone to the technological optimism can also be seen in *Ogonyok*. For instance, the article "WRockets guarding the peace" presented the newest war technology of the Soviet Union with 23 photos (*Ogonyok* 26/1965). Rockets rising into the evening sky and photos of the destructive power of their explosions linked strange discourses of war and peace. On one hand, there was talk of world peace: "The data collected by the Soviet Sputniks has been given to the public for the use of the whole of humanity. This is the clearest indication of the humanity of the socialist society, a society that with all its power seeks to promote the peaceful development of all people" (*Ensimmäinen vuosi...* 1958). On the other hand, military technical dominance was demonstrated. Photos aestheticized the Cold War with rockets on their launching pads, reddened by the sunset (**FIGURE 15**), and graphic mushroom clouds on the horizon. The photos are so heavily retouched and distorted that the rockets depicted in the end had hardly anything do with the actual technical apparati (which were classified). Still, the pictures are reminiscent of the double role played by the first Sputnik as well. Not only could one research the depth of space with rockets; it was also possible to wage war with them.

The anthropologist James C. Scott (1998) has researched politics, geography, and the power relations linked to these. He has written about "high modernism," meaning the era that began with the scientific discoveries at the end of the eighteenth century and the industrialization of the nineteenth century, when the belief in scientific–technical development was especially strong. The scientific and technical development that began in Europe at the end of the eighteenth century and the industrialization that accelerated from the mid-nineteenth century led to urbanization, the rise of the middle class, increasingly long expeditions and expanding empires, and inventions such as the telephone, the telegram, and the steam engine that transformed the concept of time and space. Photography was born in this setting in order to record it. Photography can be seen as a technology that was produced by the modern era and can be placed in the same continuum as other different technological

inventions that used images, such as the Galilean telescope and the Hubble telescope, as well as the microscope. These technologies have brought to light information that cannot be seen with the plain eye. By making seen that which was previously unseen, photography-related technologies are "changing the rules of existence" (Elo 2005: 82; Schwartz and Ryan 2006: 1–2).

According to Scott, the ideology of high modernism is depicted by a steadfast trust in the potential of science and technology to satisfy the ever-growing needs of humans. The ideology of high modernism aims for a complete control of nature (including human nature). In the Soviet Union, new technologies were seen as the answer to problems that were encountered on the way to Communism. The ideological belief in high modernism went beyond traditional political borders. The ideology prized speed, motion, and sleekness. It swore in the name of rationality and claimed to be a radical break from the past. In terms of time, the emphasis was on the future. According to Scott, "heroic progress toward a totally transformed future" was seen and emphasized in visual expressions, often in such a way that the contrast between everyday life and future-oriented images was painfully clear (Scott 1998: 1–8, 87–102). The Space Race of the 1950s and 1960s can be seen as one of the high points of this high modernism.

To Conquer – or to Explore?

One of the most consistent guiding principles of the Soviet Union was its great breadth. Although the areas covered on the map were large, they were not unified. Katerina Clark and Jan Plamper have both analyzed the spatial organization of the Soviet Union from the perspective of the sacred. Clark has stated that the country organized itself in concentric circles. The hierarchal "cartography of power" had divided the area of the everyday and sacred space in such a way that the closer one came to the innermost circle, the more sacred it became[6] (Clark 2000b: 119–127; 2003: 3–18; Plamper 2008: 339–364). Emma Widdis (2003a: 182) has researched spatial concepts in the Soviet Union through Stalin-era films, distinguishing the terms "conquest" and "exploration." According to Widdis, space in the Soviet Union was ordered in a static and hierarchical way around Moscow, the dominating center. Moscow was like a magnetic pole whose field controlled movement external to the center. As if pressed by a centrifugal force, movement was directed outside of the core.

Moscow organized power around itself in such a way that remote areas were directly related to the city center and in a circular manner, so that the most sacred area was the Kremlin. In Stalin's time, the sanctum sanctorum was his office, which was so sacred that it could not even be photographed. The reference "a light shining from the tower" should suffice – Stalin worked for his country at night. Stalin himself was a monumental, static figure. He did not depart from the central core of power; rather, people came to him. Or more precisely, people asked to approach him. Only a few had the right to cross the magical border of the inner circle (Clark 2000b: 119–127; Günther 2003: 115–116).

Moscow is also a central element in space imagery. As seen in photos, Moscow is part of space: a huge moon rises above the Kremlin, while in another photo the red star of the Kremlin is more massive than a rocket (*Ogonyok* 46/1959, cover; *Ogonyok* 7/1966: 1, photo: O. Knorring). In **FIGURE 16**, the Kremlin's red star launches the rocket with the words "Peace, Work, Freedom, Equality and Happiness." In **FIGURE 17,** the phrase "the Soviet Union, the cosmonauts' homeland" manages to fit on the label of a small matchbox. These kinds of collector's series of matchboxes with varying themes were common. The same relationship between Moscow and the universe was dealt with by Pavel Klushantsev[7] in his film *Vselennaya* (*Universe*, 1951). At the end of the film, the perspective moves from the furthest infinity of the universe to the Earth, and finally to a close-up of Moscow. Moscow was the hub of the world, the *axis mundi*, the pillar between the Earth and the heavens around which the whole universe revolved.

According to Widdis, the idea of sacred center and conquering what is outside it is not sufficient to explain all of the spatial dimensions of the Soviet Union. She introduces the concept of *exploration*, beside the concept of conquest:

> If *osvoevie* [conquest] is understood as an assimilative attitude toward the periphery, in which the periphery is subject to a structure of control from the center, then *exploration* describes a more decentered, nonassimilative investigation of space in which difference is emphasized over sameness and the quest for information is differentiated from control. (Widdis 2003b: 221)

Unlike Stalin, Khrushchev repeatedly violated the idea of the sacredness of the center. He moved in the outer ring of the circle, among the masses, in the

periphery. In the photos, Khrushchev participates, shakes hands, hugs, tastes, raises his glass, embraces, and is in constant movement. On the other hand, Khrushchev's movement in the outer rings of the domain only emphasized the meaningfulness of the center. The myth of the center was equally dependent on the clearly defined myth of the periphery.

In this chapter, I analyze photos with the help of Widdis' conceptual division. I reflect on how space was captured by photos, how photography as a tool participated in this process of capturing, and how the conceptually distinct terms "conquering" and "exploration" appear in my research material. I discuss the role of the photo as a photo, specifically as a device. The aim of this chapter is to consider how the capturing of space, the domestication of the place, was realized with the help of photos and cartography. I explore a variety of pictorial perspectives on space. In particular, I examine more closely two types of photos that repeatedly appear in the imagery. The first object of observation includes photos where the location of the viewer is the surface of the Earth. Second, I concentrate on photos depicting the Moon.

The System of Secrecy

The news that broke the launch of the first satellite did not have a photo. Actually, the magnitude of the news was not even immediately obvious. Perhaps only a few people paid special attention to the routine press release of the TASS news agency on the front page of the Party journal *Pravda* on October 5, 1957. The short notice stated that the day before, the U.S.S.R. had launched an Earth orbital satellite (*iskusstvennyi sputnik zemli*) as part of the program of the International Geophysical Year. The notice stated that the satellite was 58 cm in diameter and 83.6 kg in weight, and it orbited the Earth with an elliptical trajectory. One revolution was said to take one hour and thirty-five minutes. If one had stopped to think about this, it might have caused amazement – the speed was quite fast, as much as 5.34 mi/s. While the notice did not waste exclamation points, perhaps the last bit might have given the reader pause: the artificial satellite was promised to "pave the way to interplanetary travel." The notice ended with a statement, appropriate to the time of its release, about how "the new socialist society makes the most daring dreams of mankind a reality" (*Pravda* October 5, 1957: 1).

The next day, everything changed. The contrast with the terse notice by TASS is evident. Academics from around the socialist world praised the achievement: "science has overcome fantasy," "the future started today," and "the great victory of the creative mind" (*Pravda* October 6, 1957: 1). This was the style with which the media in coming years would describe space: with exclamation points and superlatives. Not only *Pravda*, but press around the world published the event on their front pages. In the West, the news was received with astonishment, even with shock: the Space Age had begun, but in a completely different way than expected. For a moment, the relative political strengths of the superpowers were reversed.

The lack of any photo could perhaps be explained by the paucity of media coverage in general – it is possible that the great news value of the satellite launch only became clear to the Soviet media after the sharpness of the reaction of the West. However, the photo is not found in the following day's *Pravda*. What did the satellite look like? The Western press had to settle for guesses, and the early illustrations of Sputnik resemble fantasy more than reality.

The first photo of Sputnik 1 did not appear until five days after the historic launch (*Pravda* October 10, 1957: 1): a stylized product photo without any technical details, which spread quickly to the Western press (**FIGURE 18**). A week after Sputnik's launch, the same photo was published in *Ogonyok* (*Ogonyok* 42/1957: 1). The photographer was not credited. In the photo, Sputnik is attached to a rack against a black background. It is hard to believe that this harmless-looking object changed the scientific–technical balance of superpower relations. Four long antennas are directed backwards, cutting diagonally across the black photo. The satellite shines in the photo, as if it had been rubbed with chamois. The satellite's design had been well thought out in terms of science – the shiny sphere reflected the rays of the Sun as much as possible and thus ensured the best possible visibility from the surface of the Earth – and also for purely aesthetic reasons: "It will be displayed in museums!" was the argument of the chief designer, Sergei Korolev, for its calculated elegant form and presentation (Gerovitch 2008: 219; 2015: 83).

In all its minimalism, the photo of a perfect sphere was a ready-made symbol, like a stamp, and it remained the only widespread publicity photo of the satellite itself – even though it is hard to ascertain with any certainty the authenticity of the satellite in the photo. It may also be one of the numerous

1:1 models produced of Sputnik for exhibition purposes (see, for example, **FIGURE 19**). A few photographs of the satellite's manufacture were found in the archive, but only this photo became public.

An equally limited series of illustrations are found for the next set of satellites and rockets. Not even one month had passed after the first Sputnik when the Soviet Union caused a stir with a new flight: on the 3rd of November the second Soviet satellite, Sputnik 2, was launched. This was even a greater shock for the West than the first one. Within mere months, the Soviet Union had succeeded in seizing the technological lead from the United States. Sputnik 2 was impressive on the basis of its sheer size. While the United States was struggling with repeated unsuccessful launches of its own first satellite, which weighed less than 1.5 kg, this Soviet satellite weighed over 500 kg. The Soviet press ridiculed the small size of the American satellites: "Soviet scientists would not waste their energy sending some kind of orange up to the sky" (Geim 1959: 20–23). The taunting was mutual: in the United States, the small size of their satellites was seen as an advantage, while the Russians were seen as only being capable of clumsy mechanical solutions, lacking the kind of accuracy demanded by fine mechanics (Shelton 1968: 4–5). On the other hand, the United States was also the target of ridicule from other countries: after the repeated failures, the headlines of newspapers around Europe read "[o]h, what a Flopnik!", "US Calls it Kaputnik," and "[i]t seems there is a worm in the grapefruit" (Heppenheimer 1997: 127–128).

How then was this second Sputnik represented in photographs immediately after its launch? Reportage was greater than the first time, but pictures were still scarce. *Pravda* gave the first news coverage, publishing in the usual way the release by the TASS news agency. The release described the technical equipment of the satellite in a matter-of-fact, yet abbreviated manner (*Pravda* November 4, 1957). The notice was illustrated with a stylized drawing of two orbiters bursting into the black night sky. The foreground of the drawing is dominated by a statue that strongly resembles Vera Muhina's monument, *Worker and Kolkhoz Woman*, while in the background rises the Kremlin's Spasskaya tower. *Pravda* did not publish photos of Sputnik 2's technical equipment until nine days after the first coverage (*Pravda* November 13, 1957). A full-page spread in the comprehensive article includes three photos of technical apparati, as well as an illustrative, albeit simple, cross-section of the satellite's

booster rocket from the top. Three other photos in the article present the equipment intended to research the Sun and cosmic rays. The photos are of poor quality and out of focus, but one can still barely distinguish the main features of the technical equipment. The same photos were published in *Ogonyok* (**FIGURE 109**) as part of a one-page essay titled "The scouts of space" (*Ogonyok* 47/1957). The photos are of better quality than in *Pravda*, but still remain almost indecipherable.

The paucity of visual material related to technology seems odd, especially taking into consideration the intensity with which the Soviet Union at the end of the 1950s regarded technological progress. The first Sputnik had already created the material and technical foundation required for the transition to Communism. Through the Space Race, the Soviet Union had risen to the level of a modern state that sought to justify its existence as an equal among other modern nations. Commonly used was the term "scientific–technical revolution," which suited Khrushchev's campaign of modernization, and space achievements were tightly linked to this larger scientific–technical whole:

> In this respect, the victory of Soviet science, which the whole advanced world has discovered with great satisfaction, is not the distinct achievement of a record, but the result of the co-operation of all the fields of Soviet science supporting Soviet industry. (Topchev 1957: 8)

When one considers the passion with which visual propaganda was viewed in terms of the belief in technological progress that characterized the Soviet Union of the 1950s, there are surprisingly few photos of technical equipment.

When examining *Ogonyok's* space-related imagery as a whole, overall there is little technical imagery, detailed illustrations of space technology, or photos of orbiters or rockets. Images of technology are limited to stylized illustrations or stock images like the photo of Sputnik I. If rockets or other space technologies were depicted, details were almost completely edited out of the picture. Often photographed were models of orbiters exhibited around the world (as shown in **FIGURE 19**); the model of Sputnik is on display at the United Nations headquarters in New York (*Ogonyok* 27/1960).

The reason for such a lack of visual material was censorship. Censorship was an integral part of the publishing process in the Soviet Union. The primary

purpose was to keep "ideas that were unknown to Communist ideology" out of the general consciousness, thereby thwarting public access to concepts that were in conflict with the worldview created by the Party. On the other hand, the goal was to prevent certain types of information – military or technological – from leaking out of the country (Gorokhoff 1959: 73–85). The lack of technical close-ups can be explained by means of an operational culture that permeated the whole of society.

At the end of 1959, for instance, *Life* published photos taken by Dmitri Baltermants for *Ogonyok* about the training of space dogs and cosmonauts – without any reference to the photographer, however. *Life's* attitude toward the photos reveals the contextuality of their meaning. The techniques reflected in the photos are considered to be clumsy and underdeveloped, but *Life* suspected this to be a sham. The article expressed suspicions that the Soviet space program was actually at a much more sophisticated stage, as connotations of technological primitiveness could not possibly have been the intended goal of photos that were carefully selected by the State for release to the rest of the world (*First Pictures of Russian Astronauts* 1959: 26). The Soviet censorship machine seemed to have been correct in one respect, however: photos that were published were indeed scrutinized in the West in terms of technological solutions.

The space historian Asif A. Siddiqi has called this a "secrecy regime" (Siddiqi 2011: 47–76). The space program was monitored extremely carefully, and illustrations or photos that contained technical details were not distributed to the public without careful consideration. All in all, access to the space program was an opportunity that was offered to very few journalists or photographers. For instance, the ascent in April 1961 of the first manned spaceflight, the Vostok-1 rocket carrying Yuri Gagarin, was not observed by any journalists.[9] A few months later, only one journalist from TASS was allowed to come to Baikonur to see the launch of the spaceship with Gherman Titov; according to the journalist Yaroslav Golovanov,[10] it was rumored that he was there only because "he did not understand a thing about rocket technology, cosmonautics or technology in general" (Golovanov 2001: 399).

Material intended for publication was also checked by the political censorship machine. In connection with the Council of Ministers of the Soviet Union, an institute responsible for censorship was established in 1922. This censorship body, *Glavnoe upravlenie po delam literatury i izdatelstv* (or simply Glavlit), was

responsible for the political and ideological control over the publication of all printed matter, photos, radio broadcasts, exhibitions, and public lectures. It could deny the release of work that included hostile propaganda toward the Communist administration, leaked state secrets, or included nationalist or religious fanaticism or pornography. Glavlit had agents in editorial staff and in publishing houses, at printers and at radio stations, at telegraph offices and at customs, as well as in post offices; publications were not given permission to be printed before approval by the censorship authorities. The subordinates of these censorship authorities were called political journalists, who worked in the editorial staff under the editor-in-chief, but acted according to Glavlit's mandates. The political journalists read text to be published and made the necessary corrections, according to the guidelines. They even checked the pages of magazines against a light in order to see if undesirable superimposed photos appeared through. The photos were checked for other details as well. Glavlit's executive power was only restricted when it came to publications of the Communist Party and the Academy of Sciences of the u.s.s.r. (Gorokhoff 1959: 73–85). Glavlit operated until 1991.

The secrecy connected with military–industrial know-how was not just a typically Soviet phenomenon, especially in regard to space programs. As Siddiqi (2011: 47–76) aptly notes, the trend becomes interesting in the context of the Soviet space program as the Soviet Union had a particularly strong need to keep almost all aspects of the program secret and, at the same time, a great demand to propagate it as widely as possible. This caused a self-contradictory situation. On one hand, it was clear that the propaganda machine had to spread information about the scientific–technical achievements of the Soviet Union as efficiently as it could. This was done, however, in such a way that no essential information came to light. In a paradoxical way, the publishing engine of the Soviet Union itself prevented the presentation of its most important scientific achievements in public. Close-ups of technical apparatuses were reduced to symbolic motifs, with the same photos being circulated from one publication to another, as well as to the West.

Such closely controlled publicity eliminated the possibility of chance. As far as its public image was concerned, all of the space program's achievements were calculated in advance and part of a program:

This spaceflight of the Soviet man is not, however, only the personal heroism of he who bravely began to step on the path previously untrodden – it is a legal result of the development of Soviet science and technical progress, it is the result of the dedication and professional work of Soviet scientists and engineers and workers' collectives from different professions, those who secured the success of this responsible and exceptionally important scientific technical attempt … Did a miracle take place? Of course not! (Mihailov 1961: 6)

Failures did not publicly take place in the space program. No, not as long as it was possible to avoid publishing anything about them. If a rocket did not end up in orbit, it was not disclosed. If a cosmonaut died or was hurt in training, it was not discussed. In this way, there emerged a picture of certain triumph (Siddiqi 2011: 47–76). The planned economy was working, and successes were not only natural in the socialist system but also "a legal result of the amazing development of the spiritual and material power of the Soviet people" (*Ensimmäinen vuosi…* 1958: 3). In this larger narrative, as Siddiqi has interestingly noted, errors were unthinkable. The tension between secrecy and publicity was embedded in every announcement, poster, stamp, or museum text published by the program. In photos, this tension was seen especially clearly. Included in the realistic nature of the photo was a contradiction: how to show as much as possible without revealing too much? In this context Siddiqi uses the concept of *overcompensation*. Texts describing space were overcompensated, as every detail was pregnant with excessively important meaning (Siddiqi 2011: 47–76). It is this idea of overcompensation that makes published space photos such an interesting subject of study: nothing was published by mistake and every detail left untouched was done on purpose.

Scouts of the Heavenly Depths

A new era has now started, when the life born from Mother Earth and the life it nurtured separates from the biosphere and speeds into unexplored space, where a new stage of development stage awaits. (Pokrovsky 1961: 14)

This chapter began with a photo in which the viewer is on the surface of the Earth. In the photos, man is bound to the Earth, but looks into space with the aid of technology. It seems as if technologies are reaching out into space from Earth: radars are listening to the messages of space and telescopes are staring out into the distance, while computers are processing data. Man had not yet gotten into space, but he had sent his representatives there. Sputnik was a *scout* (*razvedchik*) sent into the depths of the heavens, a pioneer, and a trailblazer (Vasilev 1957: 1; Vernov 1957: 4). Sputnik was described almost as mankind's human representative in cold space.

Above the first published photo of Sputnik was a quotation in bold that stated: "About one thing I am absolutely certain: victory belongs to the Soviet Union." The author of the quote was the scientist Konstantin Tsiolkovsky (1857–1935), who at the time of its publication was already deceased. The quote contextualizes the photo in terms of a discussion that had started in Russia over 50 years before. The dream of space flight was not a novelty introduced during the era of Khrushchev or the Cold War. The dream had a long history.

Tsiolkovsky's name can be linked to a specific cultural and philosophical movement often referred to as Russian cosmism (*Ruskii kozmizm*). This movement, situated at the beginning of the twentieth century, was a peculiar fusion of natural philosophy and religious reflection that offered a unique way of explaining the world. One interesting example of the cosmic philosophers is the original thinker Nikolai Fedorov (1829–1903), for whom the cosmic connection was especially central.[11] One of Fedorov's aims was a brotherhood that united mankind, whose ultimate fulfillment would be a departure from the Earthly sphere into a cosmic dimension. After reaching perfection, mankind would even conquer death: resurrection was a very concrete goal for Fedorov (Yegorov 2007; Kozhevnikov 1906; Zenkovsky 1953: 588–604).

Fedorov never achieved a large readership with his strange philosophy, he did not publish any works in his lifetime, and his collections, which were posthumously published (1906 and 1913) and difficult to understand, came to be known by only a few. Yet Konstantin Tsiolkovsky, quoted in *Ogonyok*, was his kindred spirit. Before his death, Tsiolkovsky was already canonized as "the father of Soviet space research," and he was a figure often found in *Ogonyok* (e.g., Dligatch 1934: 7; Sytin 1957: 12–13; Tsiolkovsky 1960: 4–5, 10; see also Hagemeister 2011: 27–42; Kohonen 2009: 114–131; Lewis 2008: 54–59). "Our planet is the

cradle of reason, but one cannot live in a cradle forever," wrote this deaf and self-taught scientist, teacher, and author (see Golovanov 1978: front cover). Besides popularizing cosmic philosophy, Tsiolkovsky also combined it with practical rocket design. Many of Tsiolkovsky's ideas actually worked as starting points in the development of rocket technology. On many occasions, he claimed the science-fiction author Jules Verne to be his inspiration (e.g., Klushantsev 1957).

Tsiolkovsky worked in isolation from the world's scientific community, but around him – in Russia and in Europe, as well as in the United States – popular interest in space was growing. In the Soviet Union, the idea of a cosmic utopia connected with space travel was tolerated; it was even encouraged, as it was seen as being a powerful driver to change society (Buck-Morss 2000: 45; Geppert 2008: 262–285). The attitude toward space changed in the Soviet Union during the mid-1930s, when utopian reveries became politically suspicious. By 1938 at the latest, the cosmic philosophy had been wiped out among the public, as its escapism of reaching out to the heavens was not suitable for the current Zeitgeist of building paradise on Earth. Publically speaking, popular enthusiasm for space did not completely disappear, but the most ardent fantasies were left in the dust by the Socialist realism of the mid-1930s. Tsiolkovsky himself had died before Stalin's oppression was directed in earnest against the cosmic dreamers, and his position was maintained even after his death. Cosmism had to take a backseat to theories focused on rocket technology. By the 1940s, Tsiolkovsky was contextualized vis-à-vis the needs of the war industry, and he was mainly spoken about as "the father of rocket technology."

As the advent of the Space Age and Khrushchev's more liberal cultural policy made cosmic utopia an accepted topic of discussion again, Tsiolkovsky was once more seen as the self-evident father of the space program. It is not possible to find in *Ogonyok* an in-depth and comprehensive treatment of cosmic philosophy. Tsiolkovsky appeared there as a canonized master whose writings were reduced into slogans that were suitable for the situation.[12] It is clear, however, that in the Soviet culture of the 1950s there existed a tradition of associations linked to space. According to Cathleen S. Lewis, who has researched the material culture of the space program, the people popularizing the program skillfully united the revolutionariness of the pre-Soviet Union with the future-directed optimism of Stalin's era. Space simultaneously symbolized a sharp break from and a strong bond to the past (Lewis 2008: 2).

The term "scout" (*razvedchik*) connected with Sputnik is interesting. At the same time as it can be linked it to the aforementioned cosmic utopia of the nineteenth century and ideas about life outside of Earth, it is also strongly associated with the expansionistic politics of Stalin's era. As a term, this scout refers first and foremost to military intelligence, but during the first five-year term at the turn of the 1920s and 1930s, it was used in another sense as well. The term describes a large group of people who were encouraged to embark to the outskirts of the young Soviet nation: the geologists and cartographers who were mapping terrain. By "finding" areas again, they transformed the czarist empire into the Soviet Union. From the very outset, the Soviet regime had sought blank spots on the map, places where it could "inscribe itself, as if on a blank page" (Naiman 2003: xiv). In the 1920s, the project included electrification and creating a railway network. In the 1930s, attention turned toward the Arctic North as well – with polar expeditions and long-distance flights – as well as the depths of the Earth via the pride of Stalin, Moscow's metro system. All of these ventures can be seen as modern projects. Aside from the idea of conquering nature, they had in common the idea of spatial expansion. By expanding into unmapped areas – even into the depths of the Earth – the Soviet Union took more space for itself, both symbolically and in a concrete way. Unknown space became transformed into a known and mapped area.

In this struggle, the Arctic was one of the major symbols of the era. The Arctic North was personified as an enemy against which battle was waged (McCannon 1997: 346–365; Widdis 2003b: 219–240). In the 1930s, the Arctic North was as mysterious as space in the 1960s, and the polar expeditions were also closely followed by the media. The projects are connected, in that they all took place outside of everyday life experiences, out of sight, "out there." Through photos, they were introduced as part of people's experience of the world (*Ogonyok* 32/1937).

In the 1960s, geological research was still one of the most important themes of conquering nature. According to Alla Bolotova (2010: 17–30), nature was seen on one hand as empty and passive, on the other hand as a treasure trove. The treasures hidden by nature were to be conquered and overcome, while emptiness was to be transformed into culture. *Ogonyok* described these expeditions directed into the border areas as romantic exploration journeys. In photos, the northern border appeared as a strongly challenging place where

team spirit was alive. The expedition members' breath steams in the freezing weather, but a homely light shines through the window, and a young man is absorbed in reading a book (Krukovsky 1963: 16–19, photos: Ya. Ryumkin).

In addition to this horizontal expansion, from the end of the 1950s the movement was also directed vertically, up into space. Outer space, like the massive Soviet nation, had to be found, mapped, and measured, so that it could be transformed into a place. As a place, it was possible to control space and, possibly one day even, to paraphrase Tsiolkovsky, to inhabit it. As the *Soviet Union Today* magazine published in Finland observed: "We have entered an era when the space surrounding the Earth is being systematically taken. Possibly even during this century, people will examine distant worlds, as well as also inhabit them" (Zvonkov 1961: 22–23). When there were "no blank spots left on Earth anymore," the map was expanded into a cosmic star chart (Pisarzhevsky 1958: 3–5). *Ogonyok* suggested replacing the term "cartography" with the term "astrography." Soviet science was credited: "blank spots will decrease, but at the same time as some mysteries are solved, new ones will be born, because the scientific work is without end, like the life itself that it serves" (Pisarzhevsky 1958: 5). From this perspective, the imagery can be read as the images of conquering and expansion.

The first ones to map space were the orbiters, who obediently reported their observations to Earth:

> Can you hear the sound of Sputnik? It is there, in vacuous space, amidst meteoric rain and cosmic radiation, in the world of secrets and eternal coldness, orbiting around our planet, above the continents and oceans. And it is not only flying at a mysterious height, it is also working. It tells about the things it sees and hears. (Kachosvily 1958: 19)

Sputnik was a scout, but the information it transmitted to Earth was left in the hands of specialists. Afterwards, voyagers sent into space were equipped with the tools of photojournalists. During the following years, the main part was played by the technical probes and the photo material produced by them. Next I examine the photos taken by the orbiters. As my case study I take the early Luna program of the Soviet Union, as far as it was described in *Ogonyok* between 1959 and 1969.

To the Moon and Around

After the first satellites (altogether three successful Sputniks in 1957 and 1958), the next target was Earth's satellite, the Moon. The Luna program consisted of a series of unmanned space probes. The program included a total of 15 successful launches – unsuccessful ones were not publicly reported – that were carried out between 1959 and 1976. On January 2, 1959, a probe poetically named Mechta ("Dream"), later called Lunnik or Luna 1, was launched toward the Moon. *Ogonyok* shows a photo of the rocket's ascent (**FIGURE 20**). In the small photo, across the gray background is some sort of rocket climbing into the air amidst smoke or clouds of steam. The photo is so stylized that the rocket could be taken from any context, even clip art (*Ogonyok* 3/1959: 4). The next issue ran a photo of the probe itself. Luna 1 is depicted in the same way as the first Sputnik, sitting on a stand in front of a black background (**FIGURE 21**). Once again the probe is a round sphere with antennas sticking out, and the object's character resembles that of a plump, benevolent robot. The photographer is not identified (*Ogonyok* 4/1959: 27).

Luna 1 was the first man-made device to achieve the so-called escape velocity of 25,000 mph. At this speed, it was able to break free from Earth's orbit into interplanetary space and shoot toward the Moon. The probe was meant to hit the face of the Moon, but contact with the lunar surface never came about. Due to a navigational error, the probe missed the Moon at a distance of approximately 6000 km. From the perspective of the space program, it was a clear failure, but the media turned the disappointment of the specialists into victory for the audience. In his speech, Nikita Khrushchev completely ignored the misfortune and declared the flight to be part of a long-term strategy.[13] According to the propaganda machine, the Soviet Union had successfully launched an "artificial planet." With this act, the Soviet Union had shaken the laws of physics, the foundations of creation: "A planet, artificially created! The world is applauding this great victory of man over nature." The article "To the Sun! To the Stars!," which reported on the launch of the probe, was illustrated with a diagram showing the locations of the Earth, the probe, and the planet Mars in relation to the probe's path of travel. In addition, the article was illustrated with two humorous drawings (Sharonov 1959: 3–4, illustrations by L. Smehov and V. Kashchenko).

The probe itself was a hermetically sealed sphere carrying a range of scientific equipment (to measure cosmic radiation and the magnetic field of the Earth, for example). In a small space, some memorabilia were also included: 72 pentagonal pieces of stainless steel had the probe's launch day pressed on them, along with the symbol of sickle and hammer. (**FIGURE 22**) They fit together in the form of a soccer ball, which was supposed to explode on impact and throw the steel pieces across the lunar surface (Harford 1997: 142). These memorabilia apparently had great value, as room was found for them in the cramped area of the probe.

The idea of a man-made artificial planet refers to a relationship with nature in which nature as a whole is seen as subordinate to man. Nature was thus seen as a resource that the (Soviet) man could endlessly shape with the help of technology. Particularly during Stalin's time, this type of paradigm had characterized the modernization discourse that described enormous building projects, monumental architecture, extending beyond five-year plans many times over, canals, and shifting the course of rivers (Autio-Sarasmo 2005: 126; Bassin 2000: 313; Clark 1990: 247; Stites 1989: 231–275).

Stalin's great projects became powerful symbols of modern life, a battle for the domination of nature. This same idea of conquering nature also characterized the turn of the 1950s and 1960s: "Now we are doing more and more for the sake of preventing man's dependency on the rampant forces of nature, to place them under his control. In this way, mankind's final obstacle to the real realm of freedom is removed" (Khrushchev 1961b: 275). Conquering nature was one of the most central themes of space discourse as well. The Soviet people had kindled a new star in the sky, and after Sputnik they sent up new earthly satellites, creating new celestial bodies. Boundless faith in the possibilities of man and technology can be seen in **FIGURE 23**, where the silhouette of a man, maybe a statue, is seen against the starlit sky. The male figure is holding a rocket in his raised hand, as if preparing to throw it into the depths of space (*Ogonyok* 39/1959: 5, photo: J. Krivonosov). Man was capable of "using the immense power of nature, Earth's gravity, for his own purposes" (Dobronravov 1958: 4–5). With the help of space research, it was possible for the Soviet people to even rule the forces of nature, to control the clouds and weather. The (Soviet) man was to become the "master of his planet" (Geim 1959: 20–23).

It was said that the Americans were rightly worried about this: "the American millionaires don't have much use for their money if they cannot play golf

in the summer or to sun themselves in Palm Beach" (Geim 1959: 20–23). Man had stepped into the place of God, and the space program was one of the symbols of a campaign of atheism:

> Human space flight gave a crushing blow to those spreading religion. From the piles of letters that I receive, I am pleased to have been able to read confessions that the achievements of science are making religious people deny God and admit that there is no God and that everything linked to him is invented nonsense. (Gagarin 1961: 182)

Prometheus was a myth that the media repeatedly referred to: "Today fantasy has become a reality and, amazingly, these events could even overshadow such wonders of our age as the release, opening up and use of atomic energy carried out by the 'modern Prometheus'" (Lyapunov 1958: 7).

The surface of the Moon was reached eight months later in September 1959. Luna 2 was almost an exact replica of the first lunar mission. At a distance of 113,000 km from Earth, a probe was released from within a sodium gas cloud that was visible from the surface of the Earth. The shining orange cloud received a great deal of attention from the media. *Ogonyok* also published photos of this "artificial comet created by Soviet scientists" (Krylov 1959: 6; Masevich 1959: 8). On September 13, Luna 2 crashed into the surface of the Moon. This can be considered the first concrete act of conquest: Luna 2 carried inside of it the same kinds of medals and pendants as its predecessor. *Ogonyok* carefully showed these memorabilia in photos, as well as the exact landing site (*Ogonyok* 39/1959, 40/1959; FIGURE 24). In FIGURE 25, the Soviet people rejoice over Luna 2 reaching the Moon, and in FIGURE 26, "Professor B. V. Kukarkin displays the photo of the sodium comet produced by the workers of the Astrophysical Institute of the Academy of Sciences of the Kazakh Soviet Socialist Republic."

FIGURE 25 was laid out in such a way that on the facing page there happened to be a photo of Khrushchev with his wife next to the First Family of the United States. Khrushchev had arrived on his first official visit to the United States three days after the launch of the Luna 2 probe. As Khrushchev asked after receiving the invitation: "Who would have believed twenty years ago that the world's strongest capitalist country would invite a Communist for a visit? Who would have believed that they would invite me, a worker?" (Taubman

2003: 419–429). The timing of the invitation made it all the sweeter: when meeting Eisenhower, Khrushchev offered him two copies of the pendants that Luna had taken to the Moon, saying:

> We have no doubt that the excellent scientists, engineers and workers working for the space program of the United States would not take their own pendant to the Moon. As an old inhabitant, the Soviet pendant will then welcome your pendant, and these two will live together in peace and friendship.

There is a photo of the occasion in *Ogonyok* (*Ogonyok* 29/1959: 4, photo: A. Novikov; Ulivi and Harland 2004: 26). This was typical of Khrushchev: shameless sarcasm, but with a grin. A little more than a year later, the same scenario was repeated when Khrushchev offered a puppy of the space dog Strelka as a present to President Kennedy's wife (Dubbs 2003: 70–71; Radetsky 2007: 181). Beating the Americans was an unhidden source of joy: "The Soviet Union appears to be in the role of Cinderella… In the West it is simply unbelievable that the *muzhikas*[14] could have achieved something like this" (Geim 1959: 21).

The idea of conquest (*pokorenie*) is closely linked to the imagery of the Moon. The Soviet media did not seem to be concerned that only two years before, *Ogonyok* had stated, "[a]ccording to Soviet opinion [in contrast to Western opinion], it is undesirable to erect any kinds of national flags on the surface of the Moon. Our aim is noble: to increase knowledge about nature for the benefit of all mankind, without borders" (Blagonravov 1957: 29). Different kinds of honorary pendants had a prominent place in each of the unmanned flights in the following years. Memorabilia were also sent to Venus in the spring of 1961 with the Venera probe. This probe was lost on the way, and it was not mentioned further in *Ogonyok*, but the third probe sent to Venus did reach the planet's surface in March 1966, thus being the first ship that man had sent to another planet. In *Ogonyok*, the occasion was considered as spectacular news. The following Venus probes were successful as well, and they received a lot of exposure in *Ogonyok*. **FIGURE 27** shows a close-up of two hands holding a pendant and star-shaped medals, as if they were precious and fragile jewelry. "This pendant and the golden coat of arms of the Soviet Union, as well as the flag of the Motherland, have been sent by the Soviet man to a distant planet."

The photo's depth of field is limited to the medals; the rest remains unfocused, which makes the photo dusky and almost poetic. The black-and-white photo is framed by a red bar of text that cries, "Greetings, planet Venus!" (*Ogonyok* 43/1967, photo: P. Barashev).

Of the probe photos, those from the surface of the Moon taken by Luna 9 are unique. Luna 9 was the first successful soft descent to the surface of the Moon. As the probe was photographing the curve of its landing site as a circular panorama, the photos were sent to Earth by radio[15]. The cover of *Ogonyok* in February 1966 features a close-up of the rocky lunar surface. The whole cover is filled with a gray stone mass, with the exception of black space in the upper-right corner. In this blackness were placed *Ogonyok*'s logo and, in the same red type, the short salutation: "Greetings, Moon!" (**FIGURE 28**). On the back cover are displayed the probe itself, as well as the pendants and honorary medals it transported (*Ogonyok* 7/1966). The propaganda was not limited to visual media: one month later, Luna 10 was sent a program to play "*L'Internationale*," which it broadcast as a steady set of beeps to the radio stations of Earth (Kozlov 1966: 1). In photos of Luna 9 published by *Ogonyok*, the information value was not as great. In the gray, unpolished photos one can distinguish the stone shape of the surface, technical equipment, and the darkness apparent beyond the horizon. The photos were in a layout that spread across the page as three wide panoramas. The essential point was not that the photos were informative, but rather that they had been taken in the first place. The photos were evidence of the place itself in the spirit of the early landscape photos. In all its roughness, the effect was powerful. The layout title next to the images proclaims "Photos of the decade" (*Ogonyok* 7/1967: 2–3).

The role of photo as the method of capturing the Moon was clear. The first known photo of the Moon is the daguerreotype by John Adams Whipple from 1851. In the middle of the nineteenth century, James Nasmyth and Lewis Morris Rutherfurd also took sharp photos of the surface of the Moon (Buckland 1980: 151). These early photos were distributed in stereoscopes and in popular astronomy books (see, for instance, Flammarion 1877). In photos of the probes' landing places published in *Ogonyok*, the photos taken by the probes from the surface of the Moon are completely plain. The photos are stark landscapes, and they can be compared to the tradition of topographic photography. Their plainness assumes the neutrality of the photo producing

deliberately alienated objectivity. The emphasis on authenticity and objectivity suited the ideal of the photojournalism of that period. The era was characterized in general by photo reportage, where the object was "found" accidentally and image sharpness and correct exposure time were secondary to capturing the authentic moment. The roughness and the blurriness of photos only increased their testimonial power (Reid 1994: 33–39). Photos provided objective knowledge about space and served as evidence. Through photos, the landscape of the Moon was transformed into a document, an explanation, a topographic and long-distance mapping observation.

A Map of the Moon

The Moon rotates on its axis when making a full revolution of the Earth. Thus one can always see the same side of its surface from the surface of Earth, while the other side of it is commonly called the dark side. On the second anniversary of Sputnik 1, on the 4th of October 1959, a probe was launched to photograph that dark side. A photo of this Luna 3 probe is shown in *Ogonyok* (**FIGURE 29**), but it is so retouched that the caption explicitly explains that it *is* a photo.

On October 7, Luna 3 settled into a predetermined orbit around the Moon, in 40 minutes taking a total of 29 photos (70 per cent of which feature the dark side of the Moon). Technology was elegant: the film was developed, fixed and dried automatically, scanned by a television unit, and sent by radio waves to the surface of the Earth (Harford 1997: 143). In spite of the first photos of the dark side of the Moon being poor quality, they were still sensational (**FIGURE 30**). For the first time ever, man was able to peek behind the backside of the eternal Moon.

Ogonyok published a photo of the dark side of the Moon in the issue that came out on November 1, 1959 (**FIGURE 31**). The title above the photo states: "Once again, one of the secrets of the universe has been opened" (*Ogonyok* 45/1959: 1). On the next page, titled "Man, automation and the Moon," there is both a photo spread and a technical illustration about the probe, as well as a descriptive picture of how the photo was taken (**FIGURE 32**) (*Ogonyok* 45/1959: 2–3). The photo of the dark side of the Moon, with its captions and headings, covers the whole page. The layout appears on the first page of the magazine in such a way that, on the inside cover, there happens to be, hardly accidentally, a

full-page photo of Khrushchev in front of the White House – as he had just recently returned from the United States.

The photo of the Moon is so strongly retouched that it seems to be a painting. The surface of the Moon is dominated by a few larger, strongly distinctive dark spots. The photo is a symmetrical square, and the Moon has been situated in the middle as a light, with its borders slightly crepuscular, against a black background. *Ogonyok's* version of the photo is not only a photo of a rocky landscape, however. Afterwards, different crops and other markings have been made on the photo. A dashed line shows the border of the visible side, while an unbroken diagonal line divides the Moon into "southern" and "northern" hemispheres, cardinal directions that are also marked on the photo. All of the dark spots are numbered, and these markings are explained in captions. The photo is no longer just a photo – it is a map. The markings on the surface of the photo have transformed it into a powerful tool. With the help of these light-colored lines and numbers, the Moon has been captured: used as a map, it was transformed from an unknown space into a known and mapped *place*.

I would like to approach this photo as a map. Mapping has played an important role in the era of every empire, each having legitimated spatial expansion with the aid of cartography. According to James Scott (1998: 87), mapping is one of the most effective tools of capturing and controlling high modernism. Maps simplify and select, and the choices of the cartographer are not random. Because the map selects, each element that ends up on the map has meaning. The way in which the map selects its points and displays them produces a certain worldview that acts as the representation of the space. According to the French sociologist Henri Lefebvre (2008: 26–38), who has reflected on spatiality, space is thoroughly social, with social relations producing space and vice versa: space produces social relations. A map displaying space is, therefore, not only a passive projection, even though it appears to be one. To paraphrase Lefebvre's idea, the social was extended to the Moon itself, and the map drew the Moon back into the circle of culture.

The map can also be considered as language. The symbols drawn on it include much more than their apparent meaning. This language can only be understood through context (Harley 1989: 277–312). What was the context in which the map of the dark side of the Moon was created? What did the cartographer draw on the surface of the Moon?

Eight previously unseen points shown on *Ogonyok*'s map were then given names. The clear-bordered dark point directly in the center has been named the Sea of Moscow (*Mare Moscoviense*). Inside the Sea of Moscow was also marked the Bay of Astronauts (*Sinus Astronautarum*).[16] A larger area in the southwest corner was named the Sea of Dreams (*Mare Desiderii*). The surface of the Moon is divided diagonally by the Sovietsky Mountains (*Montes Sovietici*). Also marked on the map are the Tsiolkovsky, Lomonosov and Joliot-Curie Craters. In the Soviet context, Tsiolkovsky had been an obvious choice, but for the wider international audience, his name was most likely unknown. Mikhail Vasilyevich Lomonosov (1711–1765) was a Russian author and eclectic natural scientist, astronomer, chemist, physicist, historian, linguist, and optics developer. The recently deceased Frédéric Joliot-Curie (1897–1958) was a French-Polish physicist and chemist. Together with his wife Irène Joliot-Curie, in 1935 he received the Nobel Prize in Chemistry. In 1951, the Soviet Union had granted the known leftist Joliot-Curie the International Lenin Peace Prize, which corresponds to the Nobel Peace Prize.

The map's topography published in *Ogonyok* was named by the Academy of Sciences of the U.S.S.R. Soon after the release of the first photos, it published a broader atlas, which included names for about 500 topographical features on the dark side of the Moon. People that had their names included in the atlas were, for example, the inventor and businessman Thomas Alva Edison (1847–1931); the occultist and astronomer Giordano Bruno (1548–1600), an Italian philosopher persecuted by the Catholic Church; the German physicist Heinrich Rudolf Hertz (1857–1894); the Soviet physicist Igor Vasilyevich Kurchatov (1903–1960); the French science-fiction author and role model of Tsiolkovsky, Jules Verne (1828–1905); the Russian mathematician Nikolai Lobachevsky (1792–1856); the Scottish physicist James Maxwell (1831–1879); the Russian chemist Dmitri Mendeleev (1834–1907); the French microbiologist and chemist Louis Pasteur (1822–1895); the Russian physicist and inventor of the radio Alexander Popov (1859–1905); the Polish physicist, chemist and pioneer in radioactivity research Marie Skłodowska-Curie (1867–1934); and the Chinese mathematician, engineer and astronomer Tsu Chung-Chi (429–500) (Barabashov 1961; Whitaker 1999: 156).

Was there something provocative about the names? Naming the large dark area Moscow was against established convention; since the seventeenth

century, it had been customary to name the lunar seas according to natural phenomena and emotional states. Nor was it customary to name a mountain range after the Soviet Union. The mountain ranges of the other celestial bodies had historically been named after mountain ranges on Earth, not after nations. The only potentially provocative name can be seen in the choice of Igor Kurchatov, who died in February 1960. Kurchatov had acted since 1943 as the director of the Soviet nuclear weapon program; however, he devoted his last years to the peaceful use of atomic energy (Rabinovich 1967: 9). In addition, Alexander Popov was not as widely appreciated in the West as the inventor of the radio as in the Soviet Union. Even from the perspective of the Cold War, however, none of these names were especially provocative. Nonetheless, the Soviet Union's announcement of new names did encounter opposition. The question was not only about the choice of certain names; the act of naming itself was difficult to accept. Naming changed the strange and unknown into known information, as part of culture, and it also meant claiming it as one's own. By means of maps, empires have always legitimized the borders of their realms, and this symbolism was indeed understood in the West. By mapping and naming, space was symbolically incorporated as part of Soviet space. As President Lyndon B. Johnson remarked to the Senate after the launching of Sputnik, played by Philip Kaufman in the film *The Right Stuff* (1983):

> Whoever controls the high ground of space controls the world. The Roman Empire controlled the world because it could build roads. Later, the British Empire was dominant because they had ships. In the Air Stage, we were powerful because we had the airplane. And now the Communists have established a foothold in outer space. Pretty soon they'll have damned space platforms so they can drop nuclear bombs on us, like rocks from a highway overpass. Now how in the hell did they ever get ahead of us?!

The situation was irritating. The international community felt as if it had been run over by the Soviet propaganda machine. In principle, authority over naming should have belonged to the International Astronomical Union (IAU), which was established in 1919. A unanimous decision about the responsibility of naming had not yet been made by 1959, however, and finally the IAU confirmed the names that the Academy of Sciences of the U.S.S.R. had announced.

In 1961, guidelines for naming were specified. According to those guidelines, which still remain, religious, military, and political leaders are not accepted in the nomenclature, but already existing names are not to be changed. Craters, rocky peninsulas and discrete mountain peaks should be named after deceased astronomers or other eminent scientists. The names are written in Latin in the form presented by the nominating nation (Transactions of the IAU 1961).

The objections of the international community were understandable against the backdrop of the Cold War. Leonid Sedov, a member of the Academy of Sciences of the U.S.S.R., had provided assurances at the press conference after the Luna 2 flight that the Soviet Union would not assert sovereignty demands on the part of the Moon where the rocket hit (*Helsingin Sanomat*, September 15, 1959). The issue was not quite as simple as this. Since Galilei's early telescope observations in the seventeenth century, the celestial bodies could be thought of as a place where a traveler might set foot[17] (Ordway 1992: 35–48). Now it was necessary to take a stand on how this should be approached. Can celestial bodies be owned? Did the nation that won the competition conquer the Moon, Mars, and Venus? At an idea level, conquest was already present with the first Sputnik and then afterwards. At least this is what the January 1958 cover of *Ogonyok* seems to hint at (**FIGURE 33**). Given this milieu, it is understandable that medals being sent by the Soviet Union to the surface of the Moon and the act of cartographic naming were experienced in very different ways. The drawing of a map hinted at the Moon being an extension of Soviet territory, even though propaganda elsewhere stated that "Soviet man moves into the universe as a researcher and a creator, not as a conqueror"[18] (Malahov 1970: 3).

In response to this concern, the UN General Assembly had established, already after the first satellites in December 1958, an ad hoc Committee on the Peaceful Uses of Outer Space. The Soviet Union was among the 25 nations to sign the establishing treaty of the committee (General Assembly 1958). The committee declared that "recognizing the common interest of mankind in outer space and recognizing that it is the common aim that outer space should be used for peaceful purposes only." In December 1966, the committee published an international treaty where the role of space research by nation states was defined as well as the use of space, including the Moon and other celestial bodies. According to the treaty, nation states cannot conquer, exploit, or declare

any of the celestial bodies as their own. This Outer Space Treaty declares, for instance: "[o]uter space, including the moon and other celestial bodies, is not subject to national appropriation by claim of sovereignty, by means of use or occupation, or by any other means" (General Assembly 1966).

When higher resolution photos of the Moon became available, it was revealed that the two biggest findings of Luna 3 – the Sovietsky Mountains and the Sea of Dreams – were only visible in the first photos. They turned out to be optical illusions. In 1970, the IAU deleted these from the lunar nomenclature. Today they are no longer known (de Jager and Jappel 1971: 138; Whitaker 1999: 231–235). The map of the Moon was redrawn, and the photo published in *Ogonyok* lost its meaning. The Soviet Union could not have lost the Moon Race in a more symbolic way.

Yet something of this enormous project remains. The first lunar probe that missed the Moon, Luna 1, is still circling the Sun between Earth and Mars. Khrushchev's pompous declaration about the "artificial planet" was at least somewhat correct. The orbit of the small artificial planet is located between the Earth and Mars. Its precious cargo is still carried within it: the heraldic symbols of the dissolved Soviet Union, relics of the great project of space conquest. One can find a melancholic irony lurking behind this idea: sealed in a hermetic vacuum, the final remains of the early Soviet imperial space endeavor are eternally traveling in the endless void. According to what is known now, its voyage will continue forever; only accidental collision with another celestial body may end that journey.

The photograph's role *as a photograph* – its scientific accuracy and truthfulness – can explain the power of the early space photographs (e.g., from the surface of the Moon). A reference to the photograph's authenticity, which was connected to it through its medium, is essential in this context. Even though the first photographs were blurry and unclear, almost incomprehensible, the fact that they had been *taken* made them fascinating. They gave undisputable evidence that man has visited the surface of the Moon. The most possessive of these endeavors was the act of mapping and naming the lunar scenery. In the context of the Cold War the lunar conquest was of the utmost importance. The cartographical act audaciously hinted that the Moon was to be included in Soviet territory, even if the official political rhetoric (piously perhaps) heralded otherwise. The emphasis on conquest in the Soviet propaganda was ambivalent

and the written propaganda constantly emphasized that "the Soviet man will walk into the Universe as an explorer and creator, not as a conqueror." Still these acts can be seen as clearly imperial: Through a carefully selected repertoire of representations, the Moon became a vital part of the Soviet Khrushchevian landscape. Via mapping and naming, outer space was mentally included in Soviet territory.

In the next chapter, we will widen our scope and turn our gaze to imagery that tends to depict man, rather than technology, in space. At this stage, the primary medium of the imagery changes from photos to illustrations and paintings.

TRAVELERS IN THE VOID

CHAPTER 3

The Gaze of Apollo

The first photograph to be taken from the threshold of space so high that the round shape of the earth could be observed is from 1946. The photo was taken from a height of 100 km with a camera that had been attached to a V2 missile (Reichhardt 2006). The missile originated from the secret military base of Peenemünde in northern Germany, where both the United States and the Soviet Union spent some days in May 1945, gathering as much information as possible about the rocket technology surrendered by Germany. On the basis of this technology, the two superpowers built their own space programs (Maddrell 2006; Winter 1990: 52–58). In this way, even the first photo from the threshold of space was linked to the superpowers' Space Race.

The photo is also interwoven with a sequence of other pictures that are much older than the Cold War. The cultural geographer Denis Cosgrove (1994, 2001) has researched different visual attempts to capture the Earth. In Greek and Roman mythology, Phoebus Apollo, the god of light, drove across the firmament with the golden chariot of the Sun. His gaze saw everything, but it was impartial and cold. Apollo wanted to control, to capture, the whole Earth. The orb as symbol of empire can be dated to the Early Middle Ages; around the fourth century it became established especially as the symbol of Christianity and power. During the Baroque period, lavishly decorated globes became popular among the royal houses. The first known attempts to display the whole world, the so-called *mappa mundi* atlases, date from the time of antiquity, but the first modern and systematic atlas of the Earth is considered to be Abraham Ortelius' *Theatrum Orbis Terranum* from 1570. Cosgrove (1994: 271–272) compares this type of capturing act to the gaze of Apollo, framing the way that Earth is depicted at a distance as a specific point of European modernization. To this sequence, it is possible to also connect this book's photos of Earth.

The first photos taken of Earth by a man in space were photographed in August 1961 by cosmonaut No. 2, Gherman Stepanovich Titov, the second man to orbit the Earth. Titov's photos were published in *Ogonyok* as a colored photo supplement. The blue-tinted photos seem almost abstract. The details of the photos cannot be seen, only blueness dotted by clouds. The first photo is framed by the round window of the capsule. In addition, a curved pipe is distin-

guishable in the photo; *Ogonyok* reports that this is part of the ship's antenna. In the upper-left corner, the photo borders the Earth's horizon in such a way that its round shape is shown. Behind is dark blue space, almost black. The next photo, spanning the spread, borders darker space on the edge of the horizon (**FIGURE 34**). This third photo has been taken perpendicularly, down from the window of the ship. The shape of the Earth is not distinguishable, but shadows made by clouds can be seen on its surface. According to *Ogonyok*, the photos (film stills) were taken by a 35mm Konvas motion picture camera through the round window of the capsule. In a small photo, Titov shows the camera, while in another small photo, surrounded by his admirers, he signs autographs on his portraits (**FIGURE 10**). The article related to the photos is titled: "Vostok-2 flies to the stars," the continuation of a piece that began in the previous issue (Romanov 1961: 16–17). On the cover is also a photo of the flight (**FIGURE 35**) that seems to be retouched. The roundness of the window can be seen clearly; in addition, there are bright stars in dark space. In the photo is the caption "Earth from 250,000m. Photos by Gherman Titov" (*Ogonyok* 37/1961). The photos can be compared to the aerial photography that became common in the 1930s, in which photos taken from an airplane highlighted capturing and mapping from an outsider's eyes, controlling but not participating (Widdis 2003b: 219–240).

In addition to the manned flights, orbiters continued their work of photographing the Earth. Zond 7 was an unmanned spacecraft that orbited the Moon in August 1969. In *Ogonyok*, two photos of Earth taken by orbiters were published. The September cover features a colored photo of the Earth rising above the Moon (**FIGURE 36**). The lower part of the photo is dominated by the gray surface of the Moon, above which the Earth rises like a blue marble. To the black background has been added in red a long quote by Lenin:

> All the miracles of science and achievements of culture will be in the possession of all people, and human intelligence or genius will no longer be the tools of jackboot or exploitation. We know this – in the name of this great historic task, shouldn't one work with all one's might? – Lenin. (*Ogonyok* 39/1969)

The quotation links the photo to a discourse that emphasized the consistently triumphal march of Socialism. Connecting present – or, even more often, fu-

ture – achievements to past deeds was typical of Soviet rhetoric. In his speech after Gagarin's flight, Khrushchev (1961a: 20) linked the achievements in space to past merits:

> When we went to Saturday work parties for the first time, when we were forging the foundations of the new smelting furnaces and building mines, when we hurled winged words to the whole world: five-year plan, industrialization, collectivization, general reading and writing skills, how many pompous "theoreticians" were there who predicted that a Russia walking in birch-bark shoes could not become a great industrial power. Where are those hard-luck prophets now?

Even though Khrushchev's era declared a break from the past in the spirit of high modernism, the space achievements were directly based on projects from Stalin's era.

The August 1969 issue of *Ogonyok* (Prozorov 1969: 1) describes Zond's flight in a large article titled "Zond-7 – a cosmic researcher and photo correspondent." Above the title is a close-up of the surface of the Moon, and on the adjacent inside cover is a full-page color photo of the Earth (**FIGURE 37**). The blue globe is embroidered with white clouds. Beneath the clouds, parts of Africa and the European continent are distinguishable. The Earth does not appear in the photo as a completely full sphere, as its "upper-left corner" remains in shadow. The photo is impressive, with the blue-and-white globe seeming to be floating in pitch-black emptiness. The photo will not, however, become a symbol known by everyone, such as what the United States succeeded in creating three years later. The "Blue Marble" (NASA AS17-148-22727) is a photo of a perfectly round earth in the middle of a black square. The photo was taken in December 1972 by the astronaut Harrison "Jack" Schmitt (although apparently there is not complete certainty about the photographer) on the Apollo 17 flight, which was the last manned flight by the United States to the Moon. This photo became one of the most widely distributed photos of all time, partly because it was classified in the United States as a public domain work, which guarantees its free use by citizens of the United States without any copyright fees. Zond 7's photo never reached the level of international icon, even though it was almost identical with the "Blue Marble" photo. Furthermore, as it was also earlier, by

all means it should have deserved greater attention from the world. At the time of its publishing, the photo became lost in the noise of the United States' manned lunar flights, and it was not widely published in the West.

Cosmic Landscapes

On that day, the 4th of October, when the world's first – a Soviet! – satellite was launched, a man could feel like he was a resident of the universe. For the first time, he crossed the threshold of his home. That home, where he had been born and raised, was called Earth. (Lyapunov 1958: 6)

An interesting portion of images published in *Ogonyok* are illustrated or painted fantastic landscapes that show humans in space. The motif of human beings in space was not typical, and if humans were depicted they were painted or drawn, not photographed. This is natural, as actual occurrences of men entering the vacuum of space happened only a few times in the 1960s. In addition, the aforementioned regime of secrecy prevented the media from publishing, for example, high-resolution photos of the cosmonauts inside the space capsules. For the most part, magazine illustrators had to rely on their imaginations. Here also they had to be careful. Technical illustrations that were too detailed or that hit too close to the truth could cause problems. Andrei Sokolov, a Soviet illustrator who specialized in space themes, told that he wondered why even completed commissioned works were sometimes rejected with no explanation. Only later did it become clear to him that the illustration, in some technical detail, had succeeded *too* well (Sokolov and Lavrenyuk 2001: 94–96). Most of *Ogonyok's* illustrations were stylized. Caricature-like vignettes and cartoons were included, as well as drawings illustrating the articles and informational graphics.

The images can be examined within the genre of landscape depiction. A landscape can be considered simultaneously as a specific view and a representation of that view. As is the case with maps, objects do not accidentally appear in the picture, but are carefully chosen to be depicted in a landscape. This can be thought of as naturalizing cultural structures in order to represent the artificial as a given, striving toward an ideal. The starting point in that case is the idea that an image of a landscape is never neutral, free of meaning,

or purely descriptive (Johansson 2009: 32; Mitchell 2002: 2–5). In the visual culture of the Soviet Union, this was taken for granted: Socialist realism took the landscape seriously as one of the fundamental reflections of ideology, and it established boundaries for acceptable ways of presenting the landscape. For instance, an article published in 1957, reflecting on magazine illustrations, instructed accordingly:

> A landscape intended in a magazine illustration should not only satisfy the aesthetic taste of the viewer. It should primarily serve educational aims: to introduce the reader to the faces of our Motherland, to enlarge his horizon, to tell him something new. […] The landscape should not beautify reality, but present honestly the characteristic features of the place it describes, reflecting its growth and renewal. (Vyazemsky 1957: 157)

Ideology does not need to be "found" separately from Soviet landscape images; it exists as a given (Bassin 2000: 314). "The landscape has to depict the ideals of the time, the soul of the era" (Larionov 1960: 45). The art historian Simon Schama stated,

> Landscapes are culture before they are nature – constructs of the imagination projected onto wood and water and rock […] once a certain idea of landscape, a myth, a vision, establishes itself in an actual place, it has a peculiar way of muddling categories, of making metaphors more real than their references; of being, in fact, part of the scenery. (Schama 1995: 61)

The landscape constructs concepts of space. In terms of its influence, the image of a place can be stronger than the place itself – especially if only a few, if any ever at all, had access to the places in question.

Ogonyok regularly published these cosmic landscapes. For instance, in August 1962 – in the same issue that ran a large photographic essay of Gherman Titov – four fantastic images of space were published (*Ogonyok* 32/1962). The first of the images was a full-page, strong red landscape resembling a hellish furnace (**FIGURE 38**). Above in the sky, blazing in different shades of red, is an enormous sun. Bizarre formations arise from the surface, which looks like a burning sea. The name of the image is "On Venus," and it depicts Earth's hot

neighboring planet. In the middle of the image is some kind of technical device, which resembles a radar equipped with tracks – perhaps the Soviet Union's brand-new Venera probe? On the next page are two images that are just as colorful (FIGURE 39). In these, we are already outside of our solar system. In the upper one, a strange sun almost entirely fills the sky. Crystal-like formations arise from the surface of the planet – and the name of the picture, "Crystal Life," indicates the strange planet's organisms. In the lower image, we are on a completely different, rocky planet. In the sky shine two suns, referenced in the name of the picture, "The Planet of Two Suns." The flat crust is broken by vertical rocks, below which is a chariot equipped with some kind of tracks. Next to this are two figures with their backs towards the viewer. Large shadows are formed from their small figures. Also on the back cover is a picture from the same series (FIGURE 40). Two figures clad in space suits, pictured from behind, are walking away from the viewer, leaving footprints behind them. In the clear black sky is a great blue sphere. We appear to be on the surface of the Moon.

The illustrations were originally published in Andrei Sokolov's book *In the Cosmos*. In *Ogonyok*, they illustrate "Interstellar Life," a large manuscript found in the archives of Konstantin Tsiolkovsky (Tsiolkovsky 1962: 24–25) that, according to the magazine, had previously been unpublished. The apparent colorfulness of the photos hides a darker, melancholic, almost escapist dimension. In relation to the landscape ideal of the Socialist realism, these landscapes are startling. The cosmic landscapes more resemble the impressionistic paintings of Konstantin Yuon (1875–1958), especially "New Planet," his most known work in the West.[19] As landscape portraits, they resemble the nineteenth-century Russian landscape painting, which was inspired by the desolate greatness of Russia, its vast wastelands, and empty, melancholic space. The Russian landscape painting had developed its own kind of melancholic and spiritual relationship with landscapes, as seen in the formless emptiness and endlessness of the epic landscape. The cosmic landscapes seem to repeat a Slavophilic myth inherited from periods of relationship between outer poverty and inner richness (Nivat 2003: 52–53). This myth seems to have been transferred to the cosmic dimension: the barer the landscape, the greater the promise of spiritual richness potentially awaiting the space traveler.

There is something familiar about the figures in the images. A quick look at the cosmic landscape imagery published in *Ogonyok* and other popular media

confirms my observation: a small figure dominates almost all of the landscape views (e.g., *K Zvezdam* 1970). The figure is rarely alone, and he almost always has his back turned to the viewer. He climbs mountains, often with technical equipment. But frequently he just stands, staring into infinite space, as if mesmerized by the view.

What is the origin of these small figures, these miniature men and women, who stubbornly hide their faces from the viewer? The pose is surprising: the back being turned to the viewer was not typical of the visual culture of the era. According to Matthew Cullerne Bown (1998: 268–269) a beautiful and handsome person was framed in the principles of Socialist realism as being morally good. Hiding one's face was to be avoided even. A hidden face suggested private thoughts, secrets, and outright dishonesty. In the 1930s and 1940s, for instance, even prominent artists such as Arkady Plastov or Vladimir Kostetsky had been criticized for hiding the faces of their central figures.

The closest correspondence to these stark cosmic landscapes can be found in Western popular culture. Chesley Bonestell (1888–1986) was an artist, illustrator, and architect who had specialized in astrological perspectives in his illustrations. Together with the science-fiction author Willy Ley, in 1949 Bonestell published a popular book named *The Conquest of Space*. The book was extremely well-received, and it was translated into many languages. Bonestell worked in Hollywood as a set designer and photographer of miniature models. When making images, he often used a special technique, sculpting from plasticene a 3D model that he photographed with a pinhole camera (see **FIGURE 47**). On the photo that was created in this way, he painted the actual piece (Miller 1990: 35). The finalized images thus have a strangely realistic, almost three-dimensional feeling. And, when one looks closer at the photos, a familiar detail can be found: almost all of the images have small figures, as if to add scale (Bonestell and Ley 1952).

Alexei Leonov, an Artist on a Journey

An interesting perspective on the cosmic landscapes can be had by noting that one of the artists published in *Ogonyok* was also a cosmonaut: Alexei Leonov, the man who performed the first spacewalk in March 1965 (**FIGURE 41**).[20] **FIGURE 42** was painted by him, and it was published in a popular book pre-

senting the cosmic landscapes. In the picture is a desolate landscape, spotted by cracks and craters, in whose naked crust nothing grows. On the right side of the image is a deep abyss. In the front, with their backs towards the viewer, two people are standing on an outcrop. It is impossible to say whether they are men or women, as their clothing does not show. The figures are staring at the distant horizon, where more mountains loom. One of them holds in their hands a special instrument, which shines red light on both of their shoulders and their helmeted heads. Except for this red glow, the coloring of the photo is blue, all shades of blue, and black. The starry sky is scattered above the figures. This is not a usual night sky, however: behind the horizon, instead of the Moon, rises the Earth (*K Zvezdam...* 1970).

Leonov was one of the 20 pilots chosen from among the first cosmonaut trainees from different parts of the Soviet Union. After five years of intensive training, in March 1965 he opened the hatch of the Voskhod craft and stepped into the void. In the unclear black-and-white photos published in *Ogonyok*, he can be picked out, floating at the end of a cable, alongside the craft (**FIGURE 43**). These are among the rare photos in which a person appears in space. According to *Ogonyok*, the photos were taken from the live television transmission[21] "when the entire country was following the unprecedented flight of Voskhod 2" (*Ogonyok* 12/1965). On the cover of the following issue is also a photograph of the spacewalk, which is just as unclear. A light-colored, undefined figure is floating in the middle of blackness. This is how Leonov described his feelings when the photo was taken: "I felt almost insignificant, like a tiny ant, compared to the immensity of the universe. At the same time, I felt enormously powerful. High above the surface of the Earth, I felt the power of the human intellect that had placed me there. I felt like a representative of the human race. I was overwhelmed by these feelings" (Leonov and Scott 2004: 105).

After the experience, Leonov's artistic expression changed. He started to almost compulsively paint space, to reach that experience of free fall. Leonov's statement is full of emotion, which in aesthetics is described by the concept of "the sublime," a concept in art theory that has been reflected upon since antiquity. It refers to the awe felt in front of majestic objects – mountains, oceans, the opening of infinite space. Dazzling greatness beyond understanding breeds not only terror, but also pleasure and enjoyment (Nye 1994: 7–8). The sublime is linked to the idea of enormity and grandeur without comparison. However,

the crux of Leonov's statement was not about witnessing the great view itself, but instead the profound emotion that followed the encounter. In this respect, his experience approaches the theory of Immanuel Kant, for whom the sublime (*das Erhabene*) was not an attribute linked to the object. The experience of the sublime was born through a dialogue between the individual and the object. The ability to experience the sublime was, therefore, in man himself, and the experience of the sublime was born at the very moment when man realizes himself to be capable of understanding nature and examining it, despite its inconceivable greatness (Kant 2007: 77; Nye 1994: 7–8).

This elevation of man is interesting in relation to cosmic imagery. In the Soviet discourse, emphasizing human awareness was of paramount importance. The foreword to a book presenting the cosmic landscape states: "The thinking capacity of man is the core of awareness. If we have strong faith in the boundless possibilities of the human mind, the dream about distant worlds can come true" (Malahov 1970: 6). Russian cosmism had lifted up man as the center of the universe, even Tsiolkovsky, to such an extent that he was willing to give up all other "forms of imperfect life." Lower life forms, harmful plants, and animals – even criminals, inferior races, cripples, and the sick – should be wiped from the surface of the Earth. The "perfected man" achieved in this way would be the embodiment of the will of the universe, which would spread to every planet in the solar system[22] (Hagemeister 2011: 32). From this perspective, the cosmic landscapes did not depict distant worlds as such, but "Soviet man and his materialized thought" (Malahov 1970: 6). Small-scale people act as reminders of this.

Was it then a coincidence that on both sides of the Iron Curtain, cosmic landscapes were pictured from very similar perspectives? Taking into consideration the popularity of cosmic landscapes, it is possible that Leonov had been acquainted with the productions of Bonestell or Bonestell. When one moves back in time a bit more, it is possible to find at least one common model for Leonov and Bonestell's landscape images. Depicting space was an appreciated branch of the popular literature of the nineteenth century. In any case, the period resembled in many ways the end of the 1950s and the beginning of the 1960s, an era marked by scientific optimism. Richard Holmes (2008), who has researched the perception of science in the eighteenth and nineteenth centuries, sees that time as deeply romantic. The discovery of the planet Uranus in 1781

changed the understanding of the surrounding universe. In 1783, the Montgolf-
ier brothers built the first hot air balloon to successfully be flown. Suddenly,
the spatial perception of man expanded 450m upward into empty air. From
then onwards at an accelerating pace, science and technology seemed to be
capable of anything. Electricity, the railroad, and steamships were inventions
that transformed man's understanding of space and time. After the middle
of the nineteenth century, popular excitement about space increased all over
the world. The science-fiction author Jules Verne inspired many illustrators.

The French popular astronomer Camille Flammarion (1824–1925) is an
interesting case. In the 1800s and 1900s, he wrote many books on astrono-
my that he also beautifully illustrated. Another intriguing example of these
types of pictures is Lucien Rudaux (1874–1947), also a French illustrator and
astronomer, who especially in the 1920s and 1930s published popular books
on astronomy (Flammarion 1877, 1881; Rudaux 1948). The books were ex-
tremely well-liked, and they were also translated into Russian directly upon
their release (Flammarion 1865, 1908a, 1908b). It is easy to imagine that these
dark landscapes influenced Russian cosmism. Michael Hagemeister (2011: 38)
considers Flammarion – in addition to Jules Verne – to have been one of the
most important influences on Tsiolkovsky, even more than Fedorov, who is
often linked to him. In Flammarion's careful engravings, rocky barren land-
scapes of planets are depicted (**FIGURE 44**). There are no miniature figures in
the pictures, but their atmosphere resembles that of Leonov and Bonestell's
images: bleak but fascinating.

Flammarion's pictures continued the tradition of depicting sublime land-
scapes that the fine art of Romanticism had started less than a hundred years
before. The idea of artists and scientists researching and making journeys had
evolved with Romanticism. For the science at the time of Romanticism, nature
was a mystery that the scientist opened with his instruments – scalpel, mi-
crosope, telescope. Art and science united in this era of searching, wonder, and
discovery. The Romantic landscapes that the period produced were a mixture
of the scientist's curiosity and the artist's subjective view (Holmes 2008: xviii;
Jacobs 1995: 9–17).

The Romantic worldview immersed in expeditions and questing was also
in the background of the cosmic landscapes. A blend of wonder and terror
characterized stories from the Romantic period. From the time of Romanti-

cism, a fairy-tale mysticism crept into the cosmic landscapes. The fairy-tales of Romantic period were mystic and wild, but they had happy endings (Tully 2000: vii–xx). An infatuation with mysticism also dominated science. For instance, the English artist Joseph Wright (1734–1797) in his work depicted men in the course of doing scientific experiments. The dramatic paintings simultaneously evoke mystery and terror.

In one way, it can be said that Camille Flammarion's dark views would not have been possible without Romanticism. The notion of portraying a cosmic dimension presumes that the views behind the journeys have to be *imagined*. The idea of these fantastic landscapes was born in conjunction with the landscape painting of Romanticism. The landscape was not a mere projection of the view in front of the artist's canvas, but a reflection of his inner world, his mental landscape (Miller 1990: 36).

It is perhaps not surprising that the figure roaming the romantic landscape has turned his back to the viewer. Every now and then, creators of pictures have turned the back of their central figure to the viewer, and even more so since the sixteenth century. Often these figures act as indicators of scale or direct the gaze (Wilks 2005). It was only during the Romantic period that the traveler who turned his back, the *Rückenfigur*, became the defining figure for the entire painting. The best-known example in this context is the German landscape painter Caspar David Friedrich (1774–1840). He was a traveler whose journeys were born of Romanticism, an artist driven by Romantic restlessness. I introduce Friedrich because figures pictured from behind play the main role in his work. In what is certainly the most well-known study on the *Rückenfigur*, the book *Wanderer above the Sea of Fog* (1818),[23] a wanderer who has turned his back prevents the viewer from seeing the landscape in its entirety (**FIGURE 45**) (Koerner 1990: 162–163). The viewer has to peer over his shoulder.

Even though Friedrich remained on the surface of Earth in his paintings, cosmism was often present in his works. One of Friedrich's favorite themes was a moonlit landscape. He described the theme in a number of his paintings: for instance, *Man and Woman Contemplating the Moon*[24] (c. 1830–1835), *Two Men Contemplating the Moon*[25] (1819) (**FIGURE 46**), and *Evening Landscape with Two Men*[26] (1830–1835). In the images, two figures that have turned their backs stand in the twilight. Twilight and especially moonlight were themes that pervaded Romantic art. Moonlight represented a connection with the infinite.

Melancholy, exaltation, and fear were combined in the Romantic longing for communion with nature (Koerner 1990: 243; Sala 1993: 174; Vaughan 1994: 142).

Friedrich's *Rückenfigurs* had come to a halt before the landscape, unmoving, mesmerized by the view. The miniature figures of Bonestell and Leonov are more rarely satisfied by standing still, but there is still a lot of similarity in the paintings: the statuesque, rugged landscapes of the paintings, the tension between the forefront and the background, and the almost palpable wonder of the figures staring at the horizon. Even though the paintings are separated by a hundred years, the amazement of the travelers before the landscape is the same.

One known painting of Bonestell, *Nightfall on the Montes Leibnitz* (1949) (**FIGURE 47**), depicts the Montes Leibnitz, the highest peak on the Moon, which Camille Flammarion has called "the mountain range of eternal light" (Bonestell and Ley 1952: 42). The mountain is depicted at the moment when the Earth moves between the Moon and the Sun. If this image is compared to Friedrich's *Two Men Contemplating the Moon* (**FIGURE 46**), one can notice the similarities in lighting, color scale, and composition. If to Friedrich the Moon represented an unattainable object of nostalgic longing, Bonestell has located his figures on the surface of the Moon as the perfection of Romantic longing. In fact, the illumination depicted by these two artists is exactly the same. It originates from the Sun. The reddish glow in Bonestell's work is light borrowed from the atmosphere of the Earth – as the airless lunar environment could not have created a sunset. In the painting, the light has only travelled 380,000 km further to reach its tiny viewers.[27]

Interpretations emphasizing the lonely traveling man were not inconsistent with the new humanism that characterized the Khrushchevian visual culture of the 1960s. Even though Socialist realism was still officially patriotic, optimistic, and heroic, the era of the thaw gave increased flexibility to the expression of these socialist values (Bown 1998: 305–410). Serguei Oushakine has referred to this Soviet version of Romantic thinking and its implementations as *sotsromantizm*: combining humanism, modernism, and enthusiasm toward technology, Khrushchevian modernity can indeed be seen as exceptionally Romantic by nature, in the nineteenth-century sense (Howell 2015: 5).[28] Even Friedrich was seen as interesting again: in the 1960s and the early 1970s, there were several exhibitions in Moscow and Leningrad where his works were on display.[29]

If the small-scale "migration history" of the *Rückenfigur* is extended later via diachronic research, one can note that by no means does it disappear as a theme. In fact, the further the Brezhnev era progressed, the more widely the figure with its back turned or face hidden became widespread in visual culture. For instance, see Andrei A. Tutunov's *Fisherman and his Sick Son*[30] (1964) (**FIGURE 48**), Mikhail Kugach's *Return*[31] (1969) (**FIGURE 49**; see also **FIGURES 85–86**), and Geli Korzhev's *Mother*[32] (1966–1967). According to Matthew C. Bown (1998: 435–437), the purpose of the backward-turned figures was to reduce the myth of the greatness of the Soviet man, a method of making the main character of the picture "smaller," as only one of the inhabitants of the world.

Horror Vacui: On Infinity and Congestion

As I pulled myself back towards the spacecraft I was struck by how fragile and vulnerable it looked in the vastness of the universe. (Leonov and Scott 2004: 108)

"The first question with which one is confronted in the representation of space flight is one that it shares with some other genres, such as tragedy; namely, for example, why should we take pleasure in the contemplation of what must be among the most painful and uncomfortable, constricting, claustrophobic physical experiences recorded by human beings?" Frederic Jameson (2008: 172) wondered this while reflecting on the history of spaceflights. Mikhail Epstein has conceptualized this contradiction between "rarefication" and "condensation" as a basic paradox that penetrates all levels of Russian Soviet spatiality (Epstein 2003: 279–282). Literature and painting encompassed almost obsessively the theme of large spaces. The steppe, which was empty as far as the horizon, was a reminder of the freedom that a densely populated Europe had lost. There existed a "built-in" horror of sublime space, the empty unknown and immeasurable depths. Escape from the terrible emptiness was found in rural community, in a farm collective in the middle of the spacious steppe, in the center of a stuffy room on a commune. Amidst the enormous vastness, the Russians jammed into a small space protected from the void (Epstein 2003: 279).

Alexei Leonov, artist and cosmonaut, was on an artist's twentieth-century journey par excellence. If anyone did, he knew that nature did not easily surrender to conquest. The disparity between crowdedness and the void was

very apparent in Leonov's Voskhod 2 flight. Or rather, it would have been if all of the details of the flight had not been kept secret. In public, the flight was praised with the appropriate superlatives. In practice, the flight was anything but perfectly successful. The cosmonauts ended up in serious mortal danger on several occasions. The first problems started during the spacewalk. After floating in a vacuum for ten minutes, Leonov began returning to the craft. He had rehearsed spacewalks more than 150 times in a simulator, and the task had become completely automatic. During the spacewalk, however, his spacesuit had expanded in such a way that he could not fit through the hatch of the craft. The situation was terrifying. Time was passing, and the allocated supply of air for the spacewalk was starting to run out. Leonov made a quick decision: he opened the air-valve of his suit and let oxygen out. This was extremely dangerous and definitely against the protocols of the manual, but it was an easy decision to make: had he not been able to enter the craft within the next few minutes, he would have suffocated. When he finally succeeded in wriggling inside, it became apparent that the hatch of the craft was not closing properly. Valuable oxygen was leaking into space. Voskhod's life-support system compensated for the leak by pumping pure oxygen into the capsule. This caused a serious danger of fire, as even the smallest electrostatic spark could have caused an explosive conflagration. Both Leonov and the other flight's cosmonaut, Pavel Belyayev, had witnessed the death of their colleague on Earth under similar circumstances. This had happened only a few weeks before Gagarin's flight, when the cosmonaut-in-training Valentin Bondarenko burned to death in a pressure chamber filled with pure oxygen (Burgess and Hall 2009: 126, 253; Gerovitch 2007: 143–153; Leonov and Scott 2004: 100–122; Portree and Trevino 1997: 2).

The thought of cosmonauts in the middle of the vacuum of space, crammed into a life-threatening place, is riveting from the point of view of a narrative of "the stuffy room of the commune." Yet this idea was not leveraged among the public. Officially, everything went flawlessly. Some of the problems on the flight may have been felt on the sofas at home: the television broadcast was cut immediately after problems started coming up. Instead of watching the spacewalk, the audience on Earth again got to listen to Mozart's *Requiem*. The choice of this piece points to a strange sense of discretion: playing it was a general custom before the announcement of the death of a head of state (Leonov and Scott 2004: 109; Burgess and Hall 2009: 253).

The death announcement did not come, however, and the cosmonauts made it back alive to the surface of Earth. Yet even this did not take place without incident. Due to a navigational mistake, the return capsule landed hundreds of kilometers away from its target. Buried in the deep snow in the middle of the bitter winter of Siberia, the capsule almost imprisoned the cosmonauts for good. When they finally fought their way out, they had to wait for two days, almost freezing, until they were found. Because the first rescue team could not land amidst the trees, the helicopter dropped things to the freezing spacemen. High-tech equipment proved to be useless, and the journey out of the forest was done on skis in fur clothes (Leonov and Scott 2004: 100–122). Nature almost had the last word over its modern conquerors.

Leonov's flight can also be examined in terms of the universal monomyth outlined by Joseph Campbell, a scholar of comparative religion. In his influential book *The Hero with a Thousand Faces* ([1949] 1973), Campbell goes through thousands of mythological tales from different parts of the world and out of these tales develops a basic structure whose variations repeat, regardless of their culture or historical context. This structure he calls "monomyth." In a simplified way, Campbell's monomyth consists of three elements, the first of which is separation from world, the second is penetration to some source of power, and the third is return, which brings new power to life.

> A hero ventures forth from the world of common day into a region of supernatural wonder: fabulous forces are there encountered and a decisive victory is won: the hero comes back from this mysterious adventure with the power to bestow boons on his fellow man. (Campbell [1949] 1973: 30)

Over the border was the dark, the unknown, and the dangerous world, where the hero had to endure a series of trials, one after another. "Once having traversed the threshold, the hero moves in a dream landscape of curiously fluid, ambiguous forms" (Campbell [1949] 1973: 58). The first photos of Leonov floating in space were dim and blurry (**FIGURE 43**). In light of Campbell's monomyth, this only highlighted the mystery of the journey: the hero's journey in space was so dangerous that *it was not possible* to visually represent it. The regime of secrecy only emphasized this element of danger. The technological challenges in describing space were, from the point of view of narrative, only an advantage.

Danger, associated with the lack of photos, was not constructed in the written narrative. According to Campbell, this is typical as well of monomyths: "The ease with which the adventure is here accomplished signifies that the hero is a superior man, a born king. [...] Where the usual hero would face a test, the elect encounters no delaying obstacle and makes no mistake" (Campbell [1949] 1973: 173). In the flight, everything went "according to plan," and the potential dangers encountered during the journey were hidden from the public. The dim, blurry photos only hint at the possibility of danger. The narrative yields despite the contradiction, if it is not based on it: risks are hinted at through photos (and the lack of them), but on the other hand the existence of danger is denied. Difficulties at this point in the story would have meant problems in the larger narrative than the cosmonaut's journey: technical failures, incomplete training, or a wrong selection of the chosen hero.

This heroic rescue narrative was not publically taken advantage of. As far as the public was concerned, Leonov's flight followed the established pattern in which apparently "flawless cosmonauts flew perfect missions supported by unfailing technology" (Gerovitch 2015: 25). In line with this, the grainy photo of Leonov's spacewalk published in *Ogonyok* was not long-lived. It was replaced quickly by another, heavily retouched version (**FIGURE 50**). The new, more graphically refined photo does not give the same impression of authenticity as the almost indecipherable photo in *Ogonyok*. However, it became one of the most widely circulated symbols of the space program after the mid-1960s, one of its symbolic photos.

Photograph Versus Painting

There is something puzzling in the difference between the space photographs and fantastic cosmic paintings. It is the idea of a traveling artist that makes the distinction confusing; the existence of a human observer or eyewitness seems to be the key issue here. Take the "Blue Marble" photo discussed above as an example. One reason why it so undeniably overruled and outlived the Soviet version can be explained by the fact that, unlike the orbiter photo of Zond 7, it was taken by a *person*, not a machine. Like the earlier photo of Earth by Gherman Titov, a human photographer's knowledge brought to the photo a completely different chain of associations than the photo taken by the orbiter, whose power lies in different

kinds of ideas of objectivity, authenticity, and capturing. There was actually a clear tendency to humanize the space probes both visually (see, e.g., **FIGURE 33**) and in writing (Sputnik I seen as a docile scout, working for us "out there"). Space travelers, photographing the Earth from distant space, can be seen as modern expeditioners in the spirit of the early landscape photographers. These photographer-expeditioners were a completely new breed of picture-makers, being simultaneously scientists, reporters, and artists. Their research object included both the new medium of photography and a new, wild, and almost inaccessible landscape.

Alexei Leonov's paintings can also be seen from this perspective. In Leonov's Moon landscape (**FIGURE 42**), the small figures are "moon surveyors" (*selenodezisty*). The name refers to geological research, which was one of the basic themes in the 1960s that explained the conquest of nature, as well as in visual culture (for example, *Hudozhnik* 6/1960: 13). Already in the eighteenth century, the European geological expeditions included topographic illustrators who were educated in making systematic drawings. In the spirit of these topographic drawings, Leonov's pictures have a greater value than art, a power of witness; he himself had visited space and seen the immeasurable expanse with his own eyes. This observation changed the truth value of his illustration from a cosmic landscape into a *document*.

In July 1969, the entire world was watching the same television channel.[33] On July 20, as Apollo 11 landed in the Sea of Tranquility, the commander of the flight, Neil Armstrong, spoke his historic words. *Ogonyok* also commemorated the occasion with a full photo spread (*Ogonyok* 30/1969) (**FIGURE 51**). It is worth noting that the astronauts depicted in *Ogonyok* are posing with their spacesuits, although without helmets. The photo is staged so that it seems as if the Moon – larger than life – is rising behind them. According to Roger D. Launius, the space suit was a crucial element when astronauts were depicted in the American press. The suit was essentially

[...] a knight's armor worn heroically as the individual conducts his noble mission. More than any other single artifact of the Moon landing program the Apollo space suit represented the values that supported Americans going into space in the first place. It symbolized and reified the utopian desire to colonize the Solar System and make a perfect society at a new and pristine place beyond the corrupt Earth. (Launius 2005: 1–12)

Contrary to the astronauts, cosmonauts were seldom depicted in their space suits. In the next chapters we shall see how, more than a masculine cosmic superhero, the cosmonaut was more often represented either as a devoted father and husband or even as a laid-back homeboy, "one of us."

<div align="center">***</div>

From the perspective of narration, the previous two chapters opened the *place* of the narrative. More meaningful than the plot was the stage of the events – infinite space. The narrative did not emphasize persons; space travelers were presented as typecast models, not as individuals. The narrators as well, the obedient announcers reporting about the journey, were objective and direct, deliberately distanced. The timeframe of the narratives is tightly focused on the present moment or even the future: the main characters of the cosmic landscapes seem to be wandering in landscapes of the future.

With manned spaceflights, the stage of the narrative changes. After the curtain sets, space disappears, and when it comes up again, the narrative has descended to the surface of the Earth. The emphasis changes as well. The new main characters become more important than the narrator as an objective witness. Pavel Klushantsev's film *Moon* (1965) offers an example of the lonely traveler being replaced by a family man or mother on the surface of Earth instead. Here the familiar space-suited figures are standing with their back to the viewer. To the company of the pair has been added a third person, a child. Holding each other's hands, this settler family is looking at the barren lunar landscape. The setting encompasses the cosmism of the nineteenth century when Tsiolkovsky is given the last sentence in the film:

> Humanity will not remain on the Earth forever, but in the pursuit of light and space will at first timidly penetrate beyond the limits of the atmosphere, and then will conquer all the space around the Sun. (Klushantsev 1965)

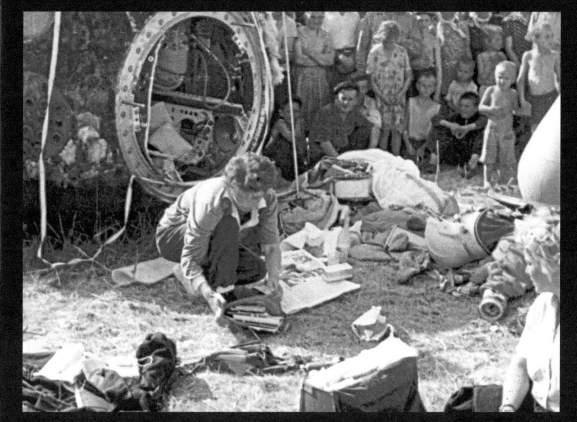

ПРОГРАММА-3

«Программы КПСС можно сравнить с трехступенчатой ракетой».

Н. С. ХРУЩЕВ.
Из доклада на XXII съезде КПСС.

Рисунои Бор. ЕФИМОВА.

2

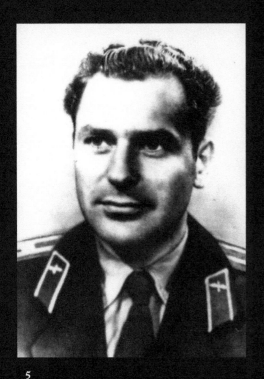

5

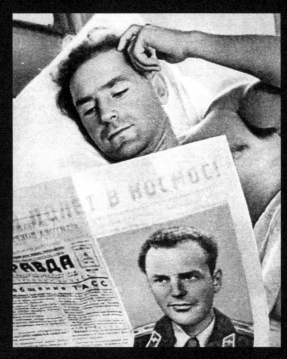

6

7

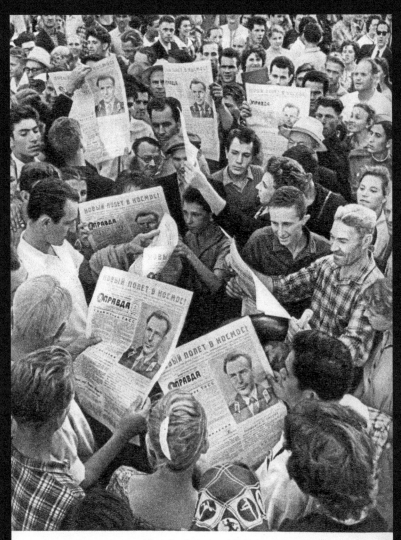

Москва, 6 августа 1961 года. Первые сообщения о полете Германа Титова.

9

10

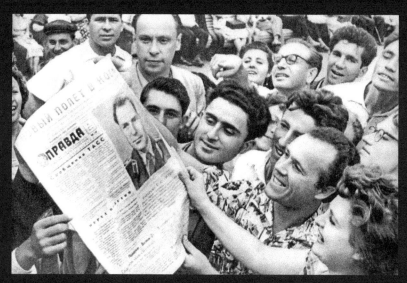

11

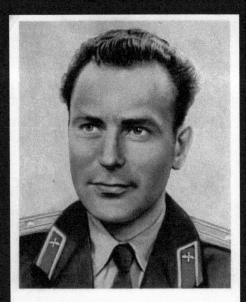

Гражданин Союза Советских Социалистических Республик
Герой Советского Союза летчик-космонавт СССР
Герман Степанович ТИТОВ.

12

13

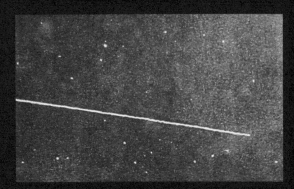

14

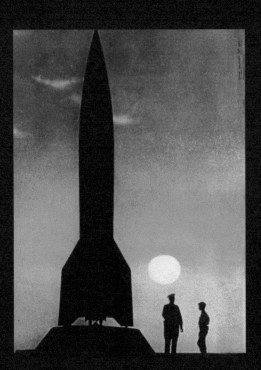

15

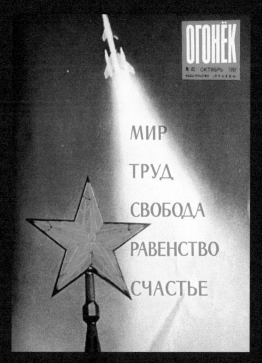

16

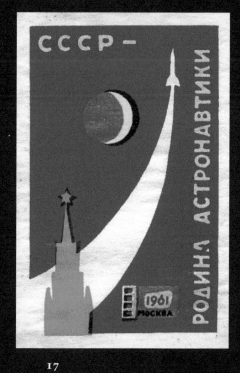

17

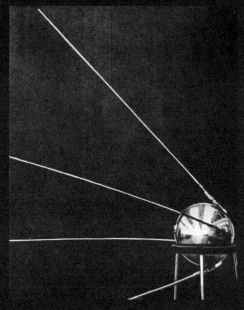

18

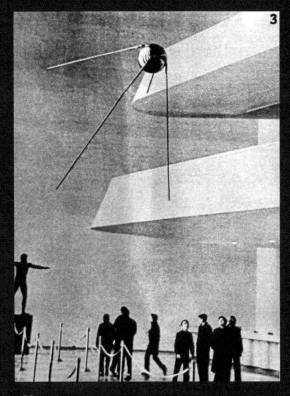

3

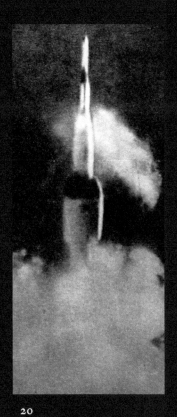

19

20

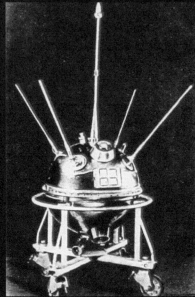

21

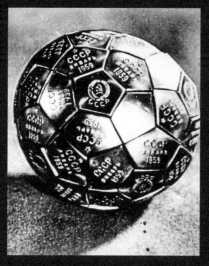

22

23

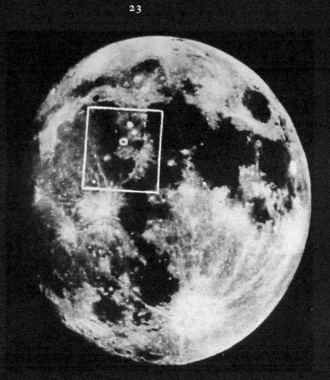

24

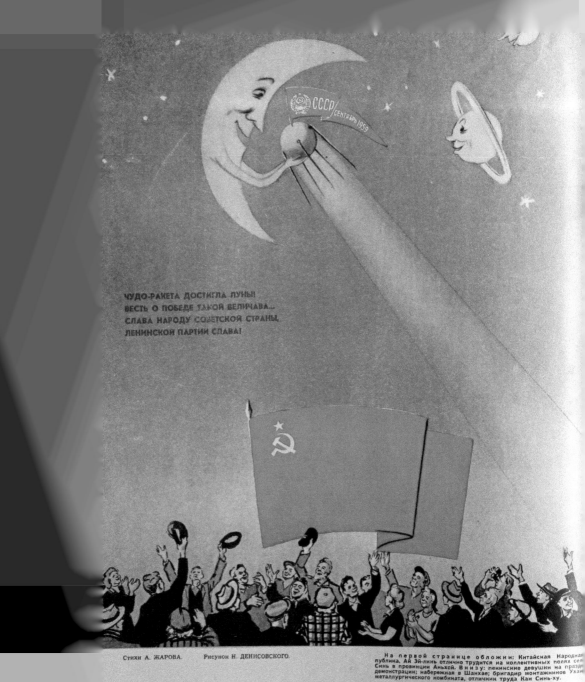

ЧУДО-РАКЕТА ДОСТИГЛА ЛУНЫ!
ВЕСТЬ О ПОБЕДЕ ТАКОЙ ВЕЛИЧАВА...
СЛАВА НАРОДУ СОВЕТСКОЙ СТРАНЫ,
ЛЕНИНСКОЙ ПАРТИИ СЛАВА!

Стихи А. ЖАРОВА. Рисунок Н. ДЕНИСОВСКОГО.

На первой странице обложки: Китайская Народная
публика, Ай Эй-линь отлично трудятся на коллективных полях сел
Синь в провинции Аньхой. В н и з у: пенинские девушки на празд
демонстрации; набережная в Шанхае; бригадир монтажников Ухан
металлургического комбината, отличник труда Кан Синь-ху.

Фото Н. Драчи

На последней странице обложки: Поезд в горах П
патья.

Фото Н. Козло

Идеи мира и дружбы восторжествуют!

Пролетарии всех стран, соединяйтесь!

ОГОНЁК

№ 40 (1685)

27 СЕНТЯБРЯ 1959

37-й год издания

ЕЖЕНЕДЕЛЬНЫЙ ОБЩЕСТВЕННО-
ПОЛИТИЧЕСКИЙ И ЛИТЕРАТУРНО-
ХУДОЖЕСТВЕННЫЙ ЖУРНАЛ

ЕЖДУ ДВУМЯ ОКЕАНАМИ

Борис **ИВАНОВ** Фото Андрея **НОВИКОВА**.
Специальные корреспонденты «Огонька»

ХОРОШЕЕ НАЧИНАЕТСЯ С УТРА

...нее утро. Еще тихо на улицах Вашингто-
...Автомобили мирно стоят в своих загончи-
...«паркингах». Только у Блэйр-хауза, рези-
...ции Н. С. Хрущева, толпятся люди. Многие
...шаны фотоаппаратами. Это американские
...налисты, они дежурят с самого рассвета.
...терпение вознаграждается. Открывается

широкая двухстворчатая дверь, и на крыльцо
выходит подышать свежим воздухом Никита
Сергеевич Хрущев. Он без пиджака, в светлой
рубашке. Никита Сергеевич улыбается, желает
журналистам доброго утра. Кто-то спраши-
вает, понравился ли ему Вашингтон.

— Очень хороший город! Вери гуд! — отве-
чает Н. С. Хрущев.

Совсем рядом — трамвайная линия. Пробе-

Вашингтон. Председатель Совета Министров
СССР Н. С. Хрущев и его супруга Н. П. Хрущева
дали в советском посольстве обед в честь пре-
зидента США Д. Эйзенхауэра и его супруги
г-жи Эйзенхауэр. На снимке: Н. С. Хрущев,
г-жа Эйзенхауэр, Н. П. Хрущева и Д. Эйзенхауэр.

гающие мимо трамваи, автобусы резко замед-
ляют скорость, несмотря на энергичные жесты
полицейского. В окнах улыбающиеся лица, сот-
ни протянутых рук: спешащие на работу ва-
шингтонцы приветствуют советского гостя.

А в это время в Белтсвилле, научном
центре министерства сельского хозяйства
США, идут последние приготовления. Сюда
утром должен прибыть глава Советского
правительства.

Белтсвилл располагает четырьмя тысячами
гектаров земли, животноводческими фермами.
Здесь ведутся научно-исследовательские ра-
боты, результаты которых затем, как сказал

26

27

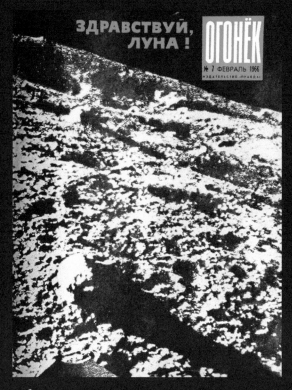

ЗДРАВСТВУЙ, ЛУНА !

ОГОНЁК

№ 7 ФЕВРАЛЬ 1966

ИЗДАТЕЛЬСТВО «ПРАВДА»

28

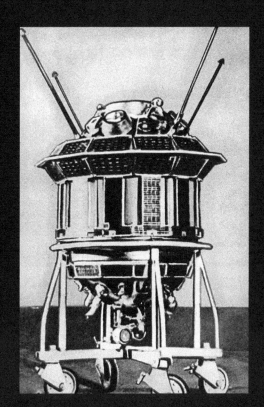

29

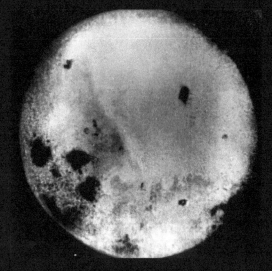

30

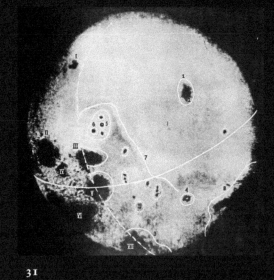

31

32

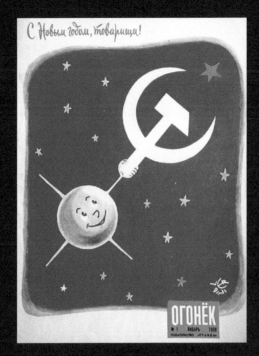

С Новым годом, товарищи!

ОГОНЁК

33

34

ПУК
Земля с высоты 250.000 метров
Снимки Германа Титова

«...Все чудеса техники, все завоевания культуры станут общенародным достоянием, и отныне никогда человеческий ум и гений не будут обращены в средства насилия, в средства эксплуатации. Мы это знаем,— и разве во имя этой величайшей исторической задачи не стоит работать, не стоит отдать всех сил?»

В. И. Ленин

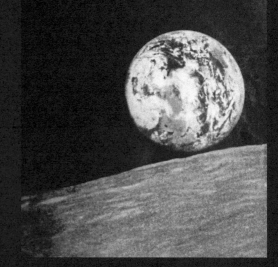

35

36

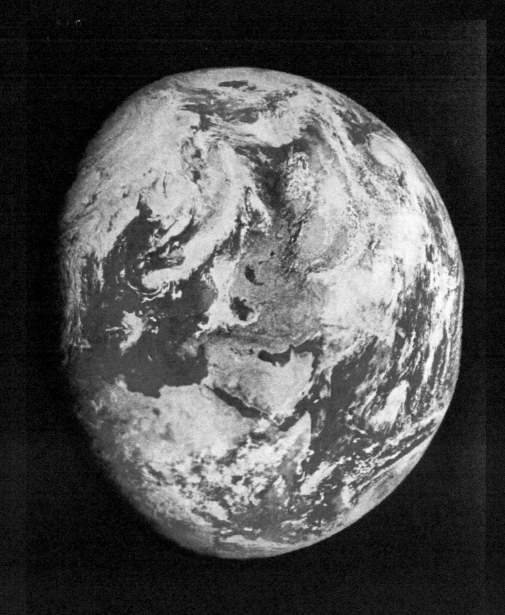

37

38

39

40

41

42

43

44

45

46

47

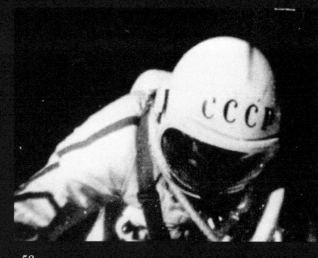

ЛУННАЯ ОДИССЕЯ «АПОЛЛОНА-11»

Кирилл ВЛАДИМИРОВ

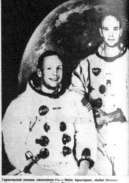

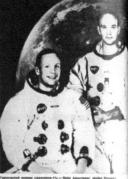

Героический экипаж «Аполлона-11» — Нейл Армстронг, Майкл Коллинз и Эдвин Олдрин.

Фото ЮСИ и ТАСС.

Исторические шаги на Луне.

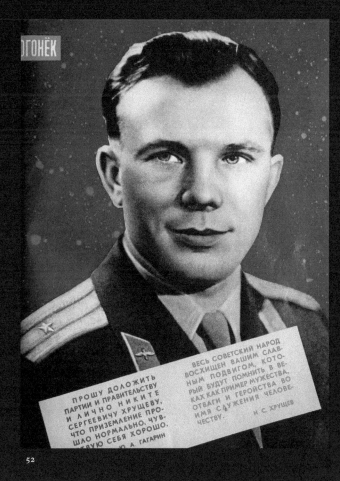

54

55

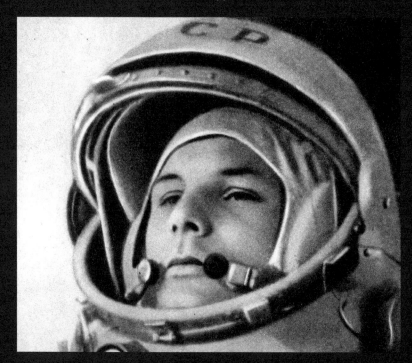

56

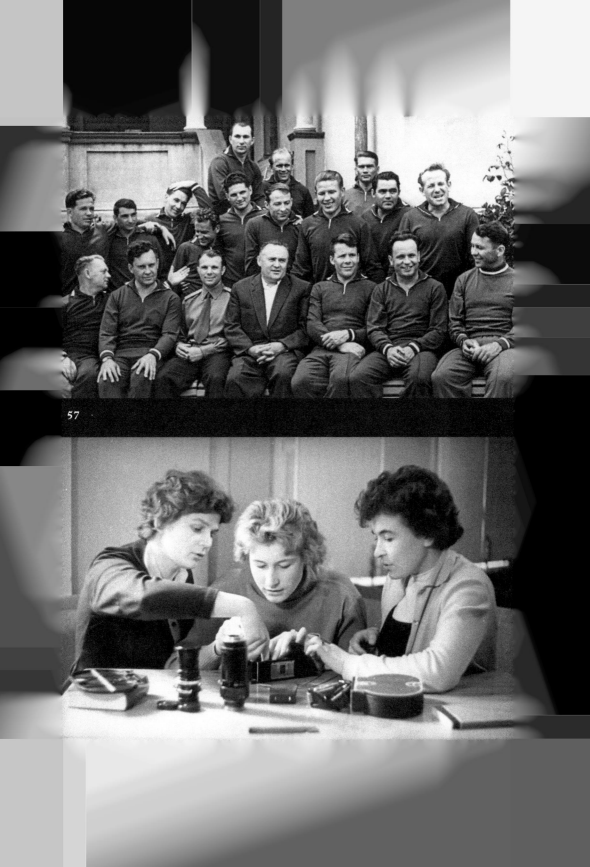

57

ГОЛОС РАЗУМА

Товарищ Н. С. Хрущев выступает по радио и телевидению 7 августа 1961 года.

Фото А. Устинова.

Т аков закон нашего общества: радости и заботы, победы и трудности партия, правительство делит с народом. Всегда. Каждый день, каждый час.

7 августа страна слушала выступление Никиты Сергеевича Хрущева по радио и телевидению. Глава правительства говорил о новом выдающемся подвиге советского народа на пути освоения космоса, о добрых вестях с заводов и полей, о грандиозных перспективах развития народного хозяйства, изложенных в проекте Программы Коммунистической партии. Это был разговор о наших трудовых буднях, потрясающих планету великими свершениями. Это был разговор о мире.

Да, для мира поднимаем мы ввысь леса невиданных строек. Для мира будоражим гудками тепловозов вековечную тишь тайги. Для мира украшаем землю новыми городами, одеваем ее в золото пшеничных полей. Для мира!

Но есть на Западе агрессивные круги, готовые на все, чтобы сорвать наши планы, планы строительства коммунизма, утвержденные на земле Мира, Труда, Свободы, Равенства и Счастья народов. Эти круги раздувают ядерный психоз, они вооружают опаснейших врагов мира и демократии — западногерманских реваншистов. «По воле западных держав в центре Европы скопилось больше горючего материала, чем в каком-либо другом районе мира. Отсюда вновь грозит пробиться пламя мировой войны», — предостерегающе прозвучал в эфире голос Никиты Сергеевича Хрущева.

Наше поколение хорошо помнит дымящиеся развалины имперской канцелярии, где провел свои последние часы обезумевший нацистский главарь. Помнит гром праздничного салюта, прозвучавшего в честь Победы. Помнит знамена отборных гитлеровских дивизий, брошенные к подножию Мавзолея. Но мы помним и другое. Как сбегались под прыгнышем западных оккупационных властей недобитые военные преступники. Как прибрали к рукам свои заводы и шахты рурские короли угля и стали, на чьей совести две мировые войны. Как тихий городок на Рейне — Бонн — превращался в мрачную цитадель милитаризма.

Мирный договор не заключен — и вчерашние эсэсовцы грозят кулаком на Восток и на Запад, требуя для себя новых территорий, нового «жизненного пространства».

Мирный договор не заключен — и сколачивается реваншистская армия, поставленная под командование генералов «третьего рейха».

Мирный договор не заключен — и Западный Берлин стал сегодня центром провокаций и шпионажа, а завтра может превратиться в новое Сараево.

ЭТОГО НЕ ДОЛЖНО ПРОИЗОЙТИ!

Вот почему Советский Союз предлагает:

ПОДПИСАТЬ МИРНЫЙ ДОГОВОР.

Такое решение отвечает интересам всех народов. Договор должен быть заключен. Он будет заключен.

В западных столицах сейчас раздаются вопли о каких-то «угрозах» со стороны Москвы. Но разве предложение заключить мирный договор с обоими германскими государствами и решить на этой основе вопрос о Западном Берлине — военный ультиматум? Разве стремление ликвидировать остатки прошлой войны и не допустить ее возникновения вновь — это угроза? О какой «капитуляции Запада» твердят некоторые безответственные политики, имея в виду заключение договора? О капитуляции перед разумом, перед доброй волей? Да, логики здесь не ищи. «Нигде стремление политического банкротства не проявлялось столь очевидно и столь опасно, как в связи с Берлином», — сокрушенно признает английская газета «Дейли геральд».

Советский Союз предлагает выход из тупика, созданного западными державами. Этот выход — переговоры.

«...Мы еще раз обращаемся к правительствам Соединенных Штатов Америки, Англии, Франции: давайте по-честному сядем за круглый стол переговоров, давайте не создавать психоза войны, очистим атмосферу, будем опираться на разум, не на силу термоядерного оружия», — услышал мир твердые, уверенные слова Н. С. Хрущева.

У советского народа есть все, чтобы на силу ответить силой, чтобы сокрушить любого агрессора. Партия и правительство приняли необходимые меры для укрепления обороны страны. Но мы не считаем, что должны заговорить ракеты и пушки.

Пусть заговорит разум.

ПРОЕКТ НОВОГО УСТАВА КОММУНИСТИЧЕСКОЙ ПАРТИИ СОВЕТСКОГО СОЮЗА

Опубликован проект Устава Коммунистической партии Советского Союза.

В сообщении Центрального Комитета Коммунистической партии Советского Союза в связи с опубликованием проекта Устава говорится, что проект одобрен июньским Пленумом ЦК КПСС. В соответствии с решением Пленума проект Устава КПСС публикуется для всеобщего ознакомления и обсуждения всеми членами и кандидатами в члены КПСС. Итоги обсуждения будут учтены при окончательном рассмотрении проекта Устава.

Новый Устав партии вносится на рассмотрение и утверждение XXII съезда Коммунистической партии Советского Союза.

ВНУКОВСКИ

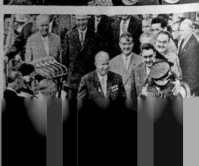

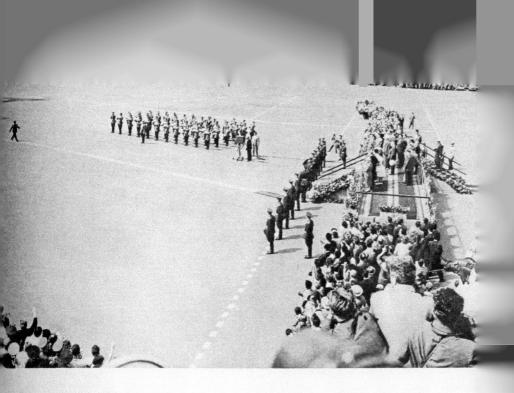

ЭРОДРОМ. 9 АВГУСТА 1961 ГОДА

Фото И. Тункеля и Б. Кузьмина.

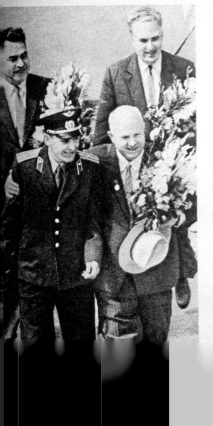

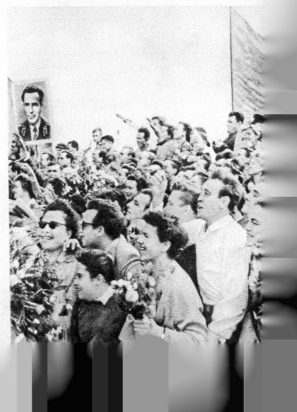

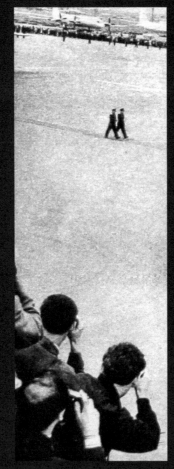

60

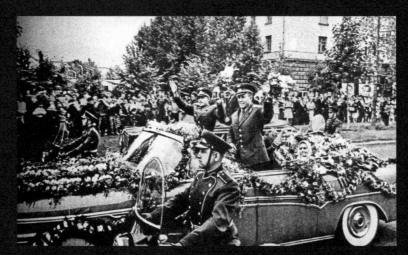

61

Фотоочерк и героям посвящают: Г. Колосов, Е. Умнов, А. Гостев, Ю. Иванушкин, Б. Щербаков, В. Улитовский.

В теплом небе над землей бескрайней,
Приближал праздничный исход,
Шел к столице богатырский лайнер
И его торжественный эскорт.

— Здравствуйте, хорошие, родные!
Падают ромашки на бетон...
— Это вам — все краски полевые,
Благодарной Родины поклон!

Это вам — улыбки и приветы,
Всплески сизокрылых голубей!..

Слушай, восхищенная планета,
Звездный гул московских площадей!
И. БЫКОВ

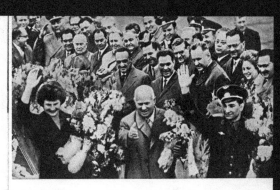

ДОРОГА СЛАВЫ

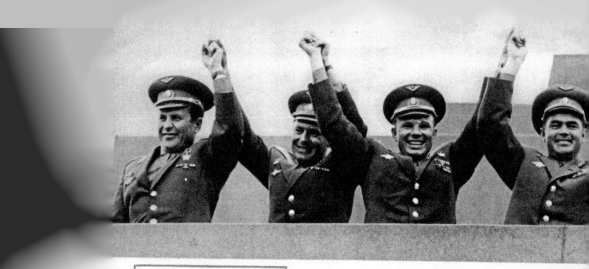

Пролетарии всех стран, соединяйтесь!

ОГОНЁК № **27 (1880)**

30 ИЮНЯ 1963

41-й год издания

ЕЖЕНЕДЕЛЬНЫЙ ОБЩЕСТВЕННО-ПОЛИТИЧЕСКИЙ
И ЛИТЕРАТУРНО-ХУДОЖЕСТВЕННЫЙ ЖУРНАЛ

РОДИНА ЧЕСТВУЕТ

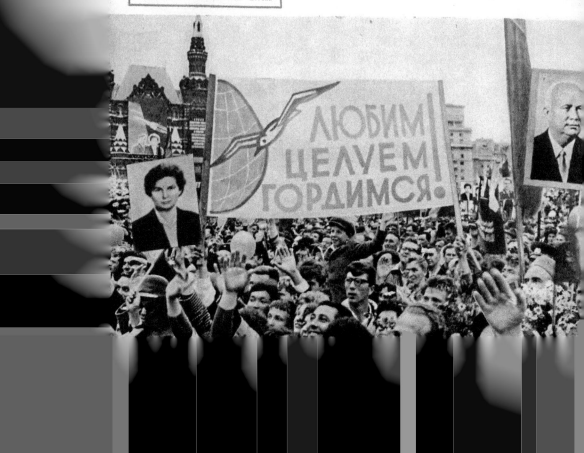

СВОИХ ОТВАЖНЫХ ДЕТЕЙ

Москва. Красная площадь. 22 июня 1963 года.

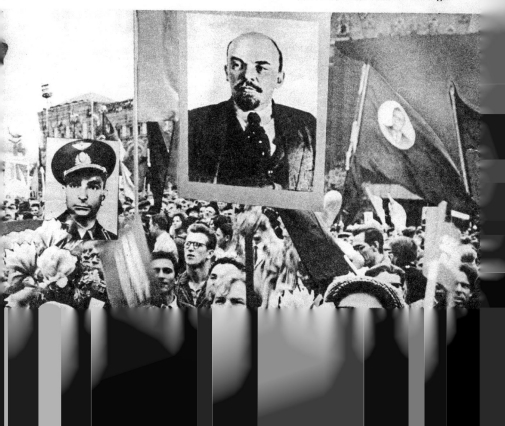

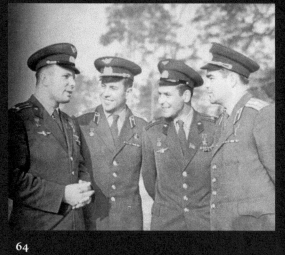

64

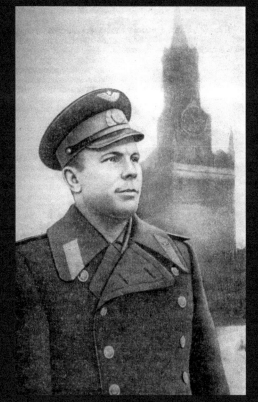

65

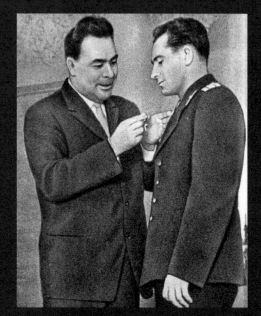

66

67

68

69

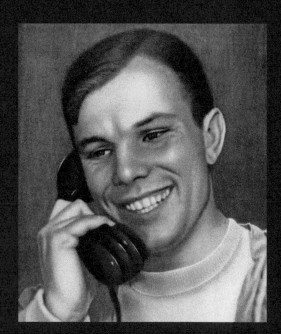

70

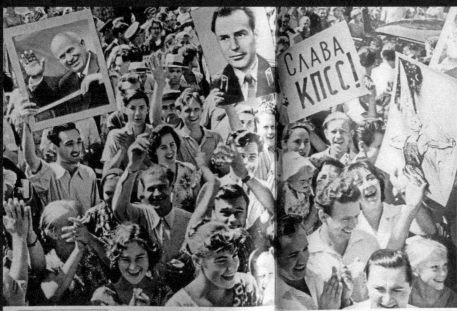

СЛАВА КПСС!

Фото В. Богданова и М. Сахаровой

СВЕРКАЮЩИЕ ОРБИТЫ

Вадим КОЖЕВНИКОВ

Огонёк

Пролетарии всех стран, соединяйтесь!

№ 33 (1782)
13 АВГУСТА 1961
30-й год издания

ЕЖЕНЕДЕЛЬНЫЙ ОБЩЕСТВЕННО-ПОЛИТИЧЕСКИЙ
И ЛИТЕРАТУРНО-ХУДОЖЕСТВЕННЫЙ ЖУРНАЛ

ВЕСЬ СОВЕТСКИЙ НАРОД, ВСЕ ПРОГРЕССИВНОЕ ЧЕЛОВЕЧЕСТВО БУДУТ ПОМНИТЬ В ВЕКАХ ВАШ ПОДВИГ, КАК ПРИМЕР МУЖЕСТВА И ОТВАГИ, ВО ИМЯ СЛУЖЕНИЯ ЧЕЛОВЕЧЕСТВУ.

ИЗ ПРИВЕТСТВИЯ Н. С. ХРУЩЕВА МАЙОРУ ТИТОВУ ГЕРМАНУ СТЕПАНОВИЧУ

71

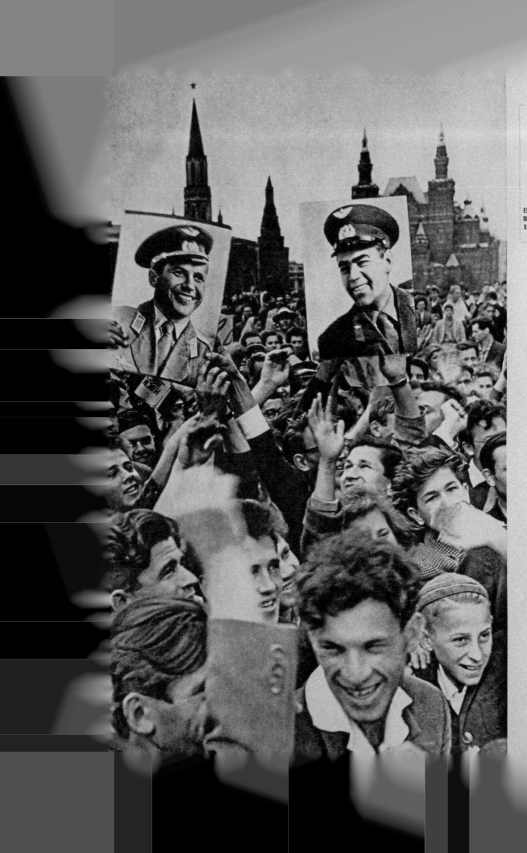

Пролетарии всех стран
соединяйтесь

ОГОНЁК

№ 34 (1835)
19 АВГУСТА 1962
40-й год издания

ЕЖЕНЕДЕЛЬНЫЙ ОБЩЕСТВЕННО-
ПОЛИТИЧЕСКИЙ И ЛИТЕРАТУРНО-
ХУДОЖЕСТВЕННЫЙ ЖУРНАЛ

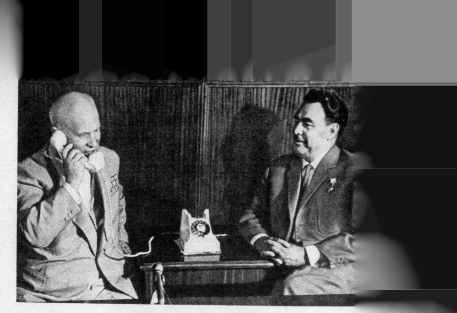

Н. С. ХРУЩЕВ:

— Все мы гордимся ва-
гордимся учеными, ин-
нерами, техниками, ра-
ими, которые создали
т замечательный ко-
ль.

*Из разговора по телефону
Н. С. Хрущева и Л. И. Бреж-
нева с космонавтами А. Г. Ни-
колаевым и П. Р. Поповичем.*

Фото Г. ТРОФИМОВА (ТАСС)

Слушай, человечество! Советские космонавты Андриян Николаев Павел Попович рапортуют:

— Программа многодневного группового полета космических раблей «Восток-3» и «Восток-4» выполнена!
Новая графа в послужном списке звездолетов: А. Николаев—более 500000 километров; П. Попович—около 2000000 километров.

ОВЫМ МАГЕЛЛАНАМ ВСЕЛЕННОЙ—СЛАВА, СЛАВА, СЛАВА!

онавты А. Г. Николаев и П. Р. Попович во время телефонного разговора с Н. С. Хрущевым и Л. И. Брежневым.

Фото Г. ОСТРОУМОВА (ТАСС).

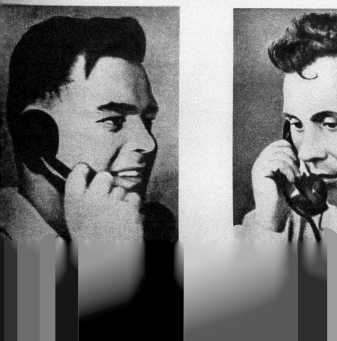
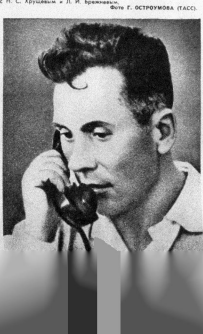

ПРИЗЕМЛИЛИСЬ! ВСЕ В ПОРЯДКЕ!

Н. С. ХРУЩЕВ: «Своим полетом Вы прославили нашу Родину и подняли на еще большую высоту советскую женщину».

Из телефонного разговора Н. С. Хрущева с Валентиной Терешковой после ее приземления.

«Вы возвысили нашу Родину своим героическим полетом. Это большой вклад в наше дело, в дело борьбы за построение коммунизма. Народ очень гордится Вами».

Из телефонного разговора Н. С. Хрущева с В. Ф. Быковским после его приземления.

74

75

76

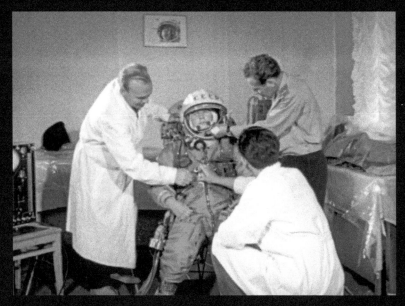

77

78

79

80

81

84

85

86

87

88

89

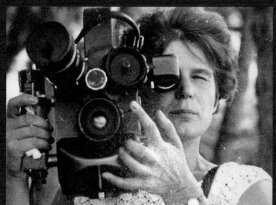

90

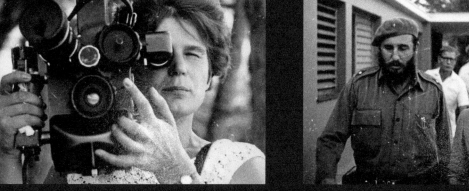

91

92

93

94

95

96

97

98

99

102

103

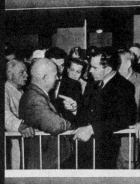

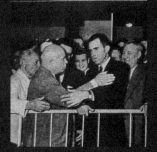

104

105

106

107

108

109

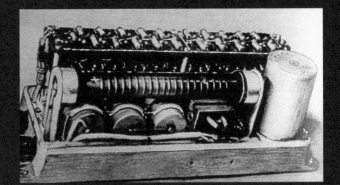

Аппаратура для исследования излучения Солнца.

109

109

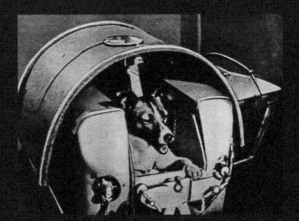

109

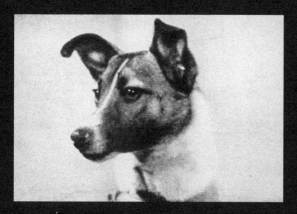

110

111

112

ВЫ ВИДЕЛИ ЭТО НА ЭКРАНАХ СВОИХ ТЕЛЕВИЗОРОВ — ДВА ВОЛНУЮЩИХ МОМЕНТА: СТЫКОВКА КОСМИЧЕСКИХ КОРАБЛЕЙ И РАБОТА ЧЕЛОВЕКА В ОТКРЫТОМ КОСМОСЕ.

Московский фотор-
картин ведет Л. БОНИ-
ДУЛИН, А. БОЧИНИ.
А. УЭЛЛ, Д. УШ[?]-
СКИЙ.

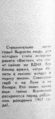

Строительные лет-
годы Выросли люди, для
которых стала историей
ракета «Восток», что сто-
ит сейчас на ВДНХ. Все
ближе время, когда по-
лёты в космос войдут в
норку жизни. Советский
герб и на Луне и на
Венере. Кто знает, какие
ещё тайны Вселенной
раскроются перед ребя-
ком, рождения 1967 го-
да!.

116

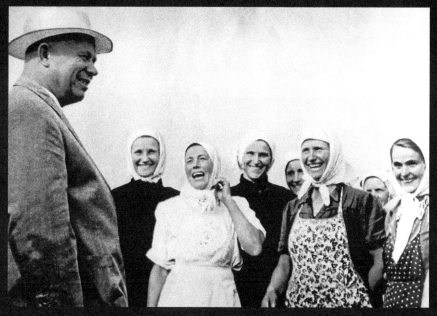

117

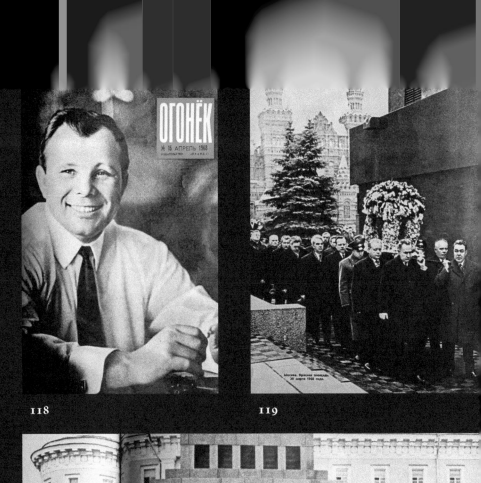

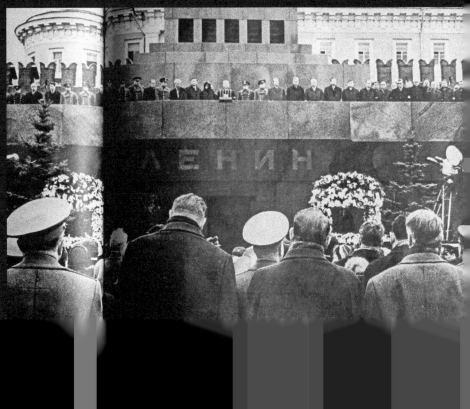

118

119

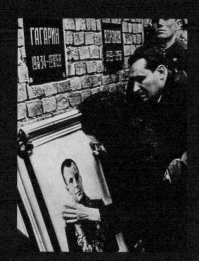

121

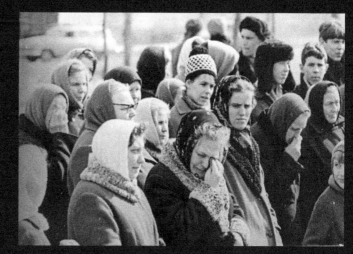

122

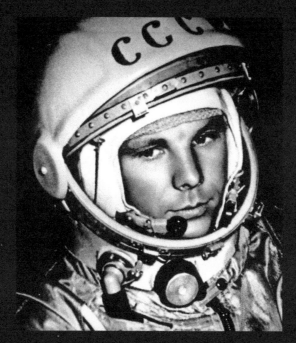

123

124

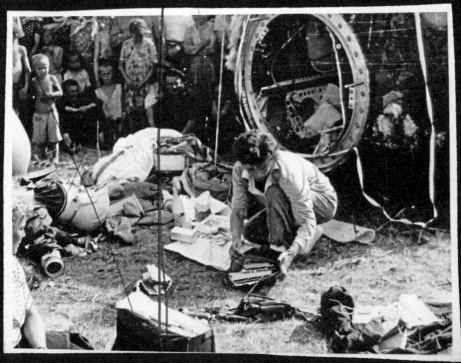

125

STORY OF THE HEROIC CONQUEST OF SPACE

CHAPTER 4

His smile is good and honest, and it is not necessary to add that this man, who first dared to fly into space to greet the stars, this man who was the first to gaze down on our Earth, has a truly large and dignified nature. This can be seen from his smile, from his intelligent eyes.

(Helsingin Sanomat April 13, 1961)

 n April 13, 1961, a special extra issue of *Pravda* was published. Its title declared in red letters: "A major event in the history of mankind!" The caption continued in red:

> For the first time ever the Soviet craft "Vostok" has conducted a manned flight around Earth, and it has happily returned to the sacred soil of our native country. The first person to enter space is a citizen of the U.S.S.R., Yuri Alexeievich Gagarin. (*Pravda* April 13, 1961, special issue)

The article is illustrated with a portrait of a young man, dressed in an Air Force uniform and looking ahead with a slight smile. His face has been retouched as to be flawless. The news coverage shows no trace of the slight reticence that accompanied the launch of Sputnik three-and-a-half years earlier.

The same photo was published in *Ogonyok* (**FIGURE 52**) four days later. The magazine had actually been printed already, but the photo of Gagarin was included in an extra cover attachment. The neutral gray background of *Pravda* was changed to bright blue with spots of light, as if the portrait of the fresh space pilot was floating in the cosmos. Across the lower part of the photo is a greeting from Gagarin to Khrushchev: "I beg to inform the Party, and personally Nikita Sergeyevich Khrushchev, that the landing went normally, and my health is good. Yu. A. Gagarin." Khrushchev's reply to this greeting follows: "The whole Soviet people are thrilled about your glorious feat of valor, which

will be forever remembered as an example of gallantry, bravery and heroism of mankind. N.S. Khrushchev" (*Ogonyok* 16/1961, special cover).

During the following years, that face and smile would illustrate newspapers, postcards, posters, trading cards, statues, and pins – there was no limit to the imagination of the commodification. The heroism of Yuri Gagarin reached proportions in the Soviet Union of the 1960s that are hard to grasp from today's perspective. And it was not only Gagarin that was a worshipped hero. The cosmonauts that came after him shared in this limitless admiration. Children were named after the cosmonauts, as well as schools, streets, and entire towns. After 1961, the cosmonauts were unsurpassed icons of the space program. They were as close as one can get to a modern-day superstar.

Space-related imagery also increased in quantity in *Ogonyok* in 1961, and it remained copious for many years. The theme was kept alive with every new manned spaceflight, and it slightly quieted between them. After 1961, the cosmonauts were standard illustrations of the magazine. Each new flight was followed by enormous media publicity. *Ogonyok* reported on the news with extensive articles and lots of illustrations. After the actual news, which told about the latest flight, small pictures of the cosmonaut would be featured throughout the year: he might be seen posing with an Italian film star or with heads of state, glimpsed in the audience of a Party meeting, acting as a judge in a sports competition, climbing a pyramid or receiving flowers in different parts of the world.

This public role, role of a hero, was not new. Shortly after the Revolution, the Soviet Union had declared itself to be a "nation of heroes" (*strana geroev*) (Kendrick 2010: 171–180). One of the main goals of the early Bolsheviks was to create a heroic new man (*novyi chelovek*) but it was Socialist realism that truly elevated heroism into the center. By the 1930s heroism was institutionalized as a ubiquitous phenomenon that penetrated the whole of society. The new Soviet heroes were strong, young, optimistic men and women. They were huge in size, photographed from below, larger-than-life superheroes, determined, happy, and always on the move, changing the world (Bonnell 1997: 38–42; Günther 2003: 108–109). Cosmonaut heroes shared much in common with this ideal figure. But as we shall see, the picture was perhaps little more distorted that that.

Cosmonauts and the Regime of Secrecy

The previous chapter revealed the tension between secrecy and display that pervaded the entire space program. Technological solutions were not the only things held as state secrets. Whole groups of people, such as the engineers who planned the space technology, were hidden from public. The space program was built by people that did not officially exist. Siddiqi (2011: 63) has talked about "limited visibility" in this regard. The system of secrecy created a space of limited visibility, where only a group of people were allowed to appear publically (for instance, representatives marginally linked to the space program in some way). The real agents of the space program were invisible to the public. A good example of these hidden experts is the main designer of the space program, Sergei Korolev, who during his lifetime only appeared under the cover of the mysterious pseudonym Chief Designer (*Glavnyi konstruktor*) (Golovanov 2001: 271). During his lifetime, his personal information was never published, nor was any photo or hint of his real persona. The researchers and engineers working at the heart of the military–industrial complex had a public voice only via their aliases. This "culture of pseudonyms" characterized the whole of the Soviet Union, particularly its science and technology. Even behind their aliases, the experts had to pay close attention to their words. The few chosen spokesmen had to balance between two extremes: in order to avoid being concrete when discussing the program, they either kept to very plain generalizations or dove into almost absurd detail, as Siddiqi has observed (Siddiqi 2011: 47–76).

The culture of pseudonyms had only one exception: cosmonauts who had already flown. Secrecy caused challenges in the public role of the cosmonauts, who were the most appealing and effective representatives of the space program. Many restrictions were imposed on their public image: cosmonauts were not allowed to be photographed inside spacecraft, talk about cosmonauts that had not yet flown, discuss the connection between the space program and the war industry, describe their spacecraft, or give any details about future plans. In this way, two features were combined in the cosmonauts: they were simultaneously the most influential and the weakest representatives of the space program. They were the elite of the space program, and the weight of their public image was enormous. . On the other hand, they had no power whatsoever over that public image, and every statement, published photo, and other representation was subject to the basic narrative – the story of a victorious nation conquering outer space (Siddiqi 2011: 47–76).

Chief Designer Korolev died in January 1966, and this was the beginning of his posthumous publicity. *Ogonyok* immediately published a laudatory obituary, which included a photo of the deceased designer (*Krupneshy ucheny...* 1966: 4). There publically appeared photos of him and the first cosmonaut, Yuri Gagarin. A photo that was published in several contexts shows Korolev speaking into a microphone (**FIGURE 53**). The photo was taken (or staged) in a situation in which "he is in contact with Yuri Gagarin, in Baikonur[47] on April 12, 1961" (Nesterov 1987: 26). Both the photographer and the subject of the photograph knew at the time of shooting that it could not be published then. It was taken for the future, to be linked to the narrative of what was to come. Among those photos taken for future publicity were also the training photos of cosmonauts that had not yet flown. Despite all of the photos, however, this future publicity never came. For instance, the female cosmonauts Valentina Ponomaryova, Irina Soloviev, Zhanna Yorkina, and Tatyana Kuznetsova – who were trained along with Valentina Tereshkova – never flew into space. These women did not become worshipped heroes. Their photos were never spread to the press, and they did not even exist for the public. Photos were taken of the training sessions and then archived for possible publication in the future (see **FIGURE 58**).

Some cosmonauts were dropped from the program along the way due to health or disciplinary reasons. In **FIGURE 54**, Grigori Nelyubov is seen behind Gagarin. For a long time, he was considered a strong choice for first pilot. Yet Nelyubov was dismissed from the program "due to bad behavior." He was transferred into service far away in the periphery, where in 1963, apparently drunk, he was run over by a train and killed (according to a rumor, intentionally). Thus he was erased from the side of Gagarin (Danilevskaya and Yakovlev 2007). In the archive, there are photos of him and other candidates who were dismissed. In the photos, they are playing the piano, putting their children to sleep, and celebrating the New Year. The photo imagery was ready to be connected to their narrative, but never became public. They were erased from group photos. **FIGURE 55** was published in *Izvestia* magazine. In the background, a hint of Nelyubov can still be seen, but he can no longer be distinguished in the photo published in a book shortly after Gagarin's flight (**FIGURE 56**).

FIGURE 57 is from May 1961, shortly after Gagarin's flight. The cosmonauts who were training then got together for a group photo in Sochi, where cosmo-

nauts vacationed between the instruction periods. Touched-up versions of the photo were released later. In these, all of the people that had "disappeared" from the program were deleted.[34] In FIGURE 58, Valentina Tereshkova is practicing putting a camera together with Tatyana Kuznetsova[35] and Irina Solovieva.

Removing people who had become politically unpopular from all visual media had been a common practice since the beginning of the Soviet Union. The historian David King, who has specialized in visual research material, aptly observes that the history of Soviet power could be written with the help of touched-up photos (King 1997). People removed from photos reflect in a stark manner the ruthlessness of the political system. The practice was based on an idea that was already called in Roman antiquity *damnatio memoriae*, "cursing the memory." The person that was declared *damnatio memoriae* was completely removed from writings, statues, and photos. Every trace was erased, as if the person had never existed (Brugioni 1999: 145–146). There are countless examples of this in the Soviet Union. W. J. T. Mitchell has used as an example a photo of Lenin speaking to the people. In the original photo, next to Lenin is People's Commissar of Military and Naval Affairs Leon Trotsky; subsequently ousted by Stalin, he was airbrushed from later versions. For Mitchell, this is an expression of propaganda in its simplest form: the propagandist wanted the viewer to believe in his manipulation (Mitchell 1992: 196–218).

The destruction of religious or political images and symbols, iconoclasm, has appeared in many different types of contexts. Iconoclasm is the reverse of the usage of power connected to images (Latour 2002: 18–19). Even if the destruction of images in the Soviet Union was systematic and extensively practiced, was it really iconoclasm? Does iconoclasm require public humiliation of the image, like in a violent pyre or with a bulldozer? The piles of icons collected by the Bolsheviks in the early years of the Revolution, the church towers that were ripped down, and the toppled statues of the Czar – these all reflect iconoclastic acts. But what about the gradual disappearance of Trotsky, Stalin, and other politicians and public officials that fell into disfavor? Or the army of silent political journalists, who over time systematically and selectively erased undesired players from photos, street scenes, subway station walls, and city names? This action refers rather to a kind of real-life "straightening out of history," described by George Orwell in his dystopia of 1984. Orwell's main character, Winston Smith, *straightens out the past* in the secret Ministry of Truth in such a way:

Day by day and almost minute by minute the past was brought up to date. In this way every prediction made by the Party could be shown by documentary evidence to have been correct; nor was any item of news, or any expression of opinion, which conflicted with the needs of the moment, ever allowed to remain on record. All history was a palimpsest, scraped clean and re-inscribed exactly as often as was necessary. (Orwell [1949] 1978: 46)

Orwell's novel has often been interpreted as describing the Soviet Union of Stalin's time. This interpretation provides a simplified picture of the photo's mode of communication. In the Soviet Union, the purpose of even slight retouching was not always to erase. Sometimes the question was about showing. Political retouching, even if it was made to appear secret, could fundamentally also be public. Using Trotsky's photo as an example, Mitchell misses the cultural role of the photo in the Soviet Union. Trotsky's removal from the photo was a political statement: when reality changed, the photo also had to change. The removal of Trotsky involved an action whose form was also clear to the viewers: the purpose of the powerfully manipulated photo was to communicate the change of the political situation, not to mislead somebody to believe that Trotsky had ceased to exist, as Orwell seems to indicate in his novel. This may explain the fact why standard retouching in the press could be clumsy – more clumsy than technically necessary. It is sometimes possible to distinguish in the photos the trace of a person who was *almost* removed. The question was more about the act of showing: due to a person's unpopularity, heavy-handed elimination of him or her was made visible and known in this way.

Visual Narratives of Space Heroes

Inside the special cover of *Ogonyok* that told about Gagarin's flight is a photo of a rejoicing crowd. The first actual page is illustrated by a photomontage in which a stylized rocket is shooting from the surface of Earth into the blackness of the night sky. In the rocket's fiery trail flaps a flag with a patterned relief of Lenin's profile (*Ogonyok* 16/1961: 1, the author is not mentioned). The following three spreads are dedicated to spaceflights. The photos illustrate people's amazed reactions, their joy, and the cosmonaut himself and his family. In this way, all of the photos in *Ogonyok* articles describing new manned spaceflights were organized serially.

By the end of the 1960s, fifteen manned spaceflights had taken place in the Soviet Union, an average of one per year. A total of 21 cosmonauts visited space with these flights. Six of the flights were either concurrent with another flight or there was more than one cosmonaut in the ship's crew. In four flights, the cosmonaut was alone. One of these, the Soyuz1 flight in April 1967, ended in an accident in which the cosmonaut Vladimir Komarov was killed. This was only reported on with a brief obituary. Aside from this accident, including the concurrent flights and the flights manned by more than one cosmonaut, altogether there are nine photo series reporting on new flights during the timeframe of the study.

The photo series of *Ogonyok* combined seemingly unrelated photos. Some of the imagery is from the cosmonauts' own home albums, some from the training program, and some from public appearances. At first glance, the photo series seems to be an amalgamation of disparate pictorial fragments. Yet when the nine series are observed as a set, the impression of disconnectedness changes. The more photos are seen, the more clearly apparent their similarities. The individual photos are certainly unique in terms of shooting perspective, cropping, and other aesthetic aspects, but common photographic themes recur time and time again. The order changes, but the same elements repeat from one narrative to the next. In all the nine narratives, only the individual actors change, while the form remains the same. The repetition is so obvious that I decided to focus on it. Why were certain themes repeated in each of the photo series?

The recurring story in the pictorial narratives of *Ogonyok* is replicated again in outline form in biographies written about the cosmonauts in the early 1960s, in collection card series, telling about their lives, and in countless little booklets. (For instance, see Gagarin 1961; *The First Man in Space*, 1961; Murayev, Kochovalova, Kvashuk 1961; Titov 1961.) Even in the archive, this same sequence appears every now and then. For instance, one finds a long organized section about Gherman Titov, which includes over 200 photos in more or less chronological order, from his preparation to the flight to his stepping out in public. In this section, all of the themes mentioned in this book are repeated in tens of variations collected from many different sources (RGANTD 1.14539–1.14759). Other similar sudden and transient instances of organization were also found in the archive.

Next I go through the different elements of a cosmonaut narrative (i.e., the themes, details, and other compositions that are repeated again and again from one narrative to another in *Ogonyok*). Is it possible to isolate recurrent pictorial functions from an ensemble of nine narratives, following each one sequentially? I follow the footsteps of Vladimir Propp, a researcher whose life's work was focused on Russian wonder tales. His work *Morphology of the Folktale* was published in Russian already in the 1920s, and it was translated into French and English in 1958. Propp divided folktales into their smallest narrative elements, and reconstructed from these *functions* a kind of basic tale. Based on his analysis of recurring persons and events, Propp concluded that traditional Russian wonder tales contain only 31 general and recurring basic elements. Regardless of what kinds of people or events an individual tale is based on, according to Propp it is always possible to isolate the same, recurring functions (Propp [1928] 1968: 19–24).

My analysis is aimed at seeing the nine cosmonaut narratives located in my material as different variations of the same story. The stories and heroic tales that Propp used as his material are repetitive in the same way as the visual narratives used in the material for this research. However, my intention is not to apply cosmonaut-related visual narratives in a systematic way to the structural patterns of Propp by finding a visual correspondence with certain functions.[36] In my close reading, I use nine pictorial narratives that discuss the cosmonauts. What kind of story is constructed by the cosmonaut photos in *Ogonyok*? I explore the construction of this story through individual narratives, one by one. From my examples is constructed an "average narrative" whose themes can be found, albeit with somewhat differing emphases, in almost any of the nine pictorial narratives that I analyze. After finding a recurrent theme, I compare it with the archive material: is the same theme or detail repeated there as well?

The photos construct a story of the arrival of the cosmonaut in Moscow, his preparation for the flight, his family, and his life before and after the flight. Only a few people were granted permission to visit the homes of the cosmonauts and they often became close to the photographers. The narrator's position is that of a co-experiencer, not an outside observer.

In the story of the cosmonaut hero, I have isolated ten recurring themes, following Propp's *functions*:

1. The hero arrives at Vnukovo airport.
2. The hero meets the Secretary General.
3. The hero continues in an honorary procession to Lenin's Tomb.
4. The hero meets a rejoicing crowd.
5. The hero receives a call from Secretary General.
6. The hero lives an ordinary life.
7. The hero's childhood.
8. The hero at home.
9. The hero has trials.
10. The hero's death.

Contrary to Propp's analysis, these ten functions do not follow a strict order. In fact, the whole story starts in a reverse way than Propp's analysis, which proceeds from the beginning to the end. In the individual narratives, the story of a cosmonaut was constructed backwards: the first photo of the new hero to be displayed in public followed the heroic deed. The events of the story were already in the past, and subsequent photos open like flashbacks to reveal the story of how the finale was reached. Each individual narrative includes, with the exception of the last function, all of the functions described above. The last one, the hero's death, was displayed only once. I will start my analysis by describing the return of the cosmonaut to Moscow.

The Hero's Homecoming

The public life of the cosmonaut began in a ceremony that took place on his arrival in Moscow, a celebratory return, the ritual homecoming of a hero. The ceremony started at Vnukovo. Before this, cosmonauts did not publically exist. Only those cosmonauts who had already flown were public figures, while those who were waiting to fly were still classified as state secrets. Vnukovo airport is seen in every photo story, not always as the opening image but usually among the first photos. **FIGURE 59** is a series of photos that runs across a double-page spread (*Ogonyok* 33/1961, photos: I. Tunkel and B. Kuzminin). At the top is a photo of a miniature-sized cosmonaut, Gherman Titov, walking the red carpet toward a podium. At the top of the stairs stands a man that is recognizable if one has seen many pictures of him: even in a thumbnail photo, the figure's

posture reveals him to be Khrushchev. In front of the podium stands an honor guard. Titov's steps are high and energetic, and the distance to the podium is long. He has arrived in an airplane, which is partially cropped out of the top of the photo. The photo has a lot of empty space. To the left of Titov as he walks is a marching band, and the bottom part of the photo is bordered by a crowd. The atmosphere is charged, as if people have stopped to hold their breath.

The other photos in the spread continue the story after the tension has lifted. We see how Titov meets his parents and continues his journey, snagged under Khrushchev's arm. Everyone is holding flowers and smiling. The last photo of the spread shows the rejoicing crowd. Someone is carrying a poster, an enlargement of a photo that is familiar to us (**FIGURES 6–13**). In one spread is presented a story about the arrival of the cosmonaut at the airport, his meeting with the Secretary General and his family, and the rejoicing crowd waiting for his arrival. This kind of a thematic photo spread is typical in the context of cosmonaut photos.

Vnukovo airport is depicted similarly in other stories. Recurring themes include the descent of the cosmonaut from the airplane, the rejoicing crowd, cosmonauts walking on the red carpet, and meeting Khrushchev and other members of the power elite. Once a certain theme was established, a mere hint about it would suffice: in August 1962, Andriyan Nikolayev and Pavel Popovich walking at the same time on the red carpet was depicted only in a very small photo (**FIGURE 60**). Shot over a wall of other photographers' backs, the main characters appear insignificantly small, figures walking "shoulder to shoulder along the legendary red carpet" (*Ogonyok* 35/1962, photos: L. Borodulin, G. Koposov, Yu. Krivonosov, S. Raskin, M. Skurihina, E. Haldei, I. Tunkel, V. Cheredintsev).

From Vnukovo airport, the journey of the cosmonauts continues in a motorcade. The procession is surrounded by motorcycles, and the road has been emptied of other vehicles. The roadsides are crowded with people. The roofs, pylons, and all possible vantages where one could catch a glimpse of the passing procession are swarming with photographers. The car of Andriyan Nikolayev and Pavel Popovich is festooned with garlands (**FIGURE 61**). They themselves are standing in a car, waving at the people on the side of the road. Seated in the back, an old and very small woman wearing a headscarf – most likely the mother of one of them – can hardly be seen among the flowers

(*Ogonyok* 35/1962, photos: L. Borodulin, G. Koposov, Yu. Krivonosov, S. Raskin, M. Skurihina, E. Haldei, I. Tunkel, V. Cheredintsev).

In the photo series published in conjunction with the flight of Valentina Tereshkova and Valery Bykovsky, the journey from the airplane to the motorcade is condensed into three photos in a single spread: in the first one, Tereshkova and Bykovsky have just stepped out of the airplane (**FIGURE 62**). Bykovsky has a uniform, Tereshkova a dark, well-fitting jacket suit and white high heels. In the second photo, they are adorned with flowers and waving, with Khrushchev between them. In the background are the leading figures of the Party (for example, Leonid Brezhnev, Alexei Kosygin, Anastas Mikoyan, and Otto Ville Kuusinen). Also in the background are some cosmonauts who have already flown, together with their families. With the exception of the cosmonauts in military attire, the men in the photo have bared their heads. The cosmonauts in the foreground look as stiff as dolls, their waves frozen. In the photo below, which was taken from a birds-eye perspective, is seen Red Square and the arrival of the motorcade at the bridge crossing the Moscow River. The whole bridge and the sidewalks preceding it are crowded with people, but the road has been emptied of other traffic. The caption between the photos declares this the "road to honor" (*Ogonyok* 27/1963, photos: G. Koposov, E. Umnov, A. Gostev, Yu. Krivonosov, B. Vdovenko, D. Ukhtomsky).

The ceremony climaxes at the arrival of the motorcade in Red Square. Now the crowd has grown enormous, filling the entire square. Flags fly. Crowds celebrating in Red Square or nearby is an oft-repeated theme in *Ogonyok*, not only in conjunction with the cosmonauts but with many different celebrations and parades. Sometimes the photo of the crowd is cropped in such a way that it seems to extend into the distance forever. Most often the crowd consists of young men and women. Another repeated theme is raised hands, with photos and text as signs carried by the celebrating people. In the photos are enlargements of the portraits of the cosmonauts and photos of Lenin, Khrushchev, and other political leaders. **FIGURE 63** is from Red Square (*Ogonyok* 27/1963, photos: G. Koposov, E. Umnov, A. Gostev, Yu. Krivonosov, B. Vdovenko, D. Ukhtomsky). The layout of the photo crosses over the spread, and its perspective crops the celebrating people at the bottom. The faces in the lowest row seem to be craning upwards. The effect is highlighted by a line of lifted hands. Into the center rise the signs carried by the crowd. To the left side of

the photo can be seen a poster of Valentina Tereshkova. Next to it is a sign that says "We love! We kiss! We are proud!" Painted on the sign is the Earth with a seagull flying over it. *Chaika*, or "seagull," was Tereshkova's call sign during her flight. The signs next to it have portraits of Khrushchev and the cosmonaut Valery Bykovsky. In the foreground is a portrait poster of Lenin, while in the background several flying flags can be seen, as well as some more photo posters. The crowd seems to continue into the distance. Flowers, balloons, and waving hands can also be seen in the photo. The photo posters look like as if they have been added later, and in addition some flowers have subsequently been inserted into the foreground.

The Tomb

After arriving at Red Square, Khrushchev, the celebrated cosmonauts with their families, and the cosmonauts who have already flown, along with their families, and other members of the entourage, climbed up to the roof of Lenin's Tomb. The more flights the Soviet Union had behind it, the greater the crowd at the Tomb. In **FIGURE 64**, from left to right, are the cosmonauts Pavel Popovich, Gherman Titov, Yuri Gagarin, Andriyan Nikolayev, Valentina Tereshkova, Nikita Khrushchev, and Valery Bykovsky. All are smiling and have lifted their joined hands above their heads. With the exception of Tereshkova, the cosmonauts are wearing uniforms – the first cosmonauts were test pilots for the Air Force, and they dressed in uniform at official events. "The Motherland celebrates its brave children" declares the caption between the photos (*Ogonyok* 27/1963, photos: G. Koposov, E. Umnov, A. Gostev, Yu. Krivonosov, B. Vdovenko, D. Ukhtomsky).

The Tomb was an important place in the homecoming ceremony of the cosmonauts, as it was the main stage of the homecoming. The ceremony continued in such a way that Khrushchev, cosmonauts, and possibly the others also gave speeches. The occasion could take hours (Abramov 2005: 233–235; Lane 1981: 210–212). Lenin's Tomb was the symbolic center of the Soviet Union, the sacred place, where the Soviet ideology inclined toward Marxism-Leninism found concrete form (Lane 1981: 210–212). The Tomb acted as the stage of all the most important state rituals: here, "in the presence of Lenin," pioneers were initiated and Mayday, as well as many other political occasions, was celebrated. On Victory Day of the Great Patriotic War (May 9), the armed forces floated in a

slow stream past the Tomb.[37] During the Cold War, the development of political relationships was interpreted on the basis of the order in which the members of the Politburo climbed up to the Tomb: who got to stand closest to the leader, and who had been dropped from the column? During weekends, a queue a hundred meters long meandered toward the door of the Tomb, as people sought to pay their respects to their embalmed leader. The cosmonauts also visited the Tomb before their departure in order to "ask for power from Lenin." This had to be done in secret, as nobody knew yet that they were future heroes.[38] Gagarin's official autobiography, as well as the booklet *The Soviet Pilot – The First Cosmonaut* (*Sovetskiy lyochik – pervyi kosmonavt*) published right after the flight, present a photo of Gagarin at Red Square "only a few hours before traveling to the launch site" (Gagarin 1961: 146–148; Murayev 1961: 11) [39] (**FIGURE 65**). The photo itself is so strongly retouched, however, that it could have been taken anywhere. Spasskaya Tower, seen in the background, looks like it was hand-painted into the picture.

The decision to put Lenin's embalmed body on display after his death was symbolically a meaningful deed. For Orthodox Russia, this naturally brought to mind the resurrection. The fact that Lenin could die and simultaneously remain living implied the possibility of a new kind of immortality in the post-Christian context. If Christianity emphasized the victory of spirit over death, with the help of science the Communist state could also have victory over physical death. Even before his death, serious illness had caused Lenin to withdraw from politics. This caused a situation in which an immortal Lenin – total, all-embracing, an eternal abstraction – came to replace the weak, human Vladimir Ilyich. This dualism transformed Lenin into an immortal as a political symbol (Starr 1978: 248–250; Tumarkin 1983: 133–165).

The previous chapter referred to Nikolai Fedorov, the unusual cosmic philosopher for whom victory over death was a concrete goal. Lenin's Tomb inevitably brings him to mind, even though the temporal context is different. The idea is not completely far-fetched. Here at Lenin's Tomb, after all, was crystallized the theme of death and resurrection that inspired Fedorov.

The building itself was designed by the architect Alexei Shchusev, but the interior bore the handwriting of another architect. Konstantin Melnikov had designed the sarcophagus wherein rested the embalmed body of Lenin. Melnikov was an original character in the field of Soviet architecture, a visionary and designer of architectural utopias that integrated all of the arts. What is

interesting for us is a small biographical detail: he was a loyal admirer of Fedorov (Starr 1978: 248). Could the homecoming ceremony of the cosmonauts be interpreted as some kind of variation of Fedorov's resurrection philosophy? In the context of his sarcophagus plan, Konstantin Melnikov himself had hinted at *Sleeping Tsarevna*, the Russian version of Sleeping Beauty. In the story, as everybody knows, the princess seems to be dead, but she is only sleeping in innocent beauty until the prince arrives and brings her back to life with his kiss (Starr 1978: 248–250). Could the cosmonauts be these princes? If we do not think about the resurrection of Lenin concretely, like the Fedorovians, the era *was* after all full of hope for his rediscovery. After the personal cult of Stalin, Lenin experienced a renaissance in the visual culture. The "return to Leninian principles" was an often-quoted sentence in an era trying to recover from Stalin's time (Buchli 1999: 138; Reid 1997: 179). In *Ogonyok* at the beginning of the 1960s, this was seen as a cornucopia of pictorial Lenin themes. The cosmonauts themselves can be interpreted as living proof that the utopia initiated by Lenin was finally coming true, that the new era had finally arrived.

In April 1961, when Yuri Gagarin climbed up to the top of the Tomb, not only Lenin was resting in "innocent beauty" below him but the embalmed body of Stalin also lay next to Lenin in a glass coffin. Understandably, the thought was unsettling to the leadership of a party seeking to dispense with Stalin's legacy. Half a year after Gagarin's flight, in the dark of night his body was hastily removed from the Tomb. Stalin was buried without ceremony in the wall of the Kremlin (Abramov 2005: 135–142; KPSS *v rezoliutsiiakh* VIII, 173–325). In his poem "The Heirs of Stalin" (1962), Yevgeny Yevtushenko describes this night operation thus:

> Mute was the marble. Mutely glimmered the glass.
> Mute stood the sentries, bronzed by the breeze.
> Thin wisps of smoke curled over the coffin.
> And breath seeped through the chinks
> as they bore him out the mausoleum doors.
> Slowly the coffin floated, grazing the fixed bayonets.
> He also was mute – his embalmed fists,
> just pretending to be dead, he watched from inside [...]
> (Yevtushenko 1962)[40]

It is unlikely that the reformists of Khrushchev's time knew of Fedorov's philosophy, as he was such a marginal figure even during his lifetime. However, it is possible to also find death-defying ideas by Tsiolkovsky:

> Death therefore is simply one of the illusions of the weak human mind. Death does not exist [...]. The universe is constructed in such a way that not only is it itself immortal, but also all its parts, in the form of living, blessed beings. (Tsiolkovsky 1928, cited by Hagemeister 1997: 198)

Similar ideas can also be found in the ideological textbook *Fundamentals of Marxism-Leninism (Osnovy marksizma-leninizma)*, which is an introduction to a society at the threshold of Communism. The Fedorovian resurrection fantasy comes to life in the last pages of the book, where the future Communist society is described. Through the methods of science "the average length of life could be increased 150–200 years, dead people could be reanimated, [...] and it is possible to learn to resurrect someone, if chance has caused a premature death" (*Fundamentals of Marxism-Leninism* 1961: 876; Vihavainen 2003: 30). Science had replaced the mystical philosophy of Fedorov, such that in Communism resurrection could be possible. "And I, appealing to our government, petition them to double, and treble, the sentries guarding this slab, and stop Stalin from ever rising again and, with Stalin, the past" (Yevtushenko 1962).

From the Tomb, the cosmonauts continued celebrating in the evening in the ballroom of the great Kremlin palace. Here they were decorated with a medal of Hero of the Soviet Union. That five-pointed star is seen, for example, in **FIGURE 65** on the lapels of Gagarin, Popovich, Titov, and Nikolayev. All of the cosmonauts to visit space received this honorary title. In **FIGURE 66**, "the Chairman of the Council of Ministers Leonid Brezhnev pins Lenin's medal (*Orden Lenina*) and the golden star of the Hero of the Soviet Union to the lapel of the pilot-cosmonaut Gherman Titov."[41]

The Jubilant Crowd

The ceremony at the Tomb was the final culmination of the journey. In fact, it was not just a festive ceremony, but a powerful ritual in which the status of the cosmonaut was transformed from that of an ordinary person into that of

a hero. The cosmonaut rose from anonymity to a hero of the people. Such a rise in status could not happen by itself; the transformative power of ritual was needed as well. Rituals like this, as "rites of passage," are often connected with moments of transition to different points of life (for instance, birth, puberty, and death), but they can also be linked to a rise in social status. The rite of passage is usually divided into three phases: separation from community, transition, and reincorporation back into the community. The first one, separation from community, refers to the separation of the object of the ritual from his old location in the social structure. In the second phase of transition (the liminal phase), he is between two spaces: he has been separated from the community, but not yet reincorporated back into it. In the third phase, the object of the ritual is taken back into being a member of the community. He is now expected to behave according to the established norms and ethical rules held by the bearers of certain positions (in systems that maintain such positions) (Turner [1968] 1997; van Gennep [1908] 1960).

Ritual actors have carefully specified acts and locations. Photos from Vnukovo airport present the most important actors of this ritual: the cosmonaut who was the candidate-to-be transitioned from one position to another; his or her family, whose presence was obligatory for the ritual; Khrushchev and the other power elite, who held in their hands the power to legitimate the ritual; and the bystanders. In **FIGURE 62**, made possible probably by a montage, the power elite are gathered around the cosmonauts. There is no caption in the photo, as those photographed were so clearly familiar to their contemporaries. They *had to be* present, even though the clumsiness of the montage makes one suspect that at least some of them were elsewhere when the photo was shot. For the realization of the ritual, it was mandatory to have people gathered in the photo. The cosmonauts are waving at a crowd that cannot be seen in the picture. That crowd is apparently so important that it almost steals the spotlight from the celebrated heroes themselves. In the photo, they represent the community that the photo-viewing reader of the magazine also belongs to. The ritual took place before the eyes of the community, without which the ritual would not have had any power.

Elements of this homecoming ritual had existed even before space flight. The ritual had its model in the past. One much celebrated media event in *Ogonyok* in the 1930s was the rescue operation of the Arctic expedition Chelyuskin,

which was mapping the Northern Sea Route. The steamship SS Chelyuskin was looking for an open passage in the Northern Sea from Murmansk to Vladivostok when in February 1934 it got stuck in the ice and sank in the Arctic Ocean. To rescue the expedition, an enormous flight operation was organized. The director of the expedition, Otto Schmidt, and the seven pilots that participated in the rescue became national heroes. The first honorary titles of Hero of the Soviet Union were given to the pilots that belonged to the rescue expedition. One of them, Nikolai Kamanin[42], later played an important role in the education of the cosmonauts (Lewis 2008: 115; McCannon 1997: 346–365).

The arrival in Moscow of the Chelyuskin expedition and their rescuers was an occasion that was reported in the media in an unprecedented way. This media event also acted as a model for portrayals of the homecoming celebration of the cosmonauts later on: in the same way as the aforementioned homecoming photos of the cosmonauts, *Ogonyok* showed crowds welcoming the Arctic expedition with posters and flowers, a motorcade, and Stalin standing on the Tomb (for example, see *Ogonyok* 8/1934: 7, photo: Shrivinsky; *Ogonyok* 9–10/193, cover photo: B. Ivanitsky; *Ogonyok* 12/1934, cover photo: A. Shaikhet). In 1936 as well, the fictional space travelers – three brave visitors to the Moon in the film *Cosmic Voyage* (*Kosmicheskiy reys*) by Vasili Zhuravlov – were welcomed with flower bouquets and photo posters, just like their future colleagues (Zhuravlov 1936).

In the context of photographed celebrations, the carrying of photo posters and flags has been common among revolutionary movements around the world. In Soviet celebration parades can be found elements of Orthodox Christian processions of the cross and military parades from the time of the Czar. The syncretistic mixing of new and old ritual elements in the Soviet Union was not limited to processions only. Soviet power repurposed holidays linked to the Christian tradition, as well as other calendrical rituals and transition rituals linked to age and life stages, to its own calendar in a flexible way (Lane 1981: 229–238; Petrone 2000: 24–25). Eric Hobsbawm has talked about "invented traditions," meaning top-down, institutional rituals that legitimate the exercise of power (Hobsbawm and Ranger 1983: 1–11). In a similar fashion, Karen Petrone (2000: 46–47) has seen media events linked to early expedition heroes and pilots in terms of nation-building, as the process of creation of a so-called imaginary community.

Interpreting Soviet traditions as invented traditions, following Hobsbawm, seems to be natural, and it has been done extensively (e.g., Bonnell 1997: 1–22; Petrone 2000: 11). This perspective has also been criticized. Hobsbawm's approach is based on the assumption that behind ritual behavior can be found a correct and pure reality, with which the validity of the ritual or the media description can be compared. What would a *valid* ritual be? Even the Christian rituals replaced by the Bolsheviks were transformations of rituals linked to folk traditions. Determining the history of a ritual's birth is an interesting starting point, but disclosing that a ritual is invented does not explain its power. (For critiques of Hobsbawm, see Friedman 1992: 837–859; Thomas 1992: 213–232.)

David Carr (1986: 123–177) has studied the way in which the community is talked about as an acting subject. According to Carr, we talk about our community as a sort of a plural doer; when an individual speaks of "us," he is identifying himself with a group. This *we* is not just "me" on a large scale, but an actual plural subject, and it forms a unity that the members of the community create from within. Carr emphasizes that the community doesn't have just one big story, not even in a totalitarian society. The story the community has told itself is in constant movement, and its existence depends on its repeated performance. According to Carr, the only requirement for the story creating a community is that the members of the community recognize the story and are aware of the other members of the group. In this way, the story about *us* constantly creates a new biography for the community. The *we* in the story not only refers to members of the group presented in the same historical time: historiography is also part of the storytelling process that creates the community (see also White 1973: 1–6).

The story of the cosmonauts spread through newspapers, radio, films, and magazines. Photos can be interpreted as constructing the idea of a common nation rejoicing together. Nick Couldry has talked about media rituals, meaning these kinds of communal spaces built through media. According to Couldry, media deliberately creates a picture of itself as the center of communality (Couldry 2003: 2). Newspapers (television, radio, films) enable the idea of a uniform nation, the idea of millions of other readers in common and people experiencing at the same time; through it, endlessly, the national identity is recreated and reconfirmed (Anderson 1983: 5–36).

Photos of people listening together to the radio, watching television, or reading the same newspaper strongly advanced this kind of image (e.g.,

Bashkatov and Samelyak in *Ogonyok* 40/1962) (**FIGURES 9, 11 AND 67**). *Ogonyok* even photographed the beloved radio announcer Yuri Levitan in the recording studio reading the news about Gagarin's flight (**FIGURE 68**). Levitan's deep voice saying "Attention, Moscow is speaking" (*Vnimanie, Govorit Moskva*) had shared the news about the onset of the Great Patriotic War and its conclusion with the death of Stalin.

A Call from the Secretary General

Each of the first homecoming stories included an unusual photo. This photo – of a cosmonaut talking on the phone – is not directly related to ritual itself, but is clearly important in terms of the topic, as it is not missing from any of the initial stories. When I first saw this type of photo, I didn't pay much attention to it. When that same detail of a phone receiver at the cosmonaut's ear was repeated time and time again, in the archive as well as in the biographies of the cosmonauts (**FIGURES 69 AND 70**), I realized that the telephone was somehow significant as an object. All of the first cosmonauts were pictured in *Ogonyok* talking over the phone right after their ascent (*Ogonyok* 17/1961; 33/1961; 34/1962; 26/1963).

Who were they talking with? It was not just any call, but a phone call from Nikita Khrushchev. In **FIGURE 71**, it can be seen how *Ogonyok* combined two phone photos – one of the Secretary General and, in this case, one of the cosmonaut Titov – thus showcasing the parties of the conversation. The same occurred in the context of Gagarin, Nikolayev, and Popovich (**FIGURE 72**), but in a photo that filled the entire spread. Tereshkova and Bykovsky (**FIGURE 73**) speak without any direct reference to the Secretary General. It was no longer necessary, as the reader could connect the photo to the recurring event. "We have landed! Everything is okay!" exclaims the title below the photos.

The situations depicted in the photos have most likely been photographed right after the flight. For example, in the photo where Gherman Titov speaks on the phone (**FIGURE 71**), he is dressed in overalls with suspenders crossing over his chest. His hair is messed up and faint stubble can be seen covering his face. The unkempt look of the cosmonaut in the photo is intentional: the photo makes the viewer understand that Titov has rushed to directly update Khrushchev the first thing after landing, before changing his clothes or cleaning

up. Titov's flight lasted over 24 hours, which explains his run-down look. His hair is hanging loose, as if the space helmet has just been taken off. The photo is telling us that Khrushchev is brought up to speed right away, he immediately knows what is going on, and he is completely involved. The telephone is not, after all, an unimportant detail, but a symbol of power. Even on first glance of the cosmonaut, one understands that he is a hero – he is speaking with the Secretary General himself. Secondly, the telephone integrates Khrushchev, even though he is not physically present in the picture. Thus, the Secretary General is an active participant in a historical event. By telephone, he plays a role and he has power over the course of events. Khrushchev even speaks directly into outer space with Tereshkova and Bykovsky. In the first photo, he is between Mikoyan and Brezhnev, clearly in some sort of press conference. Khrushchev is dressed in a dark suit, and in front of him are three microphones. Sitting to the right, Brezhnev is holding a white telephone with a smile. In front of him is another telephone. Mikoyan is also smiling, and he is leaning towards Khrushchev (*Ogonyok* 26/1963, cover photo: A. Ustinov). In the other photo, Khrushchev is only in the company of Brezhnev, talking now directly to the flight with Bykovsky. In the upper corners of the spread are also out-of-focus photos of Tereshkova and Bykovsky's faces: "The new term cosmovision has appeared – television broadcast from space. Millions of viewers have seen Valya Tereshkova [...] but on this screen is the pilot and cosmonaut Valery Bykovsky, the commander of the spaceship Vostok-5" (*Ogonyok* 26/1963: 12–13, photos: S. Baranov, V. Zhikharenko, S. Korshunov, T. Melnik, V. Sobolev). Television broadcasts straight from space, telephone calls between outer space and Earth – no wonder that Khrushchev is smiling in the photo. Aside from commenting on power relations, the telephone had a role in emphasizing advanced technological know-how. With the telephone, the Secretary General could directly contact outer space, even though literally and physically he was not there. And photos bear witness to this event.

Suddenly the phone calls came to an end. On October 12, 1964, Boris Yegorov, Vladimir Komarov, and Konstantin Feoktistov started their journey in the ship Voskhod 1. The ship itself was a small technical wonder. Instead of one cosmonaut, no less than three were squeezed into it, and two of them were something else than pilots by education: Yegorov was a doctor and Feoktistov was an engineer. It was estimated that the journey would last about a week.

Due to lack of space, the spacesuits and ejection seats had to be left out, which led to new kinds of requirements for the safety of the capsule itself. Or it would have, if the designers – of whom the engineer Feoktistov was himself one – had had a bit more time to focus on safety details. The design of the ship had taken place in the usual hurry, after Khrushchev demanded an impressive new record. Because of the rush, safety details were ignored and the capsule was sent into space, where the three men were tightly crammed together like sardines without any possibility of escape or being able to rescue themselves, should there be any problems during the flight or during the descent (Harford 1997: 180–182).

While the cosmonauts were in orbit, back on Earth the political direction of the Soviet Union had changed. The discussion between Khrushchev and the flight crew was broadcast as usual. Soon after this discussion, however, Khrushchev was called to the Kremlin, where he was quickly and rudely removed from power (Kamanin 1964; Taubman 2003: 3–17). Working in space, the cosmonauts could not foresee any of this, and they were extremely surprised when Korolev ordered that the flight be interrupted only 24 hours after the launch. Nor did they understand why Khrushchev did not make his usual congratulatory phone call after their successful descent (Kamanin 1964). Five days later, *Ogonyok* published the resignation of Khrushchev after it was already public. Or not quite: The TASS bulletin, published on the first page of the magazine, informed that the new Secretary General was Leonid Brezhnev and the Chairman of the Council of Ministers was Alexei Kosygin. However, there is not a single word about Khrushchev in the bulletin. He did not exist anymore in the public media.

There was also political cleaning of the archive at some point: for FIGURE 74, there is the index card of the familiar phone call photo. Originally the card read: "G.S. Titov gives a report about the completed mission to N. S. Khrushchev." At some point, the archivist had crossed out "to N.S. Khrushchev." The photo itself was still usable, and only that reference to the ex-Secretary General had become awkward. After October 1964, not a single photo was published of Khrushchev. He had become persona non grata, and he disappeared from all visual presentations.

A new era began under the guidance of Leonid Brezhnev. Within the timeframe of this research, the phone receiver is not seen in his hand in *Ogonyok*; it was left out of the story. Later on, the era of Brezhnev would be talked

about as the "era of stagnation." Many reforms that had started during the time of Khrushchev slowly faded away, and a reversal of cultural life was clearer in some respects. This cannot be noticed in *Ogonyok* at the end of the 1960s. The changes took place slowly.

A COMPLETELY ORDINARY HERO

CHAPTER 5

And what do you yourself find most difficult?
Gagarin: Fame

(Golovanov 1978: 183)

A fter seeing countless photos of the cosmonauts' homecoming, I got hold of a film depicting the event. The film *The First Journey Towards the Stars* (*Pervyi reys k zvezdam*, 1961) shows Yuri Gagarin's arrival in Moscow at Vnukovo airport. The situation is the same as in the aforementioned photos: the crowd is standing on the edge of the airfield, surrounding an open expanse where a red carpet has been spread. The cosmonaut hero walks along the seemingly endless carpet toward the leaders of the Party and Nikita Khrushchev, who is waiting with open arms. In one respect, the film shows more than the photos taken of the event. The angle of view reveals a surprising detail: it can be clearly noted in the film that while he is walking along the red carpet the cosmonaut's shoelaces are untied! In the homecoming party, the hero brought before the people is presented as anything but a clumsy lout tripping on his shoelaces, and none of the photo stories of *Ogonyok* reveal this sort of detail. In the photo in which Gagarin comes down from the plane, the shoes are cropped behind the staircase (*Ogonyok* 17/1961:2, photo: D. Baltermants, A. Bochinin, Yu. Krivonosov, A. Novikov, M. Savin, I. Tunkel). There was not a single photo found in the archive in which the shoelaces were not retouched or cropped out. The unwanted detail was easy to touch up in photographs, unlike the film. The untied shoelaces seem to be such an embarrassing blunder from a current perspective that one might wonder if the film-makers would have edited the film excerpt in a different way if the detail had been noticed. Was it just a mistake, a detail that was accidently left in the film?

Devil in the Detail?

Can such a small mistake contribute toward analysis and open new perspectives? Focusing on this kind of meaningless detail, I follow the counsel of a

venerable authority: the master detective Sherlock Holmes, created by Arthur Conan Doyle, advised his assistant Watson thus:

> Not invisible but unnoticed, Watson. You did not know where to look, and so you missed all that was important. I can never bring you to realise the importance of sleeves … or the great importance that may *hang from a bootlace* [43] (Doyle [1892] 2006: 72–73).

Through this advice, Holmes highlights the importance of even the smallest details.

Here my perspective comes close to the micro-historical approach of the Italian Carlo Ginzburg (1996). Ginzburg developed the so-called "clue method" on the basis of the systematic research method, aiming at the scientific accuracy of the Italian doctor and art researcher Giovanni Morelli (1816–1891). For Ginzburg, apparently meaningless details act as hints and clues that direct interpretation. The method resembles the work of a detective, where a researcher ends up with results based on clues that for others are meaningless, in the same way as the detective Sherlock Holmes, to whom Ginzburg repeatedly refers (Ginzburg 1996: 38).

In a photo, a detail is thematized in a completely different way than in a painting. The details of a documentary photo or film seem to be especially unintentional, having randomly become subjects of the image. Roland Barthes has reflected on the relationship between a photograph and a detail in his posthumously published book *La chambre Claire* (1980, in Finnish: *Valoisa huone* 1985). In this much cited book, Barthes introduces the concept of *punctum*. The punctum is something personal for Barthes, (often) a detail in a photo that catches the eye in such a way that it cannot go unnoticed, even to that extent that it comes to define the interpretation of the entire photo (Barthes 1985: 32). Barthes stresses the randomness and unintentionality of the punctum. At first glance, the shoelace seems to be an unintentional detail, like the punctum, that has slipped into the photo, bypassing the given meaning. However, it was anything but.

I would be willing to admit that the detail was a mistake, sloppiness on the part of the censor, had the system of secrecy not been so meticulous in relation to the cosmonauts. They were the morally exemplary citizens and the public image matched that. Control at the detail level was focused on all pub-

lic photos or texts that the cosmonauts were even indirectly connected with. A good example of control extending into small details is the popular song "Fourteen Minutes to Go" (*Tsetyrnadtsat minut do starta*), whose lyrics were written by Vladimir Voinovich (the melody by Oscar Feltsman). In 1962, a section was censored from the lyrics of the song, where it says: "Boys, let's smoke a cigarette before the launch, we still have 14 minutes to go." Smoking was changed into singing a song ("Boys, let's sing…") because cosmonauts did not officially smoke (Rogatchevski 2011: 263). Aside from training perfect space pilots, the cosmonaut program was also aimed at molding polished public performers. If one failed at this, there was a risk of expulsion from the program. In conjunction with the training, the cosmonauts toured museums and cultural events, and they trained at giving speeches and in fluent discussion skills. All this was necessary. From 1961 to 1970, the cosmonauts who passed the training would participate in over 6000 public events and make over 200 trips abroad (Burgess and Hall 2009: 179–186; Kamanin 1964; Gerovitch 2007: 150; 2015: 411). If we add to this the eagle-eyed censorship machine, it feels most unlikely that the shoelaces would have been accidentally left in the finished film, even though it was almost impossible to retouch film with 1960s techniques. Before its release, the film went through many different stages of review, and it is implausible that the detail would have made it unnoticed through the sieve of the censors. Somebody made the decision to leave the detail in the film, and this decision was upheld through all the different phases of censorship. What is significant is not whether the shoelaces being untied was a mistake, but that this mistake was purposefully left in the film rather than being cut out.

The exceptionality of the shoelace detail is underscored when it is examined against the background of imagery surrounding the hero in the Soviet Union. One of the most important goals of the Third Party Program was to create a new man (*novyi chelovek*). During the transition era to Communism, "there were increasingly more opportunities to raise a well-balanced, mentally rich, morally clean and physically perfect new man" (*Programma* KPSS 1961: 121). The cosmonauts were described in exactly these terms as ideal men, both physically and mentally, the cosmonauts strove for perfect performance: lifting weights, cycling, performing acrobatics, and diving. In texts, they are also described as being athletic:

[…] even as a child, Titov became interested in flying […] The boy knew that a pilot has to be strong, persistent and tough, and therefore he never missed a single sport session or competition […] At military school, he also became interested in gymnastics, which is very important for a pilot, and he trained to be quite good at it. He often performed acrobatics with his friends at the comrades' evening parties […] Later on, Titov also became excited about diving as a hobby. Even the first time, he succeeded so well that his gymnastics teacher admired him […] (Gavrilin 1961: 31)

In particular, the archive catalog shows cosmonauts enthusiastically training in different ways. In these photos, the cosmonauts training bare-chested resemble the visual ideal of Socialist realism, particularly its idea of a *positive hero*. Since the 1930s positive hero had been serving as an example of both morally and physically a perfect human being. The hero had to be recognizable from real life, but at the same time serve as a prototypical example of the mental characteristics and physical attributes that were aspired to. Positive heroes were healthy, young men and women radiating *joie de vivre*. (Bown 1998: 166–175). A typical example of the positive hero of the era was the Stakhanovite worker figure, the representative of a movement named after the miner Alexei Stakhanov (1906–1977), who broke all records of productivity and urged for bigger and greater achievements in every aspect of production. In photographs we can see that also cosmonaut bodies are top-notch and perfectly perform the demanded task. Training, competing, and striving toward ever more perfect performance produced visible joy (**FIGURES 75 AND 76**). Nudity was rare in the (publicly accepted) visual culture of the Soviet Union, but exposing the upper body had been part of the iconography connected with the model of the male worker since even before the Revolution (Hobsbawm 1978: 127–128). Tereshkova also trained in a tracksuit with strange-looking devices, playing ball, laughing and completing tasks, concentrated with headphones on her ears, next to Gagarin. The catalog conveys that training to become a cosmonaut not only demanded physical perfection, but also required concentration and intelligence.

In this context, the untied shoelaces seem inappropriate. In their awkwardness, they suggest a humorous antihero rather than a national hero. Even though humor has a meaningful role in the hero tradition of different subcultures, combining laughter with the humor is generally difficult. At least unin-

tentional comedy does not suit the hero (Kemppainen and Peltonen 2011: 22). Perhaps the role of the new man, striving for perfection, was not self-evident for a cosmonaut? Perhaps the narrative did not seek to construct a picture of a perfect hero after all.

The Hero as an Everyman

Who is this person? What distinguishes him from the rest of us, or does anything differentiate him? After all, in the photos he looks like an ordinary guy, a war pilot – we are used to seeing his type in the streets of our hometown and in the parades of Red Square. Certainly something must single him out, as he has executed a historic, epic assignment. He was chosen for it. We talk about him: "simple, ordinary." Why just him, and no one else? (Alexeyev 1961: 30–31)

In order to grasp the possible meaning of the shoelaces, they have to be examined in a context that gives room to interpret the heroism of the cosmonaut more freely. When one tracks *Ogonyok*'s pictorial articles on the homecoming celebration, one may notice that the glossy iconic picture of a perfect hero actually changes. The uniformed figure stiffly waving at the Tomb acquires other symbolic interpretations along the way. In the *Ogonyok* pictures, cosmonauts can be seen lifting weights, but the hero striving for perfection is not the primary object of the shoot.

In addition to muscular cosmonauts training bare-chested, another kind of reality can be concluded from the training photos. In the photos, the cosmonauts spend time together, offering a shoulder to cry on, laughing and working together, putting their spacesuits on together. The training program shows friendly camaraderie, with cosmonauts engaging in all kinds of activities without any hierarchy. For instance, **FIGURE 77** reveals how the cosmonaut Gherman Titov assists in the fitting of Tereshkova's spacesuit. In general, the milieu of the photo is mundane: patterned wallpaper and lace curtains bring a special homey feeling to the moment, far from the hermetic conditions of the laboratory. The photo is from the archive, and I do not know whether it was published as such. Another photo, emphasizing home in a similar way, shows the cosmonaut Alexei Leonov concentrating on painting a typical U.S.S.R. logo on the front of his helmet (**FIGURE 78**). If the photo is compared to pictures

with a retouched helmet (**FIGURES 3 AND 4**), it seems an unusual fabrication. The photo conveys the sense of a kind of handyman-cosmonaut, who even takes care of fine-tuning the equipment. When browsing through the file cards, I almost started to expect to see a photo of a cosmonaut fixing his spacesuit with a needle and thread.

The leisure time of the cosmonauts was also depicted as being modest. In **FIGURE 79**, three men are pushing a car to the side of the road on a beach. The men are in short sleeves. There are a few trees on the beach and the road looks dusty. In the photo is Yuri Gagarin with his brothers and friends, a *kompaniia*, group of friends. They are on their way to fish, but "sometimes a fishing trip is more difficult than the journey to space" In the photo next to the article, Gagarin is laughing, showing the catch. The photo has been taken from the bank. He is without a shirt, in the reeds next to a small rowing boat. "This will make good fish soup – cosmic!" In the third photo, the men are already cooking the soup. Gagarin holds a big fish over a pot above a small campfire, stirring the soup at the same time. "Fish soup chef – the new specialization of a cosmonaut." Two men are intensely engaged in making the soup, gesturing with their hands and – this can be imagined in such a situation – giving loud instructions. As for the third man, it is only possible to see the back of his head. His hair looks wet, as if maybe he has been swimming? In the background is seen the front of a tractor or another sort of work vehicle. We are in the countryside (*Ogonyok* 27/1961: 20–21, photos: D. Sashin). The photos are part of a small article that describes the cosmonaut Gagarin's trip to his hometown of Gzhatsk (later Gagarin). In another context, Boris Yegorov is standing in the subway, holding a magazine. "Boris Yegorov will soon have to change his mode of transport ..." (*Ogonyok* 43/1964: 6, photos: Cheredintsev and APN) (**FIGURE 80**). He can still take the subway, just like any other anonymous person living in Moscow. In the third context, the neighbors Leonov and Gagarin are looking at hunting equipment. Gagarin is photographing his family on the couch. The children are running wild with the cosmonaut on the living room rug. Life appears to be happy, spending time together with the family and the neighbors (Golikov 1968: 31–34, photo: D. Ukhtomsky). And again, the cosmonaut Yevgeny Khrunov is squatting by the campfire (**FIGURE 81**). "Yevgeny Khrunov's specialty is shashlik," says the caption (*Ogonyok* 4/1969: 31, photos: V. Cheredintsev, A. Monkletsov). Khrunov is seasoning the skewers

frying on the campfire, and his position looks uncomfortable. The campfire is smoking and there are trees around – it seems that the photo is from a trip to the woods. The other cosmonauts also enjoy the forest: Titov and his wife squat with a basket "on one summer day" (Petrushenko 1961: 12), while Gagarin and Leonov laugh and hang a catch "after a successful hunting trip" (Cherenov 1965: 26). The photos underline the down-to-earth attitude that the cosmonauts have about their old haunts. Even though they are celebrated heroes, they fish like before, they make trips to the woods, and they take the subway. Even cars can break down beneath a hero. In the article telling about Gagarin's fishing trip, the car is not separately mentioned, but the model was the GAZ-12 ZIM limousine, a car that only top-ranking citizens could drive. This is something that a contemporary viewer would notice on first glance. In this way, both features are connected with the cosmonaut hero at the same time: he is totally ordinary, just like anybody else, yet he is still a member of the elite.

> [...] I still actually have difficulties remembering any aspects of Yuri's life that could be called unusual, exciting or sensational as far as journalists might be concerned. His life and studies were identical to the lives and studies of thousands of Soviet people. His biography closely resembles the biographies of comrades of the same age group, like a water drop resembles another water drop. (Kachosvily 1961: 10)

How are the shoelaces to be read in this context? At first glance, they really seem surprising. After all, the cosmonaut was a figure who commented on the on-going construction of Communism, and embodied in him was the man of the future. Were the open shoelaces an error, a random slip of the propaganda machine? Was it possible that the pervasive and eagle-eyed censorship machine had made a mistake?

While I am writing this analysis, I find a text that reinforces the assumption that untied shoelaces were not the type of mistake that purposefully needed to be completely hidden. In Gagarin's autobiography, which was published shortly after the flight, there is a chapter that confirms my suspicion. In the chapter, Yuri Gagarin describes his feelings at Vnukovo airport while he was walking on the red carpet. "One had to go and go alone. And I went. I had never, not even on the spaceship, been as nervous as now. The carpet felt very

long. As I was walking it, I gradually calmed down. I walked along, past the lenses of the television, film, and photo cameras. I knew that everybody was looking at me. Suddenly I felt something that the others did not notice – my shoelaces had become untied. What if I stepped on them and I fell on the red carpet in front of all the people? That would be really embarrassing. The people would laugh – "he did not fall from space, but instead tripped on flat ground ..." (Gagarin 1961: 180–182). [44]

The shoelaces becoming untied was certainly a mistake, but leaving the detail in the film was not. The untied shoelaces were an episode, yet a happy slip that was taken as part of the story. Through the shoelaces, Gagarin's humanity, ordinariness, and fallibility were emphasized. This same story of a human man able to err was depicted by the other photos presented earlier. The figure was given human form – a man laughing on the floor with his child could just as well also leave his shoelaces untied. Without this person fumbling with his shoelaces, the picture of the cosmonaut would have remained monotonous and boring.

The shoelaces did not arise as a personal experience, like a punctum for Barthes, which would have arrested me in some kind of psycho-aesthetic moment. Instead, that strange detail got me searching for an answer for its existence. The shoelaces were extraneous information, an aberrant detail on the side, which led to reflection on the whole set of images from another perspective.

Later I would find the scene of Gagarin arriving at Vnukovo airport in another film from the end of the 1960s (Barashev, 1969). The scene has been edited. The detail that was cut out was not the cosmonaut's untied shoelaces – they are still in the film – but Secretary General Khrushchev, who was waiting for Gagarin. After walking the red carpet, nobody is there to welcome the cosmonaut or take him into an embrace, and the report of the flight's success echoes in empty air.

THE HOUSEBROKEN HERO

CHAPTER 6

*You Americans expect that
the Soviet people will be amazed.
It is not so. We have all these
things in our new flats.*[45]

(Khrushchev, to Nixon, 1959)

The depiction that followed the ritual of the homecoming concentrated on the family circle of the cosmonauts. This was new. During the Stalin era, the long-haul pilots and other heroes who returned from beyond the border were greeted with welcome ceremonies resembling the ritual described above, but putting focus on the hero's own family was rare. In the 1930s, long-distance flights and flights to Arctic areas were a source of serious competition between the United States and the Soviet Union. Whereas the pilot heroes of the United States were lone rangers, Stalin's pilots were seen as his own sons, the children of the common Soviet family (Bailes 1978: 391; Clark 2000c: 785–795; Lewis 2008: 73). A primary family connection was formed between Stalin and these sons and daughters who returned from afar (Haynes 2003: 52; Petrone 2000: 54).

In previous decades, great effort had been made to break the traditional family concept. The early Bolsheviks had viewed the closed family unit as harmful to the development of an ideal society, and the petit bourgeois family idyll had not belonged to the Soviet utopia of that period. To be able to grow and develop on a mass scale, the new people had to be educated in a communal way, not in the middle of a family or community of extended family (Naiman 1997: 87–88).

The Stalin era brought back the family as the basic unit of the society. The laws concerning marriage and sexual health in 1936 and 1944 emphasized the significance of family. A middle class had already started to form in Stalin's time. Photos that highlighted fatherhood were sometimes linked to the heroes of that era. In July 1937, for example, *Ogonyok* presented a new pilot hero, Valery Chkalov, on a sofa with his children (*Ogonyok* 18/1937, cover photo: S. Strunnikov). Chkalov was a comparable figure to Gagarin, having earned a hero's renown after flying to Kamchatka in 1936 and Vancouver in 1937 (Geldern and Stites 1995: 260–266; Kalatozov 1941; Papanin 1981: 59–60). However, this type of imagery in the context of the heroes of the 1930s was an

exception. The majority of the photos concentrated on posed portraits, showing the activities themselves and introducing the flight equipment (for instance, *Ogonyok* 8/1934, cover; 19/1937, cover). The heroes of the 1930s were markedly boys, not fathers. They were forever young, while fatherhood, maturity, and authority were reserved for Stalin. The period stressed "the great Soviet family" over the private family. The Russian word *rodina* ("motherland," literally "birth land") strongly emphasized the Soviet Union as the mother of its citizens. The *rodina* was the great female lap and Stalin the father of the great Soviet family (Dunham 1976; Field 2004: 96; Haynes 2003: 51–53; Petrone 2000: 10, 54).

Mothers and Sons

Emphasis was put on photographing the cosmonauts as members of their family. First and foremost, this family was their childhood family. In August 1962, the front cover of *Ogonyok* showed the new cosmonauts Nikolayev and Popovich (**FIGURE 82**). The front cover was constructed in such a way that the top left is a partial close-up of Nikolayev in a military shirt. He gazes to the upper right with a serious look on his face. In the adjacent photo is a smiling old woman, his mother. The mother is picking apples in the garden with a floral shirt and light-colored scarf on her head. In the bottom left is Popovich in a partial close-up as well, looking at the camera and smiling. Next to this is also a photo of his mother with a scarf on her head, concentrating on her handwork. The cover exclaims "The motherland embraces you!" (*Ogonyok* 34/1962). The mothers have also made their way into the inside pages of the magazine. A thematic photo spread belonging to the article "Hawks fly high!" introduces Nikolayev's childhood family. The largest photo is a close-up of the old mother's face. She is smiling with a patterned scarf on her head. In other photos, Nikolayev is posing in military attire next to his brother, a young pilot trainee, with their father in Moscow. Nikolayev's old teacher has also gotten his picture in the magazine (Golikov 1962: 223, photos: Krivonosov). At the end of the magazine is a spread of thirteen photos titled "Far from the anxiety of the launch" that presents the everyday life of the cosmonaut duo (*Ogonyok* 34/1962: 223, 301) (**FIGURE 83**). In the upper part of the spread are six photos: Nikolayev is bent over flowers, fishing without a shirt, admiring ears of corn in a field, and again with his mother, looking small and timid next to her

uniformed son. Why is the son wearing a uniform in the field? The caption is poetic: "Here is your birthplace, Chuvashia,[46] the land where you took your life's first steps. Beside you is your mother, who gave you this life." Another caption continues. Nikolayev is reading at home: "One can rest like this ...," "... or like this," as he is climbing down a steep wall without a shirt and in bare feet (photos: V. Bazanov, Vera Zhiharenka, G. Omelchuk, B. Smirnov, and APN). In the next issue as well (*Ogonyok* 35/1962), the mothers of the cosmonauts go arm in arm with Khrushchev to the Tomb to wave. How small and elderly they look like in their peasant women's scarves (photos: L. Borodulin, G. Koslov, Yu. Krivonosov, S. Raskin, M. Skurihin, E. Haldei, I. Tunkel, V. Cheredintsev).

Nikolayev's performance, especially in the corn field, was not a coincidence. Corn cultivation was a favorite of Khrushchev, who was reforming agriculture, and he himself was often seen posing with corn on the cob. While visiting the United States, Khrushchev was impressed with the possibilities of corn culti-vation, and it formed the basis of his plans to aggressively reform agriculture (Belin 1991; Khrushchev 1961b: 214–223; Taubman 2003: 371–374). The scarves on the mothers' heads also emphasized their simple background, thus building an image of heroes who had risen from humble beginnings. Such plainness and diligence were also highlighted in all the biographies and other literary material. The photos of cosmonauts as children further emphasized the harsh past, bringing to mind childhood during wartime (**FIGURE 84**).

Because the hero narrative begins with early childhood, the heroism of the cosmonaut is also combined with the common enemy, fascist Germany. It is difficult to overestimate the significance of the Great Patriotic War for the Soviet Union. The war was one of the most pictured themes in the fine arts, films, and literature of the 1950s and 1960s, and it had produced a record number of heroes. By the end of the war in 1945, more than 10,000 citizens had received the honorary title of Hero of the Soviet Union (*Geroi Sovetskogo Soyuza*) (Sartorti 1995: 176).

Photos of a child looking seriously into the camera tell about the early phase of the hero's life. The shared experience of war is suggestively present in each childhood photo, as well as in the fact that the cosmonauts appeared in uniform. That the cosmonauts wore uniforms at almost all public appearances only reinforced their resemblance to the soldiers who had returned from across the border. An attempt to visually underline this connection was found in the

archive. A series of several photos presents the departure of Alexei Leonov from his home in Star City to Baikonur. The series climaxes with the whole family embracing. Leonov is in his soldier's overcoat with his back toward the viewer, the wife embraces her departing husband, and of the daughter is seen only a hand wrapping around her father's neck. In the background there is an easel and record player (RGANTD 1-13074, photo: V. Makarov) (FIGURE 85). The photo is a clear pastiche of Vladimir Kostetsky's *Return* (1947) (FIGURE 86). This *Rückenfigur* engraved into one generation's consciousness presents a family father who has returned from the war, embraced by his wife and son at the door. To the readers of *Ogonyok*, the painting was familiar: a reproduction was published twice in my research period (*Ogonyok* 25/1961 and *Ogonyok* 17/1965).

A Modern Space Heroine — and a Cosmic Love Story

Andriyan Nikolayev was an exception among the early cosmonauts because he was still a bachelor during the flight. In his case, the illustrations concentrated especially on his childhood family. In particular, the relationship between mother and son is emphasized. Another cosmonaut without a family was the first woman in space, Valentina Tereshkova, but we do not meet her mother on the pages of the magazine. As it is constructed through photos, Tereshkova's character generally differs a bit from the male cosmonauts. She is shown as being independent. If not in the company of the other cosmonauts or the Party leadership, she is either alone or with her female friends. It seems that she does not have a family. The article "I am 'the Seagull,'" which focuses on Tereshkova's persona, is illustrated by three photos (*Ogonyok* 26/1963: 6–7, photos: A. Romanov and APN) (FIGURE 87). In the first one, Tereshkova has been photographed from the front with a bird's eye view down into a field of flowers. She is dressed in a white shirt and is leaning toward the viewer. On the next page of the spread, she is with her workmates at the airport of the aviation club. The friends are laughing in their thick winter coats in the snowy landscape. They are dressed in pants, which was unusual for women at the time that the photo was published, at the beginning of the 1960s. In the third photo, Tereshkova is sitting in an armchair looking straight ahead, an elbow on the armrest of the chair, with her hand on her cheek. Now she is more properly dressed in a simple jacket suit, and on her feet she has high heels. Next to Tereshkova is a

portable record player, and the caption explains the reason for her thoughtful expression: "The favorite song" (Golikov 1963a: 6–7). Tereshkova's father had fallen in the Second World War. Could it be that picturing the mother and daughter's relationship did not have the same kind of power as the relationship between uniformed sons and their elderly mothers? Or had the mother not agreed to be photographed? (photos: A. Romanov and APN).

Tereshkova was photographed in a way that emphasized her propriety, so that her being out of wedlock and sexual associations related to that were not hinted at. Female sexuality was still a taboo[48] of visual culture at the turn of the 1960s. Being unmarried was a potential problem. The women who were used to manly work during the Second World War had experienced marginalization from the marriage market. They had "lost their feminine innocence" when they entered the world of men (Reid 1999: 288). Would this also be the fate of Tereshkova? Who would be a suitable companion for her?

Another cosmonaut, of course. The situations of the two unmarried cosmonauts changed dramatically when they found each other. The marriage was a media event. They were celebrated in a spread in *Ogonyok* (FIGURE 88). In the photos, the newlyweds write their name in the marriage book and Tereshkova places the ring on Nikolayev's finger. Much of the crowd is seen in the background. Gagarin and his wife are also witnesses. The married couple raises a toast with Khrushchev, and they receive a symbolic present of a large doll wearing a spacesuit. Tereshkova is dressed in a white marriage gown, while Nikolayev has flowers in his hands (*Ogonyok* 46/1963, photos: Yu. Krivonosov and A. Ustinov).[49]

A year after the marriage a daughter, Elena, was born to the couple. We do not meet her in *Ogonyok*. Instead, there are several photos of the new family in the archive. Tereshkova's elderly mother is found there as well. The picture of Tereshkova is complete in light of the archival material in other respects. In the photos, she is clearly an independent woman. After the birth of her child, she is certainly pictured as a mother, even in an accentuated way, but still as a woman in movement: in FIGURE 89, she is driving a car while her husband Nikolayev sits shotgun – he has one hand on the steering wheel, though, as if securing the situation. She can also be met elsewhere, behind a big film camera or in the company of Fidel Castro (FIGURES 90 AND 91), with the badge of the Hero of the Soviet Union pinned to her modest outfit. Tereshkova had a long career – for example, in peace and women's movements – and she was a member of

the Supreme Soviet council (1966–1974) and the Presidium (1974–1989).[50] She was widely photographed making appearances, giving speeches, and meeting heads of state – as well as in the kitchen next to the stove and with a child (**FIGURES 92 AND 93**). The couple divorced 1982.

The role of the modern woman changed from mother to representative on the go. Moreover, Tereshkova also became a fashion icon. Her changing jacket suits and hairdos were followed and copied. In Khrushchev's time, femininity rose in a new way to the center of magazines. The social emancipation of women was put to the side, and fashion, cosmetics, and guidelines for feminine behavior got more play in the press (Reid 1999: 288). Tereshkova acted as a model of the ideal of modern femininity, but the kind of role that belonged to that modern woman was not unequivocally clear in the Soviet Union of the 1960s.

In reality outside of the photos, it was still difficult for women to move ahead in professional life in the 1960s. The problems related to educating children and household work were still women's problems. Women had to both go to work and arrange daycare for the children (Filtzer 2004: 29–51). Furthermore, inside the cosmonaut training center, Tereshkova and other women trainees sometimes suffered crude male chauvinism from their male peers. They were excluded from the group and ended up performing traditional gender roles. For example, on "fishing trips the men caught the fish and Tereshkova cleaned and cooked them" (Jenks 2012: 188).

Fathers and Husbands

In *Ogonyok*, Tereshkova's not having children put her in clear contrast to the male cosmonauts, who were obviously fathers of the family. In addition to photos of their childhood relatives, they are shown building a connection with their own new family. In **FIGURE 94**, Valery Bykovsky is bent over his small son, and both are laughing. "Grow, my son, you will fly higher than us," says the caption. In the background is a plastic toy (*nevalyashka*), which could be recognized by everyone at that time as something that belonged to childhood (*Ogonyok* 26/1963: 11, photographer not specified). In the second photo, the son Valery is staring concentratedly at the camera with his mother and father admiring him (*Ogonyok* 25/1963). In the third, the boy has already grown bigger (*Ogonyok* 13/1964, photo: Cheredintsev). He has a spacesuit helmet on his head

(**FIGURE 95**). And the other cosmonauts also seem to enjoy spending time with their children: a little news story features Titov with his wife, who has recently given birth, and the small baby girl (Golikov 1963b: 3, photo: Cheredintsev), Feoktistov watching his son bicycling (*Ogonyok* 43/1964, photo: Cheredintsev), Komarov listening to his daughter playing piano (*Ogonyok* 43/1964, photo: Cheredintsev), Yegorov on the beach with his son (*Ogonyok* 43/1964, photo: Cheredintsev) (**FIGURE 96**), Gagarin playing with his daughters (*Ogonyok* 15/1968, photo: D. Ukhtomsky), and Beregovoy examining a star map with his teenage son (*Ogonyok* 46/1968, photo: A. Monkletsov). In the archive, the image of the family man/cosmonaut deepens even further. Leonov is with his family in a flowery meadow. The wife and daughter are wearing summer dresses and scarves on their heads. Both have picked flowers. Leonov is squatting, examining something in his hand, perhaps a plant (**FIGURE 97**). The cosmonaut fathers are carrying the children, flying them through the air and holding them on their laps. Playing, giving baths, and laughing – it could not be clearer that these men are enjoying spending time with their children. In **FIGURE 98** is Alexei Leonov with his daughter, and in **FIGURE 99** is Valery Bykovsky with his newborn son, "born on April 12th, Cosmonautics Day."

Many of the photos were taken by Valentin Cheredintsev. Cheredintsev was the photographer of TASS in the 1960s. He was one of the few photographers who got close to the cosmonauts, and *Ogonyok* used a lot of his photos. Cheredintsev spent a great deal of time with cosmonauts in his free time as well (Kamanin 1964). Perhaps due to this, there does not seem to be posing in the photos, and he got intimate access to the people that he photographed. The photos affirm that these men also played a role in their family: they were not only heroes, but also great family men.

A large part of the photos, however, certainly involve staged poses – the cosmonauts who travelled a lot did not in reality play a big part in the everyday life of their families. Picking flowers together with the family, an evening at home, or a fishing trip was not just free time. On the cosmonauts' trips to the woods, there was also a photographer and a journalist present – and with near certainty there was also at least one KGB agent. As Andrew Jenks has noted, the KGB constantly accompanied cosmonauts to their public and private gatherings. They went as far as to make sure that no undesirable photographs were taken and even exposed the film to light if there was a danger

of an unfavorable image being published[51] (Jenks 2012: 239). Through public photos, family and home had changed into "ideological state apparatuses" in the spirit of Althusser. The public home was not a private matter, but it was given "emphasis as the interpreter of mutual values and hopes," as Johanna Frigård has stated (Frigård 2008: 272).

This kind of heroic figure was new. Children were among the most important objects of visual propaganda in the whole Soviet era – as well as subjects – but especially in the 1960s. The photos depicting the relationship between fathers and children can also be seen as commenting on the cosmonauts' own childhoods. They were the generation of men who had grown up without a father. "For many of them, their fathers had been killed in the war, and many of them were complete orphans. Each of them had suffered because of the war, seen the horrors caused by invaders, and suffered hunger and loss of their rights" (Gagarin 1961: 15). This disappearance of a whole generation (first in Stalin's purges and then in the Great Patriotic War) was also depicted in art. For instance, in the paintings of Arkady Plastov, often only very young and old people are depicted in farm work (e.g., in the painting *Haymaking*[52] from 1945) (**FIGURE 100**). The fathers are missing.

Imagery commenting on the relationship between the father and his child was also common in fine arts at the beginning of the 1960s. For instance, in the painting *Father*[53] by A. and S. Tkachev, a small girl is hugging her father while he is carving a log. A man is building a house. Another girl is squatting next to her father. She has bare toes and a scarf on her head. A mother is bicycling in the background of the picture, while yet another child is on the bicycle. The father is inactive in the picture, with signs of work around him, while the mother is moving, on her way home (*Hudozhnik* 1/1965: 24, see also *Hudozhnik* 5/1965: 4 and *Hudozhnik* 9/1965: 17). The same kind of inversion of the family hierarchy appears in the painting *Family on a Journey*[54] by M. Kugach, which was published in *Ogonyok* in the spring of 1968 (**FIGURE 101**; see also **FIGURE 48**). In the picture is a family in a train cabinet. The wife sits on the window seat, hands on the table. She is wearing a bright red dress. There are food supplies on the table: an orange, glass bottles, and a baby's milk bottle. The father of the family has fallen asleep with his head on his wife's lap. His large hands hang, relaxed. His feet are bare; shoes have been removed and are on the floor. There is a child napping on the next bench, still a baby, cheeks rosy

with sleep. He has been covered with a yellow blanket, and only a naked foot peeks out from under the blanket. The sun is shining through the window onto the floor, onto the man's shoes and the little child's toes. The bare feet of the father and child make them somehow helpless in a moving way. The mother is strong in the picture; she is awake while the man and child are sleeping, guarding their slumber (*Ogonyok* 15/1968).

Highlighting the cosmonauts' fatherhood emphasized the nuclear family at the same time. The family – the nuclear family consisting of father, mother, and children – had come to the fore in a completely new way after the end of the 1950s (Zdravomyslova and Tyomkina 2007: 96–137).

> Those who claim that in transition to Communism the meaning of family lessens and that over time it disappears altogether are completely wrong. In reality, the family is stronger with Communism, and family relationships are ultimately freed from material calculations and become very pure and lasting. (Khrushchev 1961b: 274)

The children assumed an important place in this discussion.

Modern Homes for Ideal Citizens

In the imagery connected with the cosmonauts, the time spent at home appears restful. Viktor Gorbatko, his wife Valentina, and their daughters Ira and Marina "spend free time in the evenings, preferably together." In the photo, the girls with bows are reading a picture book on the floor. The parents sit in front of the television with their backs to the girls, but have turned toward them. The father has a magazine or book on his lap. In another photo, a family has gathered together in the living room. The father, the cosmonaut Georgy Shonin, and the mother Lidiya are sitting on the sofa and the children, Nina and Andrey, are on the carpet. In the background is a modern sideboard, on top of which is a funny mascot (*Ogonyok* 42/1969: 6, photos: A. Monkletsov and A. Gostev). The family enjoys being at home in their beautiful flat.

New homes like this were continually in the media at the beginning of the 1960s. Everybody did not have that home – yet. The Third Party Program had declared the housing issue to be the "most pressing problem in regards to

raising the well-being of the Soviet people." Flats were being built at record speed. People were moving from the countryside to big cities, as well as from city centers to the outskirts. The scale of this internal flow of urban immigration was unparalleled even in the history of the Soviet Union. Between 1956 and 1964, over 80 million people – over a third of the population – moved to a new home (Reid 2009a: 140–150). The new apartment buildings were quickly built five-story prefabricated houses, which rose in the environs of all the large cities. The houses were called by the name *Khrushchyovki*, so distinctly did they belong to a personal campaign of Khrushchev. The move to the new flat was also depicted in art (for instance, in the painting *Wedding in Tomorrow Street*[55] by Yuri Pimenov). In this well-known picture, a dirty and enormous construction site surrounds the newlyweds, but the bride and the groom are proceeding in an optimistic way toward the viewer. The Third Party Program had promised everyone – even newly married couples – the right to a flat that would "meet the needs of a hygienic and civilized life" (*Programma* KPSS 1961: 94). Moving to a new home represented a shift closer to the Communism that the Party Program promised.

Besides the family, home was another essential theme connected to the story that described the life of the cosmonaut, a milieu where they were often photographed. If one returns to Tereshkova's photo (**FIGURE 87**) and pays attention to the settings around her, it can be seen that the surrounding furniture is quite modern. The portable record player is modern, the armchair and carpet are stylish, and the bookcase is classic, in accord with the period's ideal of how things should be. In another photo, Valentina Gagarina leans on a door frame (**FIGURE 102**). In the foreground is a group of contemporary, modern armchairs around a coffee table. There are a couple flowers in a vase on top of the table, and the daughter of the family, with her back to the camera, is busy with something there (Golikov 1968: 31–34, photo: D. Ukhtomsky).

Victor Buchli (1997) and Susan E. Reid (1997: 178–185; 2004: 157; 2009a: 151; 2009b: 469–470) have researched the Soviet relationship with everyday design (see also Keghel 2010). According to Reid, the modernity and stylishness of the furniture was not a coincidence. One of the important projects on modernity in Khrushchev's era was a changing association with everyday aesthetics. The old concept of *comfort* (*ujut*), which referred to the bourgeoisie, expanded to include new interpretations in the 1960s: a new home was not

enough; it also needed to be designed stylishly and according to current trends. For the first time on a large scale, the family unit living in its new home also gave birth to mother, father, and child as consumers. The Third Party Program promised "fitting and beautiful clothes, footwear and things that enhance and beautify the everyday life of the Soviet people, comfortable modern furniture …" (*Programma* KPSS 1961: 93). The cosmonauts were indeed presented as consumers – and for those who saw them in real life, they certainly played the role. As Andrew Jenks has discussed, Yuri Gagarin was well known for his flamboyant taste in clothing, furniture, and cars. He represented a new kind of *homo sovieticus*: both an official hero figure and an avid consumer (Jenks 2012: 190). Also, home consumerism became one of the themes connected to modernization. Moving to a new home can be seen as a modern purification rite: the old, irrational, tired life and its material was left behind, and the new, rational, bright, and functional life began.

In the Soviet Union, everyday life around the home and feeling homey were condensed into a great cluster of thoughts of moral and aesthetic education: it was not insignificant with what kinds of things a person surrounded oneself. Things were neither mute nor innocent, because according to the contemporary concept that stemmed from Marxist ideology, the material culture around a human was directly related to his moral growth. This brought the home and intimate household circle into a moral discussion. Home, family, and everyday life (*byt*) had been one of the most important themes of social education since the beginning of the Revolution.[56] Everyday life had previously been a point of serious political discussion during the first Five Year Plan. The basic theme of the discussion was that the old, irrational, outdated, and tired everyday life should be modified to match the future of Communism. In many ways, Khrushchev's era can be compared to the atmosphere of the first Five Year Plan. Victor Buchli uses the definition "second Cultural Revolution" from the post-Stalin era, thus referring to the constructivism and general cultural enthusiasm of the 1920s era. In contrast with the first one, the second Cultural Revolution materialized in urban and industrial society.

The period's design ideal was a modern aesthetics that stemmed from Nordic minimalism. The slogans associated with the program mostly resembled Western modern design, which adhered to simplicity, clarity and practicality. The ideal new homes were modern, bright, functional and minimalist.

New things were practical, lightweight, versatile and stripped of unnecessary ornamentation. The statement "the breaking of ornamentation" referred to the ornamental ideal in design and architecture of the previous decades. Kitsch, bad taste (*poshlost*) and petit bourgeois collecting were sharply condemned in public discussion.[57]

The imagery of the cosmonauts that centered on the home provided commentary on this modern ideal. Good taste and civilized behavior were combined with modernism and modernity. The cosmonauts represented the people who had moved from the countryside to the city, and who enjoyed being in their beautiful homes with their children. Stylish furniture symbolized the new, modern life. In these photos, home and family had obviously arrived at that stage where the happiness of Soviet man was found. In the homes of the cosmonauts, there was no unnecessary ornamentation, nor any petit bourgeois decorative objects or large, old-fashioned furniture. Found at home instead was a piano and a bookshelf full of books. As an object, a piano links material life and civilized behavior, and it is the symbol of civilized life (Reid 2009b: 487). Different generations gathered around the piano, as in **FIGURE 103**: Gherman Titov listens with his young wife to his father playing (*Ogonyok* 32/1962, photo: I. Snegirev). Gagarin's daughters also play, and Komarov's small Irotska taps out a "cosmic melody" (*Ogonyok* 43/1964).

The education of everyday life was not only limited to objects and the surrounding material culture. Through modernization, the way of life would be changed in a broader way. The term for discreet, civilized behavior, *kulturnost*, which already stemmed from the Stalin era, accurately describes the demand that the new everyday life (*novyi byt*) presupposed (Field 2004: 100–101; Reid 1997: 177–201; 2009a: 133–161). Thus, aesthetics was tightly interwoven with modernization and the lifestyle of the modern man.

At the beginning of the 1960s, the directions for civilized and good life were clear. Instructions were given with the Third Party Program, which defined as the goal of each Soviet man the moral code of Communism's builder. The moral code included the following demands:

> Devotion to the Communist cause; love of the socialist Motherland and of
> the other socialist countries; conscientious labor for the good of society – he
> who does not work, neither shall he eat; concern on the part of everyone

for the preservation and growth of public wealth; a high sense of public duty; intolerance of actions harmful to the public interest; collectivism and comradely mutual assistance; one for all and all for one; humane relations and mutual respect between individuals – man is to man a friend, comrade, and brother; honesty and truthfulness, moral purity, and unpretentiousness in social and private life; mutual respect in the family, and concern for the upbringing of children; an uncompromising attitude to injustice, parasitism, dishonesty, careerism, and money-grubbing; friendship and brotherhood among all peoples of the u.s.s.r.; intolerance of national and racial hatred; an uncompromising attitude to the enemies of Communism, peace, and freedom of nations; fraternal solidarity with the working people of all countries, and with all peoples. (*Programma* kpss 1961: 119–120)

The photos confirm that the cosmonauts' private life was morally impeccable and civilized. The photos of their homes are documents that ride the border of public and private. They were staged private moments and at the same time proofs given to the public of the private life of the cosmonauts' families. As Viktor Buchli has stated, the Khrushchev era extended political control to the intimate area of the home on a completely different scale than totalitarianism per se in Stalin's time. At home as well, it was best to follow "moral purity, modesty, mutual respect and have concern over the upbringing of children," as required by the moral code published in the Third Party Program. In this sense, aside from being a liberated period of Thaw, the Khrushchev era also appears as an era when the normativity of everyday aesthetics extended to the most intimate domains. Susan E. Reid and Deborah Field point out, however, that the control system of the Khrushchev era should not be overstated. Even though huge amounts of resources were used during Khrushchev's time for everyday life education, control did not in any case extend to the scale of Stalin's era. One did not lose one's life because of a bad choice of curtains. Reid also points out that by focusing on everyday life education, Khrushchev's era actually resembles the welfare states in the West. The everyday life education can be seen as totalitarian control of the citizens, as well as a way of patronizing them. Such a patronizing attitude toward citizens is associated with the Nordic welfare democracies as much as the Soviet Union in the 1960s (Buchli 1997: 161–176; Field 2004: 97–98; Reid 2004: 154–156). In addition, the fundamental

view of Nordic design that good design is everybody's right was also in accord with the Khrushchev era. Furthermore, mass-produced products were to be beautiful and practical. Modern design was seen as a tool of social change in the Soviet Union as well as in the Nordic welfare states (Lund 1998: 7–11; Sommar 2003: 6–7).

Modern new homes brought change to the everyday usage of space by the family. Surprisingly, the kitchen rose to the fore in many ways. A flat having its own kitchen was understandably the most important improvement for many families tired of the *kommunalkas*[58] shared kitchen. The question was not only about desire for comfort. The kitchen came to symbolize the privacy of the whole Thaw era, and it became the mythical heart of privacy: conversations held behind closed doors, mutual time spent with family and friends. Without much exaggeration, it can be said that the kitchen was one of the most important everyday spaces in the Khrushchev era (Reid 2005: 289).

Even though the kitchen spatially became the symbol of privacy, to a larger extent it was also a theme under public discussion, even a politically charged topic. In the context of the great 1959 exhibition in Moscow's Sokolniki park[59] presenting the science, culture, and technology of the United States, US Vice President Richard Nixon and Khrushchev drifted into the so-called "kitchen debate," which *Ogonyok*, however, called a "friendliest discussion" (*Ogonyok* 32/1959). The debate was photographed by *Ogonyok's* correspondent E. Umnov (**FIGURE 104**) (*Ogonyok* 32/1959, photos: E. Umnov). The photo series would later become an oft-used symbol of the Cold War. The famous debate of the superiority of the social systems and home technology momentarily elevated the kitchen as one of the most important arenas of the Cold War. The scientific-technological competition was not only undertaken in space, but also in the hearts of homes. Both parties understood the symbolic value of the kitchen. The kitchen was a place where food was cooked and time was spent, but even more than this, it was a symbol of modernization and technological progress (Lewis 2008: 213; Oldenziel and Zachmann 2009: 1–29).

In addition to technological competition, the kitchen also brought the status of women to the arena. For the audience in Moscow, the American kitchen with all of its technical subtleties was (officially) a cage where a woman was imprisoned. The working Soviet woman did not have time to spend her day in the kitchen (Reid 2005: 290, 309). In particular, before the first Five Year Plan,

the kitchen had symbolized woman's drudgery, and exiting the kitchen was a natural progression to the emancipation of women during the realization of Communism. In the future, families would not have to take care of cooking. In the 1920s and 1930s, houses were built that did not have any individual kitchens (Reid 2005: 289–316). In 1934, when presenting the new home of an over productive worker (*udarnik*), *Ogonyok* had reported how dining took place in the comfortable *stolovaya*, the work canteen (*Udarnikam luchie...* 1934, photos: Rumyantsev and Markov). The subject was not completely buried in the 1960s. For instance, the Third Party Program still promised common canteens, and even free meals at work (*Programma* KPSS 1961: 97).

At the beginning of the 1960s, kitchens were an integral part of new homes. Cooking was made as easy as technological development allowed. "Even the last remnants of the inequality of the women in everyday life have to be done away with [...] For this purpose, modern and affordable household devices, equipment and electrical appliances will be used in the household" (*Programma* KPSS 1961: 97). Soviet kitchens were compact. There was practical and movable furniture in the small kitchens. If more space was required, the table was folded into the wall, and new homes did not have a separate dining room. The food was both cooked and eaten in the kitchen (Buchli 1999: 141).

In photographs the cosmonauts – especially the men – also enjoyed spending time in the kitchen. This is remarkable, as the kitchen and home interior had been considered a feminine space while the man controlled the outer world. In **FIGURE 105** we see how the cosmonaut Yegorov is drinking coffee in the kitchen with his wife (*Ogonyok* 43/1964: 6, photo: Cheredintsev and APN). From the open window can be seen an apartment building, a similar kind of prefabricated house in the suburbs as the one in which the cosmonaut's kitchen was located, at least in the imagination. The room looks very tiny. In another photo, the cosmonaut Komarov is pouring morning coffee from a striped pitcher for his wife. Breakfast in Star City[60] looks harmonious and informal (RGANTD 2-000413, photographer not specified). In a humorous photo from January 1969, the cosmonaut Volynov's small daughter Tanya is trying space food from a tube. Beside the high chair, the father is smiling (**FIGURE 106**). The mother cannot be seen in the photo, but a hint of the happy family is found in a box of New Year decorations on the table (*Ogonyok* 4/1969: 30, photo: A. Monkletsov, V. Cheredintsev).

The cosmonauts were not only satisfied spending time in the kitchens, they also participated in household work. The reform of the use of space at home also changed the family's internal roles. In the archive, a photo was found of Gherman Titov with a floor mop (**FIGURE 107**). His wife Tamara is drying the dishes next to him. The photographer has not been identified, but a description on the index card explains that the couple is cleaning their flat in Star City in 1961 (RGANTD 1-14829). The photo is heavily retouched, which means that it was at least intended for publication. *Ogonyok* also published a photo of Gagarin doing household work in his kitchen (**FIGURE 108**). The photo is not a completely typical photo of the nuclear family, as next to Gagarin is his mother. The caption informs that the photo shows "a morning for the Gagarin family." In the forefront of the photo, one of Gagarin's daughters with braided hair is leaning on the kitchen counter. On the counter is a checkered table cloth, a pot, and other kitchen utensils, scissors, and some food on the plate. Next to the girl is a *babushka*, Gagarin's mother, and behind her is Gagarin himself. He is doing something by the stove – the photo is heavily retouched and not very sharp. There is an informal feeling; when looking at the photo, one can believe that this is the way the family prepared for the new day. Only Gagarin's clothing makes one wonder. It is as if one would catch a glimpse of a jacket, white shirt, and tie. Maybe he was already in a hurry to work? The photo is a part of a larger photo essay, which was published as part of a kind of memorial article shortly after Gagarin's death (Golikov 1968: 31–34, photo: D. Ukhtomsky).

The photos of the cosmonaut heroes participating in household work in the kitchen are surprising vis-à-vis mainstream Soviet visual culture. In the Soviet Union of the 1960s, household work was still clearly the domain of women and the home was considered a woman's area (Reid 1999: 295–296; 2009b: 476–477). According to Victor Buchli (1999: 152), the active role of men in everyday household work became part of the public discussion for the first time only in the late Brezhnev era. These photos indicate, however, that in the context of the cosmonauts, the domestication of men was being pictorially tested already in the 1960s. The heroic man doing tasks in the kitchen was an ideal, of course, a figure that had not yet materialized. Reid (2009a: 150–151) has also noticed the discussion on the domestication of man at the beginning of the 1960s. In the popular written material that she examines, the man is pulled half forcibly by women into the circle of the new suburban home, but

after struggling for a moment between the old and the new, he has to admit that the new civilized life is better that the old one.

A glimpse of *Ogonyok*'s American equivalent, *Life* magazine, reveals that the housebroken space hero was very common there, too. For example, the March 1961 issue of *Life* magazine devoted a long photo essay to astronauts with their families. There we can find quite similar poses and settings as in *Ogonyok* (*Life*, March 3, 1961). In fact, much more than their Soviet forefathers, the new cosmonaut heroes resembled their Western counterparts. The myth of the astronaut, as Roger D. Launius (2005: 1–12) describes it, was defined by the moment when the Mercury Seven astronauts were introduced to the public long before their actual achievements in space. This makes their public role quite different from that which the cosmonauts kept secret. Launius has separated five basic components as central to this mythology. He introduces the astronaut as an "everyman" that reflected all the positive attributes of the national identity; as a defender of the nation who willingly put himself in danger for the good of all; as a fun-loving young man who enjoyed his family and friends and enjoyed speed and automobiles and flying; as a virile, masculine representative of the American ideal, in excellent physical shape, engaged in a strenuous and dangerous activity, personifying youth and vigor; and finally as a media-made celebrity before even accomplishing anything outstanding. The astronauts could be likened to sports and entertainment idols manufactured for public consumption. Perhaps the most striking feature of the first astronauts was their mainstream Euro-American maleness (Launius 2005: 5).

Many of these attributes are not so far-fetched in connection with the Soviet cosmonaut. Despite the obvious ideological differences, both American and Soviet photojournalism represented space heroes in a comparable way as "extraordinary heroes and ordinary human beings" (Rockwell 2012: 139, see also Gerovitch 2015: 223–230).

THE TORMENTED HERO

CHAPTER 7

Let's go back a few years for a moment. The first space pilot was not human. *Ogonyok* introduced this four-legged cosmonaut in November 1957, only three weeks after the first Sputnik. The space pilot is photographed surrounded by technical equipment (**FIGURE 109**). In the photo there is some kind of capsule inside which a dog is lying. The dog is attached to a "hermetic cabin before it is put into a satellite" (*Ogonyok* 47/1957: 3). The article describes in detail the equipment with which the test animal could be observed in space. Instead of one's attention going to the technical pictures that are blurry and give little information, it goes to the small dog surrounded by the space capsule. The dog was a mongrel stray that at first did not even have a name in the Soviet press. The caretakers had called her Kudryavka ("Little Curly") or by different nicknames like Zhuchka ("Little Bug") or Limonchik ("Little Lemon"). These strange Russian names were soon forgotten and the world came to know the dog by the name of Laika ("Barker") (D'Antonio 2007: 86–87).

Laika immediately became headline news in the Western press, but the Soviet media did not seem to understand the dog's symbolic role at first. The TASS bulletin published in *Pravda* dismissed the satellite's passenger almost altogether. The bulletin mentioned in passing that aside from other technical apparatuses, the satellite also included a "hermetic container for a test animal (a dog), air-conditioning equipment, food stores and machinery to observe vital signs in the environment of cosmic space" (*Pravda* 11/4/1957). Understating the role of the first space traveler could have been deliberate. Even as the satellite was launched, it was clear that it would be impossible to bring the dog back alive, as there did not yet exist any technology for its safe return to Earth. At the time that the bulletin was published, Laika had actually already passed away, due to heat and stress, only a few hours after the launch. This was not told to the public – in fact it took almost 50 years before Laika's immediate death was officially admitted. Instead, the dog's "good health" was regularly reported in the press (Burgess and Dubbs 2007: 164). The impatient order to quickly send up the new satellite had come from on high. After the first satellite Khrushchev had understood their enormous propaganda value, and he strongly pressured Korolev: "Send something new into space in honor of the anniversary of the Revolution"[61] (Harford 1997: 32).

In the eyes of the world, the satellite's little passenger had the main role. Laika aroused mixed feelings in people. When the Soviet press did not broach

her inevitable fate, the Western press had to speculate on the matter. Animal rights organizations all around the world protested (Burgess and Dubbs 2007: 160–164). From the perspective of the animal rights advocates, Laika was an example of tragedy shrouded in the ideology adhering to high modernism: when rapid development came to be a value in and of itself, it was no longer a tool for the increase of well-being and happiness. This contradiction lies at the core of the ideology of high modernism. As noted by Marshall Berman, there is always a contradiction between modernization and technological development: the modern life made possible by technology, atomic energy, and weapons technology can destroy the world whose construction they have enabled. "To be modern is to find ourselves in an environment that promises us adventure, power, joy, growth, transformation of ourselves and the world – and at the same time that threatens to destroy everything we have, everything we know, everything we are" (Berman 1982: 15). The same idea has been modified by Paul Virilio; each new invention includes the possibility of a new kind of accident: a shipwreck, an airplane crash, a nuclear power plant radioactive disaster. Modernization is also a history of accidents and catastrophes (Virilio 2007: 3).

Eventually Laika also became familiar to everyone in the Soviet Union. For this, only one photo was needed (**FIGURE 110**). The photo was published in *Ogonyok* six days after the flight (*Ogonyok* 46/1957, photo: N. Filippov). The photo is accompanied by a full-spread article, and above it is a framed greeting from the poet Pablo Neruda. The photo shows Laika's profile against a light background. This photo is completely different in style from the one mentioned above, in which Laika is attached to the space capsule. That photo presented an anonymous test animal, but this photo an individual. The photo is like a stylized portrait, like the face of a family member in a photo album. Aside from these two photos, other photos of Laika were not published. Later on, just a few photos were added to the catalog. However, in the Soviet time there existed countless modified versions of the photo. A stylized drawing decorated the popular "Laika" cigarette box, and the face of the dog was found on matchboxes, pins, teacup holders, and stamps. Even now, over 50 years after its publication, the photo inspires ever newer generations to themselves create different versions (for example, **FIGURE 111**). According to Roman Marek, who has researched Laika's photo, the popularity of the photo is not surprising. Laika was a figure that transcended the Iron Curtain, an object of identification,

a martyr (Marek 2009: 251–268). After the fall of the Soviet Union, Laika's figure can still be seen as symbolizing all of the suffering caused by the ideology based on high modernism.

Robert Hariman and John Louis Lucaites (2007: 27) have defined a photojournalistic symbol in the following way: the photo has to be generally acknowledged as part of a specific historical event, widespread among a variety of media, and possessing a strong appeal to the emotions. The symbol is something that refers outside of itself, building a relationship between two separate cultural contexts. Based on these criteria, the portrait of the first space traveler is a symbolic photo.

Hero on the Threshold

Other dogs visited the threshold of space.[62] The photo series of Dimitri Baltermants presented the four-legged test driver Mishka, as well as another space dog that remains unknown (*Ogonyok* 42/1959: 4–5). The photo essay of the spread is titled "At the threshold of great heights" (Golikov 1959: 4–5). In the photo, Mishka is dressed in a spacesuit and lying on some kind of a table, panting. The nameless comrade next to her looks utterly subordinated by technology, in a firmly tied suit and slightly transparent helmet to which hoses and wires are connected. In Baltermants' photo essay, the dog is comparable to the nameless test pilot on the next page, who is also a prisoner of hoses, wires, and instruments.

Such types of photos were also published of the cosmonauts. In **FIGURE 112**, the cosmonaut Gherman Titov is sitting on some kind of a research chair, but the scale seems incorrect: it looks as if it was built for a giant (*Ogonyok* 32/1962). Somewhere into his body snakes a red hose, like it is carrying blood. Titov's eyes are closed and his head is tilted slightly back. His lips are slightly open. The photo has been colorized afterwards, and it is soft at the edges, like an art photo. The aesthetic colorization is at odds with the photo's theme. The caption says that Titov is sealed inside a soundproof room. On the back wall is a mirror – I know that it is a hatch from which one can see into the room, but not out of it. The psychological endurance of the cosmonauts was researched by means of a science called "cosmic psychology" (Nikolayev 1961: 8). They could spend even weeks in 2.5 x 2.5 meter rooms in complete silence without any

contact with the outside world. Psychologists and doctors observed the room from outside, but had no contact with the cosmonaut, who did not know the duration of the test in advance (Burgess and Hall 2009: 120–124; Gerovitch 2007: 148). This is how Gagarin describes the test:

> Not the smallest sound was heard, not a word. Nor the slightest movement of air. Nothing. No one talked to you. From time to time, according to a specified timetable, one had to send a radio telegram. But the connection was one-sided. There was no knowledge of whether it was received or not. No one answered a word. And whatever happened, no one is coming to help. Alone. All alone, and one could only rely on oneself for everything. (Gagarin 1961: 115)

Why did *Ogonyok* present such a picture of the hero? In the photo, Titov is a passive object of observation, without any power over his own body. The male body was not usually shown like this in the Soviet Union. According to the ideal image of Socialist realism, the male body was strong, transforming nature and society, and physically fit. To show man as an object that has been subjugated had not been common in art or visual culture in general. In the history of art, physical passivity and submission under the gaze has instead been a role reserved for a woman. The question of gaze has long been a fore-gone conclusion in the research of visual culture. Gaze, subjugation to the gaze, and setting oneself as the object of the gaze are linked essentially to visual culture. In particular, gaze has been problematized in the feminist-oriented art history of the 1970s and 1980s (Mulvey 1989: 146; Pollock 1988: 86). At that point was questioned the objectification of the female body, which had been taken for granted. The gaze was no longer innocent. A similar reading is possible in regard to the catalog of the cosmonauts and medical experiments. The male body is subjugated in the photos as the passive object of a gaze. Titov's head being bent back and his slightly open lips even represent classic erotic iconography associated with women (Pollock 1988: 165). The corporality of the photos almost becomes masochistic. Such a reading, concentrating on gender and gaze, is anachronistic in relation to these photos, and it would not have been supported in the public interpretations of that period, but I do not think that the intense corporeality of the experience connected with the photo

can be overlooked. Why were the cosmonauts shown being subjected to such suffering? The photos presented here of heroes being physically tormented in different ways are not exceptions. In the photos of both *Ogonyok* and the archive, the cosmonauts are being tormented in many different ways.

The anthropologist Mary Douglas (1970: 70) has stated that the human body is always treated as the picture of society, and it is not possible to approach the body naturally; it always carries the social with it. What kind of picture is drawn through these bodies? Slava Gerovitch (2007: 149; 2015: 171–230) has interpreted the demands of extreme discipline directed toward the cosmonauts in the broader sense of Soviet societal control. This control placed the citizens under constant observation and self-discipline. Interpreted in this way, in addition to being an ideal citizen, the cosmonaut figure hinted at the everyday experience of the Soviet citizen under a hegemonic machine. On the other hand, given the community focus of Communism, the idea of solitude – a citizen being isolated – was horrendous. The cosmonauts afterwards described the experiment as one of the hardest to endure – this had to be not only in terms of human endurance, but also on the level of ideology. Isolation without the support of the community was a Communist anomaly.

If the cosmonauts' ascent to the Tomb is seen as a ritual that elevated their status in the eyes of the community, the photos of the tormented candidates can be seen as a preliminary step in the rite of passage. The cosmonauts were in a liminal space in the photos, separated from their community. According to the anthropologist Victor Turner ([1969] 1997), this space is full of symbolism and is potentially dangerous because the rules and hierarchy of the old social structure are temporarily invalid. According to Turner, the liminal personae ("threshold people") in a liminal space must be passive and humble, and they must unconditionally accept even arbitrary punishments. In this way, all possible attributes are as if eliminated out of them, and when they have been stripped down to resemble each other, they can then be molded to become something new.

> [...] As liminal beings they have no status, property, insignia, secular clothing indicating rank or role, position in a kinship system – in short, nothing that may distinguish them from their fellow neophytes or initiands. Their behavior is normally passive or humble; they must obey their instructors

implicitly, and accept arbitrary punishment without complaint. It is as
though they are being reduced or ground down to a uniform condition to
be fashioned anew and endowed with additional powers to enable them to
cope with their new station in life. (Turner 1997: 95)

The liminal space of humiliation preceding the return ritual was indispensable
from the perspective of the rite of passage. The liminality connected with the
rise of status reflects the idea that no one's status can be high if others' status is
not lower. The transition between lower and higher status is through the liminal
space in which status is lacking. In order to climb the status scale, the individual
first has to descend beneath all status scales. The cosmonauts are dressed in
casual outfits in the training photos – as are the female candidates. According
to Turner, androgyny and anonymity are typical liminal attributes. In humility,
silent and passive, they submit to the orders of authority (Turner 1997: 102).

Man – Machine

The climax of anonymity was the donning of the spacesuit (**FIGURE 77**), when
even humanity is stripped from the candidates. This is also typical, according
to Turner: "they may be disguised as monsters, wear only a strip of clothing,
or even go naked" (Turner 1997: 95). Photos of putting on the spacesuit al-
so constructed an interesting relationship between man and technology. The
cosmonaut candidate was gradually transformed into *part of a machine*. The
body itself was imperfect. Exhaustion can be felt from the photos – putting
the suit on was clearly a slow and tedious process. Partly due to the system of
secrecy – the spacesuit was a complicated technical device, more so a part of
the spaceship than a piece of clothing, and in that respect a technology that
was classified as secret – *Ogonyok* published a limited number of photos of
spacesuits. In fact, comparatively speaking, photos of the spacesuits of the
American astronauts were the most published. Photos of other aspects of the
Soviet training, however, were abundant.

 FIGURE 113 shows how the cosmonaut's body was integrated as part of
the technology. Their bodies were connected to the machine through different
technical devices. In the photo is a man strapped onto a kind of stretcher. The
stretcher is lifted up and the man is held in place with the help of tight straps.

Every part of his body is criss-crossed with different types of wires. His nose is shut with pliers, and two thick tubes lead into the mouth, leaving visible only the upper part of the face. The chest and the shoulders are bare. The eyes stare into the distance. He is awake, but a prisoner, completely helpless, stuck in place by all of the instruments and hoses. Behind are two men dressed in white, their faces covered by masks. One is bent over some device, while the other seriously observes the situation. Doctors are the performers of this ritual, the authorities. The cosmonauts accept the pain and suffering caused as part of the elevation of ritual status.

> There were many doctors and each was as strict as a judge. One had no rights to appeal the verdict. The inspectors mercilessly rejected those seeking to become a space pilot [...] The primary object of research was the heart. From that, the doctors read our entire bio, and nothing could be hidden. The complex apparatus found out everything, even the smallest flaws in our health. (Gagarin 1961: 90)

The photo was published in *Ogonyok* in January 1969. Is this the "mentally perfect Soviet man" (*Programma* KPSS 1961: 121)? This man, bullied and frozen into helplessness? He looks like the victim of some kind of horrendous medical experiment, not a victorious hero (*Ogonyok* 4/1969, photo: A. Monkletsov, V. Cheredintsev). The man in the photo is the cosmonaut Alexei Yeliseyev. On the same page, there are three other photos where the other crew members of Soyuz 5 – Boris Volynov and Yevgeny Khrunov – and the cosmonaut Vladimir Shatalov of Soyuz 4 (which was in space at the same time) are undergoing similar treatment. Only Shatalov has some control over his body, but he is also uncomfortably flipped upside down in some sort of swing, to which he has been tied by his feet. Volynov is tied with his hands and hips to a chair, which seems to be part of a larger spinning device. There are also two men with white jackets and facemasks working around him. The background is striped in a striking way, which the mirror on the ceiling further accentuates. Khrunov is also sitting in a large, complex machine, which has lifted him up on a high seat. His head is tied beneath the chin and his expression is serious. Two bright lamps illuminate the room, creating strong shadows on the wall. All of the photos are taken indoors.

The photos on this page are by the trusted photographers of APN and TASS, A. Monkletsov and V. Cheredintsev, and they remind one of a mad inventor's twisted amusement park or some sort of perverse torture chamber. The psychedelic stripes and the twisting, dangling, and spinning devices look as if their purpose is to produce as uncomfortable an experience as possible for the one daring enough to jump on – or the one forced to jump on. The text between the photos states: "The difficult road to space. Training. Hardship. Heroic work."

On the next page, two photos show the caption of television screens (**FIGURE 114**). "You saw this on the screen of your television set – two worrisome moments: the docking of the spaceship and man's working in open space." From the blue-toned photos, nothing meaningful could be interpreted without the captions (*Ogonyok* 4/1969). In the photos, the broadcast looks inconceivable, almost surreal, but the symbolic power of the photo is what matters. The broadcast has come from outer space – and one has been able to watch it at home. The photo communicates that the Soviet technology is so developed that it can broadcast information from outer space directly into people's homes, into their own television sets.

In light of the scientific–technological revolution, it is clear that the photos were commenting on technological precision, the sensitivity of measuring devices, and scientific exactness vis-à-vis the kind of attitude that the space program had toward the human body. Nothing was left to chance, and everything was measured and defined, keeping in mind the future flight. Technology had priority over the human body. In the photos, man is placed in subjugation to technology, just like Laika in her capsule earlier, like a humble test animal ready to perform the assigned task. With the help of technology, the test subjects were measured, their performance tracked, and the pulse, blood pressure, and electronic impulses of the brain registered with the help of mechanical devices. They were crammed into airtight containers, isolated from the outside world for weeks, tossed and turned and pulled apart. Their bodies were submitted to extreme heat, cold, and pressure. They were spun in the centrifuge until they lost consciousness, and they were stuck with needles. All this they obediently acquiesced to, and they humbly submitted their bodies to suffering. The body was like a tool, part of a great machine.

Why did an era that emphasized full mechanization and automation in all sectors of the national economy still strongly strive to develop manned

space flight? Even though tension existed between the relationship of man and technology, it was not possible to give up the "live link," because

> [...] the quality of the research carried out on the planet can only be evaluated by a man on site, who has a scientifically educated brain, enough willpower and determined intention to solve the task. In that respect, man has victory over all kinds of automatons. The automaton can only do what it has been told to do. (Blagonravov 1960: 20)

Man would be sent into space, but he had to be suitably molded before that. In the spirit of the ideology of high modernism, human nature was to be subjugated and under control; a suitable instrument for the purpose had to be molded out of both the body and the mind.

The photojournalists of the 1930s were instructed in such a way that man controlled technologies in visual images, not the other way around (Sartorti 1987: 132–134). In the 1960s, the order of the relationship was not clear. In a full-spread photo published in *Ogonyok*, the rocket Vostok stands on the exhibition pad, appearing majestic and grand before the reader (**FIGURE 115**). Behind is a bright light, which leaves the background dim. Even though the rocket is pictured alone without any human elements, its layout in the magazine is striking. On the next page is a full-page photo of a tiny baby. The child is sleeping in a crib, tightly wrapped in a duvet. The contrast between the fragile, sleeping child and the enormous rocket is huge. The photos are part of a large photo essay telling about Moscow. The caption explains: "How fast the years go by!" The people, for whom the rocket Vostok standing in the vDNH[63] exhibition became history, have grown up. Ever closer is the time when space travel is normal life. "Who knows what kinds of secrets of the universe will still open up for the child born in 1967" (*Ogonyok* 44/1967, photos: L. Borodulin, A. Bochinin, A. Uzlyan, D. Ukhtomsky). The photo constructs a special relationship between man and technology. Which of the two is more powerful?

The value order of the relationship is not clear. A similar association is found on the front cover of *Ogonyok* 2/1968: a small girl is holding the hand of a robot the size of an adult man (*Ogonyok* 2/1968: front cover). The same uncertainty of the relationship of control is linked to many photos. Technology plays the primary role in these photos, while man remains a bystander.

The telescopes, radio telescopes, and computers are enormous. In **FIGURE 116**, the woman operating the telescope – the caption explains that she is a young astronomer – seems helpless in relation to the enormous device (*Ogonyok* 32/1960, photo: Dimitri Baltermants). The photo has been shot sharply downwards, emphasizing the immense size of the telescope. The telescope was one of the most photographed themes of space technology.

According to the view of the 1960s, the future of Communism would be the perfect union of technological and humanistic utopias, which would combine the "material and technical foundation of communism" and the "spiritually perfected Soviet man." The tension between this project's two areas – technology and man – had existed throughout Soviet history (Gerovitch 2007: 155; 2015: 171–230; Programma KPSS 1961: 121). The ideological voice hovered between two emphases, stressing either the omnipotence of technology over man or man as an active agent and the ruler of technology. The tension was seen already in the early Bolsheviks' ideas of man's role in the new society being developed by means of technology. The scientific management that originated from the United States, better known as Taylorism, also inspired many Bolsheviks. Frederick Winslow Taylor (1856–1915) developed in his research of so-called "time-and-motion" a production method that essentially saved time and made factory work more efficient. His theories included strong analogies between the human body and the machine. Workers' unions all over the world rejected as inhumane the work conditions that Taylor developed, but a number of leftist intellectual circles were drawn to the theories. Taylor had been translated into Russian before World War I, and many Bolsheviks were inspired by the efficiency and organizational skills of Taylorism. Another mythical figure of the machine cult, Henry Ford, radically changed American industry between 1895 and 1915 by developing the conveyor belt system, which enabled mass production. Richard Stites (1989: 145–164) has researched the idea's impact on the Soviet Union. According to him, Taylorism and Fordism were combined in the early Soviet Union into a kind of "Americanism," with the worship of everything American, new, and technologically progressive. The mottos of this Americanism were speed, industrial tempo, rapid development, productivity, and efficiency. The symbol of the movement was the tractor, which brought the modern pace to the countryside. Human–machine metaphors were also common in poetry and popular culture. For instance, in the works of the poet

Alexei Gastev, machines became part of the human body. Gastev also worked actively to promote the spread of Taylorism to factory work. The Scientific Organization of Labor movement (*Nauchnaya Organizatsiya Truda*, NOT) that he led was a driving force behind the scientific standardization of automation, workers' unions, language, and even ideas. Even though many of the disciplines of Taylorism were adopted in practice, Gastev himself was arrested and executed in 1939 in Stalin's purges (Bailes 1977: 373–394; Gerovitch 2002: 339–374).

In the rhetoric of the Stalin era, the relationship between man and technology was a manifold contradiction: on one hand man was "a cog in a large apparatus," on the other hand a capable "new man." (Gerovitch 2007: 155). In the 1960s, the tension between the value order of man and machine was further amplified. The relationship between man and technology was now examined as part of a broader framework of cybernetics. Cybernetics was born as the heir of Gastev's thought, and Gastev himself was rehabilitated in 1962 (Bailes 1977: 375). Among other things, cybernetics researched man as part of different systems of control, as well as man–machine interaction. It was aligned with that time period, which aimed at modernization and faith in science. In an era that was recovering from Stalin's administrative culture, the desire to believe in the objectivity of science was strong: "There is a simple but reassuring correspondence between mathematics and honesty. […] When it became clear that words lie, mathematical formulas seemed the most trustworthy" (Vail and Genis 1988: 85).

Slava Gerovitch (2007: 135–157; 2015: 193–223) has analyzed the cosmonauts in an interesting way as part of this cybernetic control system. From the perspective of the space program, man was problematic. The problem was not that man was incapable, but that man was not entirely predictable. "Our senses are far too limited, our brains react too slowly to compete with space speeds. Hopelessly out of date is the statement that thought is the fastest of everything. For instance, an ordinary calculator is faster" (Blagonravov 1960: 20). Between man and technology, the cosmonaut was defined as a "living link," and his performance was evaluated in technical criteria and terms. In this system, in an ideal situation man was submissive to technology. The flights were intended to be as automatized as possible. "Don't touch anything!" had a playful tone, but the order to Yuri Gagarin before his flight was more than half real. The work of the cosmonauts was planned to be made as automatic as possible. They thor-

oughly practiced each phase of the flight in such a way that every performed movement became habitual. In the training, there was an effort to minimize mistakes, and one's own frustration was not to be expressed. Remaining calm was as important as a flawless performance. Life-threatening situations were practiced with the help of hypnosis, and the demand for self-control extended to public appearances as well.[64] (Gerovitch 2007: 136–148).

Cybernetics blurred the border between man and machine, and it legitimated the idea of examining man from the perspective of engineering science. Being based on cybernetics, the program had to choose future cosmonauts very carefully, so that their physical and mental abilities would correspond as closely as possible to their role. Physically, the standardization started with external measurements: due to the small size of the Vostok capsule, the cosmonaut could not be taller than 175 cm or weigh more than 72 kg. They had to be absolutely healthy and in good shape. Among the first trainees, only men were accepted. The vocational background of the future cosmonauts caused controversy: would the physical and mental stress of the future flight be best endured by a submarine sailor, racecar driver, or nuclear missile officer? The contest was won by fighter pilots. The vocation of military pilot ensured that future cosmonauts – besides knowing how to fly, navigate, and use the radio – also had absolute self-discipline and that they understood the command structure of orders and unquestioning political loyalty. Social activities, family life, cultural and social hobbies, and emotional balance were also evaluated. In addition:

> The space pilot has to have great mental strength and good physical endurance. At the same time, he must have a sensitive and responsive nervous system in order to act quickly in surprise situations. If the question is about long flights, different kinds of expectations were set for man. The priority was to take some kind of "psychological marathon," which required long-term psychological endurance. If compared with the aviation industry, in the first case the most suitable is a fighter pilot, but in the latter case is a strongly built, strong-willed, and perhaps slightly slow-moving chief of a bomber or passenger plane. (Pipko and Chernikova 1961: 21)

The submission of the cosmonauts must be read as part of a context in which the human body was not seen as perfect, but also as capable of suffering. By

the beginning of the 1960s, the physically perfect positive hero was no longer the only way to visually describe the human body. The fallible and vulnerable man emerged as an important theme in the fine arts of the period. Socialist realism was painted with darker shades: one talked about a rough or a strict style (*surovyi stil*). Even small hints of the wretchedness of life were shown in photos. Even such a sacred figure as Lenin could appear physically vulnerable, and even the photos of Khrushchev in *Ogonyok* seem to comment on this possibility of physical weakness. Contrary to Stalin, who was portrayed as larger than life in paintings and statues, Khrushchev was highlighted as folksy. One of the Stalin-era archetypical pictures is found in Alexander Gerasimov's painting *J.V. Stalin and K.E. Voroshilov in the Kremlin* from 1938.[65] The painting emphasizes Stalin's status at the core of the center, static and heroic. Khrushchev's popularity among the people (or lack of it) was based, contrary to Stalin, almost only on press photos. In *Ogonyok* at the beginning of the 1960s, Khrushchev was primarily presented on the second or third page of the magazine. He was most often among people, in some corner of the expansive Soviet country (**FIGURE 117**). His dress was often remarkably informal, and his gestures and postures brought other people close. Slightly overweight, laughing cheerfully, he was highlighted as the *man of the people*, just like anybody else. Khrushchev's being shown as ordinary can partly be seen as dismantling the personal worship of Stalin.

The photos of the cosmonauts being tormented by medical experiments and training can also be explained as part of the logic of the hero narrative: the suffering hero was performing his difficult task, and his trial was an essential part of the narrative formula. This type of theme linked to the suffering and sacrifice of the human body was not new in the Soviet context.[66] A well-known example is Nikolai Ostrovsky's book *How the Steel Was Tempered* (*Kak zakaljalas stal*), which was published first as a serial story in the magazine *Molodaja gvardiya* between 1930 and 1933. The book became one of the canonical examples of Socialist realism and it was timely more than 30 years after its publication. Not only that, generation after generation read it in school, and it was also a topic of new interpretations. In 1957, Alexander Alov and Vladimir Naumov directed a popular film version, *Pavel Korchagin*, which was based on the book (Alov and Naumov 1957). Gagarin also seems to refer to the book in his autobiography:

> As I sat alone in the heat cabinet without being able to exchange a word with anybody, so I remembered how many times our workers have in a hellish heat voluntarily changed oven grates or fixed the lining of melting pots [...] In other words, everything becomes tempered in fire and so do we. (Gagarin 1961: 111)

The hero of the book, Pavel Korchagin, was a positive but tragic hero. Cruelty, the battle of life, misery, and dirt come to be primary in the book and the body of the hero is destroyed while he is pursuing his goal of a just society. According to Lilya Kaganovsky, the mangled body, discipline, and (hetero)sexuality also articulate in a general way the paradoxical nature of Stalin's era in relation to masculinity, where exemplary masculinity was represented by a damaged body (Kaganovsky 2008: 4–11). In Korchagin's suffering, it is possible to find even a kind of mystic Christianity, purifying oneself through suffering: before entry to the heaven, one's body must face hardships. The basic idea in the book is that new people will be born into a society built by heroes that sacrificed themselves, like Korchagin. The new and the old cannot live simultaneously. The hero must suffer in order for new people to come (Ostrovsky [1930–1933] 1974). The tragedy of the book comes from this unreasonable demand. Against this point of view, the promise given in the Third Party Program – "this generation will live in Communism" – is truly remarkable. The ones living in that time were also entitled to happiness; they did not have to be destroyed on the eve of the new era. The new era, however, would not come without a struggle, as a photojournalist in *Sovetskoe Foto* magazine summed up: "The more bravely and creatively we represent the struggle to overcome difficulties, the more impressive and credible the achievements will appear in the future" (Korolev 1957: 22–23). This struggle of overcoming difficulties is what the photos of the cosmonauts seem to comment on. The journey to become a hero is not easy. The photos show that they have really fought for their goal.

The Death of the Hero

One exception in the cosmonauts' heroic narrative was so important that it has to be dealt with separately. This part of the story did not repeat itself like the others. Accidents that cosmonauts had were not described in *Ogonyok*.

This was connected to the system of secrecy related to technological imagery. Accidents or failures did not belong to the narrative of the victorious space program. Accidents that were met with by those candidates still out of the public eye remained hidden from public view. The first public occurrence of death was when Vladimir Komarov was killed in the Soyuz I re-entry capsule in 1967. Komarov was already a known cosmonaut – he had been part of the Voskhod I flight in October 1964 – and the accident had to be made public. In *Ogonyok*, the case was glossed over with a brief obituary; the accident was not front-page news. In the obituary, it was stated that Komarov had performed his last duties "honorably" and carried out all of the planned scientific experiments. For this task, a "heroic, masculine and brave performance," he was awarded a second time the honorary title of Hero of the Soviet Union. The reasons for the accident were not explained in detail (*Ogonyok* 18/1967: 7).

An exception from the policy of minimal information had to be made in March 1968. On March 27th, Yuri Gagarin engaged in a training flight with a MIG-15 fighter jet. It was supposed to be a routine exercise; after a long break, Gagarin was training for a spaceflight. The other pilot in the training plane was the flight instructor, Colonel Vladimir Seryogin. Just over ten minutes after the plane took off, its signal disappeared. The plane was out of contact and no longer replying. The worst fears came true two hours later when search patrols found a thick column of smoke and a six-meter crater. The plane had been completely destroyed when crashing to earth. The official explanation shortly after the accident was a collision with a weather balloon – a neutral explanation that did not require anybody to be blamed. The explanation was adequate to quash conspiracy theories and rumors, yet new conjectures about the reason for the accident and guilty parties are still emerging (Belotserkovsky 1992; Burgess and Hall 2009: 274–278; Lewis 2008: 296–300).

The sad news faced by the nation was devastating. *Ogonyok* opened the magazine by telling the news on the front page, which was framed with a black border (**FIGURE 118**). In the partial close-up is a familiarly smiling Gagarin in white shirt and black tie – as if dressed for his own funeral. On the inside cover is a photo of men carrying the coffin (**FIGURE 119**). From the photo, I recognize Leonid Brezhnev, Alexei Leonov, and the academic Mstislav Keldysh, designer of the space program and one of the few persons in the public with (what Siddiqi has described as) limited visibility. In the background is a crowd

of people. The coffin is decorated with a large flower arrangement. This is a funeral at the level of a state leader. According to Cathleen S. Lewis (2008: 305), Gagarin's funeral, orchestrated by the members of the Politburo, was a mixture of Orthodox and Bolshevik traditions. The services were held exactly three days after his death, which was in compliance with the Orthodox idea of the spirit leaving the body on the third day after death. However, no other religious ceremonies centering on the corpse took place. The cremated remains of Gagarin and Seryogin were placed along the Kremlin wall among other recently deceased national heroes (e.g., Sergei Korolev and Vladimir Komarov). There were 200 "official mourners," but altogether over 40,000 people visited the reception (Lewis 2008: 304–307).

On the next page is a TASS bulletin where the sad news is told. The reasons for the accident are not speculated on, as Gagarin and Seryogin are only said to have died in a flight training accident. The bulletin is illustrated by portraits of both Gagarin and Seryogin. In the photos, both of them have all their honorary medals around their necks, so many that they cover the men's entire chests (*Ogonyok* 15/1968: 1).

The next spread presents a Tomb in which a solemn group of people dressed in black or men in military uniforms have gathered together (**FIGURE 120**). In the middle of the column, the only woman that can be distinguished is Gagarin's widow, small and hidden in her black scarf. The importance of the Tomb as a ritual center is reinforced. This is where the public life of Gagarin began and ended. The crowd standing below the Tomb is not rejoicing. The column of backs of black and gray coats is silent before the photographer. The narrative proceeds further on the following page with the wall of the Kremlin, where the new widow leans over the grave decorated with a portrait (**FIGURE 121**). Her open hands are touching the photo, as if embracing it. Someone is supporting her around her waist; it looks as if she would otherwise fall against the photo. Behind the grief-stricken pair is a soldier whose expression is frozen. The photo is densely packed with almost a claustrophobic atmosphere. Maybe it captures something of the experience of devastating grief? (*Ogonyok* 15/1968: 1–4, photos: A. Gostev, A. Bochinin, A. Ustinov). There are also many photos of the funeral in the archive. From these photos one can see the large number of people that followed the funeral procession. The people on the street are openly crying (**FIGURE 122**).

The public imagery of Gagarin does not end here. He remained the lasting favorite of space imagery. From the perspective of the hero narrative, the accident that happened only seven years after the flight was a blessing. Time had treated Gagarin cruelly. Travelling from one large gala occasion to another, the cosmonaut was tired, and it could be seen in the photos. Being a moral example was not easy. The first dangerous slip had occurred only shortly after the spaceflight. At the XXII Party Congress in 1961, a special role was reserved for the first cosmonaut. Gagarin had to cancel, as only a few days before the meeting he was seriously injured by jumping out of a hotel window after a tryst with a young woman. Khrushchev was furious. The event was kept secret and it was not permitted to photograph Gagarin's face before it healed. The press developed a story according to which he had stumbled while carrying his child and he had injured his face while protecting it, but "nobody believed this" (Golovanov 2001: 135–136). This incident left a scar on Gagarin's face which can be seen in later photos. After Gagarin's death, it was possible for the parties controlling the public image of the cosmonauts to now keep his picture clean. Aging stopped just before the tolls exacted by the lifestyle became too obvious. Just barely, he would forever remain a smiling poster boy.

In the issue that announced the calamity, *Ogonyok* already published "the last interview," which depicted a day with the Gagarin family only a few days before the accident. Beside the article is a photo essay that was taken at the family's home. **FIGURE 102** is a shot of the living room. At the top, near the ceiling, is a photo of the father of the family wearing a spacesuit helmet (Golikov 1968: 31–34, photo: D. Ukhtomsky). This portrait is one of the few where Gagarin's expression is serious. It is not at all a typical photo of him or the cosmonauts in general, but as time passed it would become one of the most published photos (**FIGURE 123**). There is a similar melancholy associated with this photo as with Laika's portrait (**FIGURE 110**), which also lived on as a symbol that was reproduced and altered. Gagarin's serious, almost sad expression is far from heroic bluster. Would the photo have been used as much if Gagarin had not prematurely died in an accident? Inevitably there comes to mind Roland Barthes' example, where he analyzes Alexander Gartner's photo of the condemned Lewis Payne: "He is dead and he is going to die" (Barthes 1985: 101–102; Marek 2009: 251–268). This strange past future connects the photo with a tragedy that will be met by the person in the photo. In contrary

to Barthes' example, this photo is stripped of all its concrete elements, and it seems to deny its material connection to any news event. The background is black, and the photo is tightly cropped to a close-up. On top of Gagarin's face is a painted layer that covers all blemishes. There is nothing physical in the photo; it is almost immaterial, like a saint's photo, a symbol rather than a portrait. Gagarin is beyond all suffering in the photo, and his tormented body has found peace. Sadly and gently, he gazes down on his children. In spite of all the efforts of the atheist campaign, in a popular context Gagarin's visit to heaven is clear. Even *Ogonyok* admitted this: Gagarin had been closer to God than anybody else and was therefore a saint (Rudim 1961: 8–11).

CONCLUSIONS

CHAPTER 8

The Tamed Infinity

The conquest of space, its taming as a place, took place with the help of photos and cartography. In light of the material presented in this book, the Soviet Union appears as a modern empire striving to expand the space it controlled with the help of its space program. The photos emphasized the conquest: with the help of photos, space became a part of the Soviet domain. The photos taken by probes brought confirmatory evidence, an incorruptible and objective description of that place, integrating space into the mode of experience of the Khrushchev era. The cosmic landscape was mapped with scientifically accurate photos – an added feeling of objectivity was had by the fact that they were created automatically without any human hand. The documentary and witnessing quality of a photo positioned the landscape of space as part of the scientific world view.

A reference to the photograph's authenticity, which was connected to it through its medium, is essential in this context. According to Michael Soluri (2008: 284), who has researched the relationship between the imagery produced by the United States space program and the tradition of historic photography, it was not an accident that the old landscape photographers in the United States were rediscovered in the 1960s at the same time as the first photos received from space. What they shared in common – and got their power from – were inaccessible landscapes and new technology. Soluri also sees a visual connection between the early wilderness photographers and the first photos taken on the surface of the Moon. Repeated in both are rugged mountain ranges and vast, empty landscapes. For while the photos revealed the depths of unknown space, they also created an imaginary map to newly discovered cosmic landscapes. And practically speaking, the Moon *was* mapped and named.

Through Alexei Leonov, the traveling artist, the question of space, and the relationship of man and his limits, became more intimate from the perspective of the cosmonauts squeezed into a small space capsule. In this regard, space was not only a domain to be conquered, but also a horrendous emptiness that threatened man's life. The theme of fragile and vulnerable conqueror was continued in paintings, which I have called cosmic landscapes. The cosmic landscapes did not exhaust the theme of conquest, but they broke the possessive attitude of photos. The theme of the exploratory expedition raised by Emma Widdis can

be seen especially in the cosmic landscapes. The pictures were contrary to the idea of self-involved conquest. The heroes of the pictures, the small *Rückenfigurs*, were thrown into the landscape, standing in wonder before the panorama. They were researching, not conquering. The cosmic landscapes brought a romantic and fantastic fairy tale to the world's space imagery. The small figures were a modern Hansel and Gretel, on a journey toward the unknown.

The role of man and the space technology he created was central. Space as a visual theme did not appear separately from technology and technology rarely appeared without some sort of human element. Space did not exist without man; its meaning was constructed only through man and in relation to him, while technology received its meaning only through a human user. The photos of space celebrate the victory of humankind over nature, the capability of man to even alter the order of the planets.

The photographs from the early Soviet space endeavor came to my mind in the summer of 2012 when the Curiosity rover successfully landed on Mars' surface on August 6. The Mars Science Laboratory (MSL) was a robotic space probe mission to Mars, implemented in 2011 as part of NASA's long-term effort of robotic exploration and evaluation of whether Mars could someday be inhabited. The rover was packed with cameras to shoot high-quality photos of the Martian landscape. The first of these landing photos was published by NASA in August 2012. To me, the photo looked very familiar: a barren, desolate surface – not a very interesting landscape as such, but what a sensation it gave. Once again, man stood on the threshold of a new world, and again it was a photograph that provided the means to prove that. To merely *know* that the probe has successfully landed has so much less impact than actually *seeing* it. In over 50 years, not much has changed.

While going through the NASA photo album of the Curiosity program, I turned to an even more familiar setting. A "photo of the day" (August 13, 2012) shows an official White House photograph taken by Pete Souza: "President Barack Obama talking on the phone with NASA's Curiosity Mars rover team aboard Air Force One during a flight to Offutt Air Force Base in Nebraska."[67] In the photo we can indeed see President Obama on the phone, congratulating the team that has successfully completed its mission – just like the Soviet Secretary General did 50 years before. Over a half a century has passed, but still it seems that technology and outer space – and the humans conquering

it – are connected in a story that a photograph plays a central role in telling. Even more important, perhaps, is the unique way in which the photograph is still able to communicate the power dynamics underlying those achievements.

Cosmonauts as Examples of the Good Life

At the beginning of the book, I defined heroism as the second interpretative context. What was the ideal Soviet citizen like in the 1960s? The life of a cosmonaut appeared through perfect choreography; what was important was ritual-like preparation for the actual deed, celebration after the deed, and the performance of "the good life" associated with it. The narrative was grounded with cosmonaut imagery. Space as the object of conquest was no longer an essential object of photography. The deed itself, the cosmonaut's journey outside of Earth's orbit, was actually not shown. The hero's life on the surface of the Earth had become more meaningful than outer space.

After landing back on Earth, the cosmonauts could not return to the past. Being real state secrets, before their flight they had been hidden from public. After the flight, the cosmonauts were media personalities. Their whole life was public. The entirety of Soviet life was condensed in the visual figure of the cosmonaut.

Mette Bryld and Nina Lykke (2000: 87) have defined the cosmonauts (and, even more so, astronauts) as prototypical superheroes in whom "the quintessence of legendary masculinity" is personified. Regarding the Soviet cosmonauts at the beginning of 1960s, at first glance it seems that this is completely true: a morally perfect cosmonaut was the ideal of a Soviet citizen.

A more detailed look at the pictorial material revealed a different image of the cosmonauts at the beginning of the 1960s. In fact, it seems that at least visually, the figure of the cosmonaut *took a stand against* typical heroic masculinity. Compared to earlier hero images, the figure of the cosmonaut offered more room to move in relation to male and female roles.

The imagery linked to the cosmonaut's home and family further extended the images connected to the figure. Even if the cosmonauts' homes were exemplary, they were not at all sensational. In the context of the discussion about the new everyday life, that life was something that everyone could expect for themselves. The photos of the cosmonauts enjoying their homes brought

modernization down to earth in everyday life. Just as Tereshkova's visual representations (at least apparently) stretched the role of a woman, the new male cosmonauts shown in photos challenged the idea of masculinity that had previously been connected to a hero. The cosmonauts from the first half of the 1960s were characteristically the "new men" of the Khrushchev era, who took distance from Socialist realism and its positive heroes.

According to Cathleen S. Lewis (2008: 117), the heroism of the cosmonauts was not, however, directed toward change per se, but it aspired toward a conservative ideal. This emerged in many ways in my own research, too. The role of cosmonauts as revealers of new phenomena – the nuclear family, the ordinary citizen, and modernization – included a desire for social stability, not radical change. Their "smallness," their underlined ordinariness, was in line with the new type of humanism that was increasingly prevalent in the cultural life. The new people of the 1960s were markedly ordinary, something that was visually underlined in many different ways: in the photos, a cosmonaut is puzzled by reading about himself in a newspaper; he is on vacation and spending his holiday like everyone else; on a fishing trip the car has died on the edge of a ditch. This new man was allowed to make mistakes and to err. The possibility to make mistakes was still restrained in a tight context, however. The cosmonaut candidates who stepped outside the margins and committed serious mistakes were pushed out of the pantheon of heroes.

The cosmonauts also appear in the photos as characters who object to the static and conservative hero highlighted by Lewis. In particular, the male cosmonaut was appreciated as an important subject in the imagery. Enjoying his time in the kitchen, playing with his children, he really *was* a new visual character; as a representative of masculinity, he was also an ambivalent hero. Even if the imagery in many ways repeated positive heroism and the attributes associated with it – strength, beauty, ability – the cosmonaut never fit into the traditional role of a hero. The weak man was lifted to the fore, especially by imagery that underlined the physicality of the cosmonauts. Subordinated in his place during the tests that measured his performance, he did not represent the usual type of heroic masculinity that is visually associated with heroes. The body of cosmonaut was not invulnerable or perfect. It felt pain and could even be destroyed.

In particular, the material examined in this book reflects things in a unique way. It is difficult to ascertain the weakness of a cosmonaut from written mate-

rial. And even in the photos, it does not jump out in a strong way. Sometimes the fallibility of the hero appeared as an ordinary lapse or unruly detail – for example, the cosmonaut's untied shoelaces. Instead of those untied shoelaces remaining an insignificant detail, they came to symbolize the male image of an entire era. Stumbling, this man flew to space and returned home to his modern apartment and his beautiful family. He was both a father and a hero, the real man of Khrushchev's era, modern in his imperfection.

This fallible hero image did not survive the collapse of the Soviet Union. Today, in the era of global consumerism, popular culture and its heroes are international, and it is perhaps not relevant to look for a particularly Russian hero image as a contrast to any other widespread superstar of the day. Perhaps one exception does exist, however. In the present-day media, President Putin's public image is unique and could in some way be considered as having the same kind of cultural resonance that the cosmonauts had in the 1960s. One has only to glimpse the myriad photos of him displaying his muscular upper body in various outdoor sports and other rough circumstances, often involving wild animals, to see that the ideal masculinity of today's Russia is much more macho than it ever was in the Soviet Union of the 1960s. As Valerie Sperling (2015: 37–39) states in her recent book about political ideologies of machismo in modern-day Russia, Putin's masculinity draws heavily on the idea of the "real man" (*muzhik*), who is hardy, strong, and patriotic, not much of a talker but definitively a doer. As a national hero, this ideal man takes an active stand against the open-minded American idea of liberal gender relations.

Imagery as a Modern Space Narrative

The material published in *Ogonyok* provided chronological order to the magazine's photos. The archive photos did not possess this type of time-limited context. In the archive, the imagery arrived in front of me all at once, without any order. Allan Sekula (2003: 443–452) has stated that one of the primary tasks of archives is to reinforce and hide the close relationship that exists between archiving material and the use of power. In light of this research and in terms of the photos that did not become public, this statement appears especially true. The photos that remained in the archive formed a kind of a parallel story, in which the antiheroes that remained hidden from public view were living a

good Soviet life. Their stories were photographed, ready for use, awaiting future publicity that never came. However, the photos remained. With its archive that is now open to scholars, RGANTD now produces through these photos an official and authentic narrative about the space program. As an institution, it has a remarkable role as a place of the public memory of the space story. Slava Gerovitch (2011: 87) has talked about the "institutionalization of memory by nation states," a practice in which private memories are replaced with official versions of the past. In this process, the national archives have an important role. The archives have their function as a preserver of the "correct past," and they have become a place of displaying instead of hiding. Only those incidents that are archived will remain remarkable, and the others will disappear (see also Kohonen 2011: 107).

My analysis of the material resembles Vladimir Propp's study of the fairy tale, but there are also parallels at the level of narrative content. At the beginning of the story, the hero is separated from his community and taken to a secret training center, where he is tried and tested. After completing his heroic task, he is welcomed in a celebratory ritual and marked with a golden star. The story about the cosmonauts is familiar. It really is like a fairy tale, in which the hero experiences a great adventure but finally is saved and inherits "the princess and half of the kingdom." At times, the cosmonauts were directly referred to as mythic heroes. For example, Feoktistov, Yegorov, and Komarov were called "the three *bogatyrs*" (*Ogonyok* 44/1964: 1), mythic Russian heroes that are best-known from the similarly named painting of Viktor Vasnetsov (1898).

Katerina Clark (2000a: 3–11) has noted the similarity between the basic storyline of the novel narration of Socialist realism and Propp's fairy tale analysis. In the "fairy tale of Socialist realism," the hero encounters the same adversities and challenges as in the Propp's wonder stories. The beginning, climax, and end of the conventional story were repeated in a strict order. The plot of an individual story did not formalistically repeat its antecedents; the incidents of a story were often closely bound to its time of publication and they were variable. If a single story was stripped completely bare of all of its time-bound, plot-related elements, the remaining part was, according to Clark, its *prototypical plot*. According to Clark, this prototypical plot was not randomly reversed, but it repeated ideological doctrines in a new form, as if ritually.

This similarity was not accidental. In the 1930s, Maxim Gorky had recommended that artists seek their inspiration from the world of fairy tales,

myths, and legends (Günther 2003: 109). Precisely during the 1930s, heroism was developed to become a kind of fairy tale or myth phenomenon. The cosmonaut of the 1960s follows this.

The similarity of Socialist realism, cosmonaut imagery, and fairy tales is interesting. Was it so that story-building through cosmonaut imagery in fact repeated the prototypical plot of Socialist realism, not directly the pattern of Propp's fairy tale? Does it really matter? Both types of storytelling – the novel proper of Socialist realism and heroic cosmonaut imagery – obviously repeated the structure of a story whose significance was deeper in Soviet culture than one could assume from the point of view of Cold War propaganda. The body of Pavel Korchagin suffered because the body of a hero *had to suffer* before its release – like Pavel Korchagin, the cosmonaut was tormented in photos. The similarity tells about a time and place in which it was possible to recognize the fairy tale as a structure. References to the fairy tale – whether this reference was transmitted through Socialist realism or directly from the world of fairy tales – were probably familiar to the viewer. Similarity to fairy tales was not an accident in a culture that from the beginning had made new phenomena of life public by means of fantastic fairy tales: already the early czars had been changed into heroes of fairy tales, and in the Soviet era Lenin in particular was a figure whose life story was tightly tied to the world of fairy tale heroes (Tumarkin 1983: 74–95; 237–241).

The historian Raphael Samuel (1994: 328) has questioned the use of photos as historical sources, stating that they are "more or less chance residue of the past." I understand Samuel's idea that a photo is somehow, after all, an orphan and, indeed, a random, unique, and arbitrary slice of time. The photos have possibly quite arbitrarily drifted into the hands of a researcher or were purposely chosen by him. Samuel does not exactly criticize the use of photos as sources of historical research *as such*, but rather the uncritical attitude of his contemporaries, the historians of the 1960s, toward photos as "windows" into a past world.

Throughout its history, a photo has beguiled, confused, proved, ruled, objected, pleased, and shocked. From the viewpoint of the present observer, the material of this book colored and modified the truth, covered faults, hid, and abjectly lied. The imagery connected to space published in the Soviet Union cannot be examined as neutral photos taken for the press. The referential relationship of the reality of the photos and texts as material was flexible since

the beginning. Now the political context in which they were once anchored has also lost its acute significance. An almost paranoid system of secrecy cloaked the entire space program. The situation developed a narrative of the space program like a chronicle in which individual photos were fit. This great story, the story of the space-conquering Soviet man, sought to dispel all aspects of chance. Each chapter of the story was pre-programmed, planned beforehand, and seen in advance. It still produced endless canonized biographies, memoirs, and imagery related to space. The cosmonauts, their families, and the Party leadership were enmeshed in a discourse that tautologically referred only to itself and in one direction: the victorious Communism of the future. How can one research the past with such a collection of material? From the perspective of source criticism alone, the research material produces a number of problems. The photos are retouched and manipulated – how should they be approached?

In my study, I bypassed the question of the possible veracity or falsehood of the photos. By not evaluating the authenticity of the imagery, I reviewed the material as ritual pictures, which both produced the ideal community and were produced by such a community. Photographs are, according to photohistorian Geoffrey Batchen, "social objects, not simply aesthetic ones," meaningful when seen in a wider social network of beliefs and practices and politics. Images *do* things (Batchen 2008: 128). Recurring elements – bouquets, military outfits, dinner tables, and children by a piano – acted as visual clues of ideal Soviet life. The rejoicing crowd appearing in the cosmonaut's homecoming ritual represented the person viewing the photo. The photos brought the community into the event. It is not essential – and not even possible to clarify with the material used in this study – whether individual readers believed in the veracity of a single narrative. After all, they probably recognized the story depicted in the narrative and the promise that it made. The story was told *"from us to us"*; its narrator, main characters, and audience were all the same *"us."* In photos where people are reading the same news (**FIGURES 5, 7, AND 68**), the centrally controlled media presented itself, powerfully creating the sense of its central position as a glue holding the common nation together.

In particular, the homecoming ritual of the cosmonauts and the narrative with which it was connected ignored the propaganda dimension of the foreign policy of the Cold War; it was not the only – and not even the primary – objective. The photos were propaganda, but the focus of that propaganda was di-

rected inwards, not outwards. The story of the cosmonauts was only a one-sided plot in a much broader narrative, the narrative of constructing Communism.

From the hero stories of the cosmonauts, a modern fairy tale was constructed, a myth of modern man. The story was not born of a single photo. It demanded as its support the repetition of photos, context, and other images and words, and an entire tradition of picture-telling committed to history and culture. The power of the images was born out of their ability to refer to other images and to other narratives and fairy tales. The photos of space were images of the Soviet Union at the turn of the 1950s and 1960s. They represented an ideal society, a society on the threshold of conquering space. The imagery was tightly connected to time and space. The images and the stories of distant heavenly bodies and the depths of space tell more about the way in which the man of the 1950s and 1960s perceived his existence than about those distant places, because

[…] that which we see in the world and how we see it is always cultural in some way or another, in other words, according to our size and our world of experience. Whether we want it or not, this also applies to our dreams of other worlds. (Siukonen 2003: 14)

The Last Journeying Men

Once the Sky lay near the Earth. But when people started wiping their dirty hands on it, it escaped to the heavens, out of our reach. (Vail and Genis 1988: 12)

It was possible with bare eyes to see the overflight of Sputnik (the orbiter), ticking like the little hand of a clock in the sky, measuring the infinite. The satellite made its journey around the globe in just over 90 minutes. That amount of time, barely the length of a film, is easy to understand (Anttila 1989: 90–91). How small is our globe, so fragile and alone in the universe, that it can be so easily orbited and captured.

The extreme relationship to nature inherited from Stalin's time was challenged by the view of the Soviet Union of the 1960s. The aggressive belief in progress had been softened into a campaign whose targets were science, technology, and space. Admiration was directed at scientists, engineers, and cosmonauts

(Kuchment 1990: 325–340). These were the modern people of tomorrow, who would resolve the conflicts of modern life. Nature was depicted as the feminine lap, which hides and guards its treasures, while he – the courageous Soviet man – penetrated the depths and conquered treasures for himself, not only by force, but through seduction. The rhetoric resembles the relationship of science to nature in the time of Romanticism. Science was an instrument by means of which nature was lured to uncover its secrets, and it was *conquered* also in the meaning of romantic love (Bolotova 2005: 99–124; Holmes 2008: xviii).

The artists inspired by space crossed the Iron Curtain in 1987, when the Union of Artists of the USSR invited representatives of the International Association of Astronomical Artists (IAAA) to Moscow. The following year, the groups met in Iceland. In 1989, the IAAA arranged the first international exhibition dedicated to space art in Moscow. Alexei Leonov led the reciprocal Soviet visit to Utah in the United States in August 1989. During these meetings, it became apparent that "exploration of our universe is not just techno-boondoggle, but something that strikes a deep chord in all of humanity, including creative artists as well as creative scientists" (Hartmann 1990: 12–15). The images of Bonestell and Leonov hint at people on both side of the Curtain being thrilled in the same way about cosmism. In the pictures, there rises as the central theme a man standing in the landscape, his fragility protected by the spacesuit.

With the Apollo Moon landing, one era of Cold War history had ended. The Soviet Union had lost the last round of the Space Race. The surrounding culture had also changed. The enthusiastic optimism of Khrushchev had shifted in the Brezhnev era. In the following decades, ever newer achievements made the conquest of space a part of everyday life. The cosmonauts were frozen, political icons like Lenin. A reason for the spaceflights becoming a part of everyday life can also be found in the rigid censorship. When the regime of secrecy continuously forced emphasis to only be on successful achievements, heroism was not easy to justify. Because failures and dangerous situations were hushed up in order to keep them behind the scenes, space travel began to appear quite routine. The people gradually lost interest in the flights because they seemed safe and boring. Svetlana Boym (2001: 84) has noted that the difficulties the Soviet Union had in keeping up with the Space Race was not only due to a lack of resources, but the rift that was torn between technological development, state ideology, and the utopian myth. The scientific–technological optimism

of the early 1960s was in stark contrast to the disappointment of the following decades. Bit by bit, the whole cosmic dimension faded into the background.

The excitement about space and space travel was a phenomenon in the Soviet Union that was linked specifically to the era of magazines. Popular excitement was born and lived specifically in this media, in the time before the triumphal march of television. By the end of the 1960s, cosmic enthusiasm had reached its peak. The race to the Moon had been lost, and cosmonaut heroes comparable to Gagarin were not being born anymore. Photojournalism was also at a turning point. In 1955, there were a million televisions in the Soviet Union. By the year 1960, the amount had risen to five million, and by the end of the decade, there were already televisions in 25 million households (Roth-Ey 2007: 282). By and large, the big magazines lost their position. *Ogonyok* changed as well. The longer the era of Brezhnev wore on, the more the magazine fell behind in real points of interest for the people. By the 1980s, *Ogonyok* had become an institution representing stagnation, bad taste, and a lack of style. In 1986, a reversal took place. In the spirit of perestroika and glasnost,[68] the new editor-in-chief Vitaly Korotich succeeded in lifting up the magazine as one of the voices of change. Suddenly *Ogonyok* became a socially active critic. Photojournalism arose again in a new kind of a role. In the surrounding society, a process had started that we now know resulted in the fall of the whole Soviet system (Lovell 1996: 989–1006; Porter 1990: 2–6).

Andrei Sokolov's painting *In One Hundred Years* (c. 1970) (**FIGURE 124**) can be interpreted as a symbol of the crumbling high hopes linked to space. In the almost black painting, a desolate and empty surface extends to the horizon. The picture is illuminated by a red glow that comes from a staff held in the hand of a space-suited figure that has sunk into the ground. The name of the painting suggests that he has been lying immobile for a hundred years. I recognize him – this is the little hand-waving measurer of the Moon from Leonov's lunar landscape (**FIGURE 42**). His face, buried in the dirt, now remains an eternal mystery. The figure's hand holds the staff, which is still shining, while the other hand has scratched deep tracks into the gravel. A little further away, a couple that has just arrived is staring at this sight. In a hundred years, spacesuits have become lighter and more elegant, but these travelers seem quite familiar. They no longer turn their backs to the viewer, and we see their faces. Their facial expressions are terrified; out of fear a hand is raised, grabbing the other's arm. The unmoving, starry sky is spread above.

A more recent work, which through a kind of cosmic claustrophobia touches on that disappointment, is the installation *Back to the Future* (2004) by Irina Korina (b. 1977), a modern artist from Moscow. The work is an installation that one enters into. The entrance is a futuristic, shining white corridor, whose wall-paneling brings to mind the spacecraft of a science-fiction film. The corridor takes such a sharp turn that one cannot see to the end. What kind of vision of the future awaits around the bend? When the viewer dares to proceed further, she will face a disappointment. A vapid, government-like wall prevents further progress. From behind the wall peek the mosaic eyes of a cosmonaut wearing a space helmet, and a hand is waving. A smile can just barely be distinguished on his face, but even if one tries to stand up on one's toes, one cannot touch him. The promised future remains out of reach.

The Descended Hero

Let us finally return to where we started our journey, to the photo of Valentina Tereshkova having just landed in a field. Is it possible now to understand it any better than at the beginning of this book? She is surrounded by a crowd of people, looking almost lost, confused, and baffled. The fact that the Soviet cosmonauts landed in a field was worth mentioning also in *Ogonyok*: "I heard that the cosmonaut landed in a field, what a symbol – a rocket and bread! It does not feel at all the same, that the rocket sinks into the ocean and a navy ship picks it up!"[69] (Rudim 1961: 8–11). The photo's elements – the field, women in scarves, milk and eggs – bring to mind Arkady Plastov's painting *The Tractor Driver's Supper*[70] from 1951 (*Ogonyok* 15/1966) (see also **FIGURE 100** in this book). In the painting, a young girl is pouring milk from a container into a bowl in the evening sun. A man is slicing bread and a boy is lying on his stomach with a spoon in his hand. In the background, a tractor steams and a ploughed field delimits the landscape.

Tereshkova landed in a field that was close to the border of Kazakhstan on the outskirts of the huge Soviet country. Even though these people saw things that were classified as state secrets, it was not significant due to the extreme scale of the country. Soviet history is full of stories of strange miracles, events that someone has seen, stories that were believed to be true – in that sense, what would it matter if a confused spacewoman was encountered by one village? Who cares what these people see or whisper at home? The public image of the

Soviet country focused its gaze on the horizon, on major lines, to space. Still, it is noteworthy that the archivist has shut the public out of the photo with an angry mark across them. (**FIGURE 125**) Is it any wonder? When one compares this miserable group to the public that surrounds the cosmonauts in the public photos, it appears obvious that the photo would not be published like that.

From the perspective of ritual, the cosmonaut who has just landed can be seen as still under the influence of the transcendent world, "potentially danger-ous," a candidate still in liminal space. Only the homecoming ritual changes the situation. As they climb to the Tomb, the cosmonauts have overcome the trial. They have again dressed in accord with their status: the male cosmonauts in mil-itary uniform, and Tereshkova in clothing that was approved by her community for women. As the climax of the ritual, the candidates – now heroes– receive a sign of their new status, the five-pronged star medal of the Hero of the Soviet Union. That star was a strong metaphor, already a symbol wrapped in fairy tale.[71]

The continuation of the story describes cosmonaut life in terms of new status. In the imagery of the cosmonauts' everyday life, the cosmonaut lived according to those established norms and ethical rules demanded by the new status elevated through ritual. Cathleen S. Lewis (2008: 117–118) sees the prima-ry tasks of a cosmonaut to support social stability and to demonstrate the feasi-bility of the prevailing political trend. The cosmonauts were to simultaneously represent the ideal community and the member adjusted to this community. The shift toward future Communism was to take place through agreed upon, accepted, and established values. The imagery related to the family circle of the cosmonauts can be seen as commenting on the new status achieved through a transition rite, which presupposes behavior in accord with the new position. The set of clearly defined structural rights and duties toward the other members of the society belong to the new status (Turner 1997: 103). In the context of the cosmonaut, these rights and duties were clearly defined in the moral code of the Third Party Program. The photos of life after the ritual testified to the cosmonaut continuing his life in line with what was expected by the increase in status, as part of the great story of the construction of Communism. From this perspective, the photos of the cosmonauts' homes, families, kitchens, and living rooms are anything but *casual* in the prosaic meaning of the word. They are part of the ritual, part of the life of a hero demanded by the new status. In the life presented in these photos, everyday life had been transformed into the heroic.

The appearance of the cosmonauts at the Tomb, one after the other, resembles a certain basic story of Socialist realism, which presents the hero's journey from the outskirts toward the center. Landing from space took place far away from the center, in the periphery. In the hero's journey from the remote area toward the center, there materialized the time-space revolution that was typical of Socialist realism. The journey across the vast nation was not photographed, and the heroes appeared as if out of nowhere in the sacred center. The return of the cosmonauts to Moscow created a close connection between the periphery and the center. There was no distance, as it was condensed to being non-existing. The telephone photos (**FIGURES 69–74**) can also be interpreted in this light: the two spatial dimensions were combined as one with the help of adjacent telephone photos.

Having just landed, Tereshkova was not yet a hero.[72] Heroism was constructed later on, as an endless repetition of the same theme ensured that the larger public got the message. Time after time, the pictorial narrative was repeated almost in the same way, producing a ritual space. The photos *made* the hero. Publicity was the core of the whole phenomenon. Frigård has noticed the repetition in the popular imagery. According to Frigård (2008: 270–271), "the recurring photos [...] train the viewers in the primacy of certain interpretations, repetitions define the area of core meanings." Without the endless repetition of themes, gestures, postures, and details, the story of the space-conquering hero would not have existed. Enthusiasm for the cosmic was born and lived specifically in the media. Making the liminal phase public was also essential. With the help of photos, the community was permitted to witness the trial of the candidates, and humiliation took place in front of the whole community.

Later I read (Clark 1988: 22) that the photo of Tereshkova sitting in the field might not be from the landing, but instead from the training, even though the information on the index card claims that the context is just after re-entry. As I write this, I do not know which interpretation is correct. It feels as if the manifold nature of the phenomenon I am researching is crystallized in this one photo; not only at the level of the photo's appearance, but also as a material object, a picture object, this photo contains an era when nothing was sure and nothing could be taken for granted. The photo seems to defy all attempts to attach a fixed explanation to it. And it is precisely this that makes it so fascinating.

ENDNOTES

1 The "Thaw" (*ottepel*) refers to the era of dismantling Stalin's personality cult and move towards more liberal cultural politics. The term comes from Ilya Ehrenburg's novel of the same name, in which the art style of Socialist realism was questioned for the first time (Ehrenburg 1963). The era of the Thaw roughly lasted from the mid-1950s to the early 1960s.

2 At the First Congress of the Writers Union of the Soviet Union, which was established in 1934, the principles of Socialist realism were defined as the basic method of art and its only acceptable expression. The art of Socialist realism was "realistic in its form, socialist in its contents." This requirement was extended to all forms of art, not only visual art (Bown 1998: 140–145; Ekonen and Turoma 2011).

3 Largest being *Rabotnitsa* (working woman) and second largest *Krestyanka* (peasant woman).

4 At the turn of the 1950s and 1960s, photos had five-year copyright protection in the Soviet Union. Regarding press photos, a photograph's copyright belonged for the most part to the publisher not the photographer himself (Antimonov and Fleiyshits 1957; Buzek 1964; Gorokhoff 1959: 69).

5 In fact, Sputnik 1 itself was not bright enough to be seen with the naked eye. The object seen in the sky was its adrift booster rocket.

6 The related ideas of sacred and center have been worked on, for instance, by the anthropologist Clifford Geertz, according to whom the sacredness of a person increases in relation to how close to the center he is (Geertz 1983: 124).

7 A popular scientific film-maker in the Soviet Union of the 1950s and 1960s, Klushantsev's films deserve study in their own right. He is a good example of the influences that crossed the Iron Curtain. *2001: A Space Odyssey*, the science-fiction film by Stanley Kubrick from 1968, in the staging of many scenes borrows directly from Klushantsev's film *Doroga k zvezdam* (1957), which was made more than ten years earlier.

8 The International Geophysical Year (1957–1958) was a research program that brought 67 countries together to research the geophysical phenomena of the Earth. One principle of the program was to have a free exchange of knowledge between the research groups. Almost all of the countries in NATO and the Warsaw Treaty participated in the program (Bulkeley 2000: 125–152; Wilson 1961: 72).

9 However, there are photos published of the event. These are either staged photos or taken by somebody that was closely linked to the space program.

10 Yaroslav Golovanov is a journalist whose life's work was centered on the space program and whose diaries give an interesting perspective on it.

11 Other central figures included, for example, the geochemist Vladimir Vernadsky and the biophysicist Alexander Chizhevsky (Hagemeister 2011: 30).

12 Cosmic philosophy has arisen again in today's Russia. According to Michael Hagemeister, who has researched the movement, it is a question about a typical case of the invention of tradition where cosmic philosophy is linked to parapsychology, nationalism and various kinds of lifestyle ideologies (Hagemeister 1997: 201; 2011: 37).

13 It took more than 30 years before the Soviet Union admitted that Luna 1 had been intended for the surface of the Moon.

14 A pejorative word for Russian peasant.

15 An interesting, almost comical detail of Cold War history is linked to this mission: virtually by an accident a team at the Jodrell Bank Observatory, Manchester, UK, managed to pick up the signal, print it out on a fax machine borrowed from the local newspaper, and publish it well before the Soviets did.

16 This is not a question of some far-sighted honorary gesture of respect to the manned spaceflights of the United States, but a general name derived from Latin for space explorer or astronaut; in 1959, no competition existed yet between cosmonauts and astronauts.

17 The imaginary journeys to the Moon and the stars were made already
before Galilei, but only his observations made the possibility concrete
(Miller 1990: 24–27).

18 "Sovetskij chelovek pridet vo Vselennuju kak issledovatel, stroitel, no ne
kak zavoevatel." N. Malakhov, 'Dolog i truden put …', in *K Zvezdam.
Risunki lyochika-kosmonavta A. Leonova I hudozhnika-fantasta A. Sokolova.*
(Leningrad, 1970), pp. 5–11.

19 *Novaya Planeta,* 1921. The Tretyakov Gallery, Moscow.

20 Leonov did not have a formal artistic education. He was more of an enthusiast,
who along the way received the opportunity to publish his art quite widely.

21 In reality, the transmission was not exactly live – this would have been risky in
terms of procedures of secrecy – and the delay of the transmission was about
30 minutes (Leonov and Scott 2004: 109; Burgess and Hall 2009: 253).

22 Such ideas were not openly discussed in the Soviet Union in the turn of
the 1950s and the 1960s. Here Tsiolkovsky also differs from Fedorov, whose
cosmic project included the whole humankind, including even the deceased
forefathers.

23 *Der Wanderer über dem Nebelmeer,* Kunsthalle, Hamburg.

24 *Mann und Frau in Betrachtung des Mondes,* Alte Nationalgalerie, Berlin.

25 *Zwei Männer in Betrachtung des Mondes,* Gemäldegalerie, Dresden.

26 *Abendlandschaft mit zwei Männern,* Hermitage.

27 I give thanks for this perfectly romantic idea to my father, the artist
Lauri Anttila.

28 See also materials of the 2014 Princeton conference, *Romantic Subversions
of Soviet Enlightenment: Questioning Socialism's Reason* here:
http://sotsromantizm.princeton.edu/

29 In 1963 in Moscow: *Zhivopis i risunok v Germanii I Avstrii ot xv do xix v.*, Pushkin State Museum of Fine Arts; in 1968 in Leningrad: *Ot Diurera do Pikasso: 50 let sobraniia i izucheniia zapadnoevropeiskogo risunka v Gosudarstvennom Eremitazh*, Hermitage; in 1970 in Leningrad: the exhibition of new acquisitions of the Hermitage (from years 1959–1969) (Hermitage); and in 1974 in Leningrad: *Kaspar David Friedrikh i romanticheskaja zhivopis ego vremeni*, Hermitage.

30 *Rybak s synom*, 1964, private collection.

31 *Vozvrashenie*, 1969, Cultural Ministry of Russia.

32 *Mat*, 1966–1967, Russian Museum, Leningrad.

33 Only in the Soviet Union and China did television broadcast normal programs.

34 In the bottom row of the photo: Nikitin (parachute trainer), Karpov (chief trainer), Gagarin, Korolev, Khrunov, Gorbatko, Popovich. Second row from left to right: Shonin, Bykovsky, Nelyubov (dismissed in 1961), Titov, Volynov, Zaikin, Rafikov (dismissed in 1962), Nikolayev, Leonov. Third row from left to right: Belyayev, Anikeyev (dismissed in 1961), Filateyev (dismissed in 1961).

35 In the information on the file card, Kuznetsova was referred to by her maiden name Pitskhelauri.

36 This could be possible, as Propp's structural analysis has thus been used to analyze different narratives and even to construct them; for instance, film scriptwriters are often aware of the model.

37 The Great Patriotic War (*Velikaya otechestvennaya voyna*) is the name used in the Soviet Union for the war between Germany and the Soviet Union during the Second World War. In the West, these battles are often known as the Eastern Front. At the time of this writing, the ritual of Victory Day has not lost its meaning, but continues to be celebrated in similar types of ceremonies.

38 This reminds of Propp's function 23, the unrecognized arrival, in which the hero returns home but is not known.

39 Even though the book has Yuri Gagarin cited as its author, it was not written by Gagarin himself. It was written "according to the narration of the author" by special correspondents of Pravda, N. Denisov and S. Bondarenko. The book was translated into many languages directly after its publication.

40 Translated by George Reavey.

41 For Propp, this would correspond to function 17: the hero is branded.

42 Nikolai Kamanin was the general responsible for the cosmonauts' education. His diaries (1960–1971) discuss the development of the space program and the surrounding politics. The first diary was published in 1995.

43 Holmes to Watson in Arthur Conan Doyle's *A Case of Identity*, 1892.

44 There are even claims that Gagarin himself was the one who insisted that footage with the untied shoelace should remain as a proof of his sincerity and truthfulness (Jenks 2012: 161).

45 Khrushchev to Nixon during a visit to Moscow in July 1959. http://news.bbc. co.uk/onthisday/hi/dates/stories/july/24/newsid_2779000/2779551.stm.

46 Nikolayev was born in Chuvashia on the middle fork of the Volga.

47 This corresponds to Propp's function 11: the hero leaves home.

48 A good example of a conservative attitude toward nudity is Arkady Plastov's painting *Spring (Old Village Bath)*, which would later become quite well-known. The painting caused uproar after its appearance in 1956. In the painting, a naked mother is dressing her child in front of a sauna. In addition to nudity, the painting was also criticized for the old-fashioned way of life it presented (Reid 1999: 289).

49 In Propp's analysis, the final climax of the fairy tale is marriage (function 31: the marriage, the hero gets married and/or ascends the throne). The homecoming ritual of the cosmonaut can also be interpreted as this kind of a marriage celebration or coronation, whereby the hero attains the greatest happiness possible.

50 The Presidium of the Supreme Soviet (Parliament) took care of the tasks
of the Supreme Soviet when it was not in session.

51 This perhaps explains the slightly odd fact that in the archive there were hardly
any photographs showing cosmonauts in any unflattering or adverse positions.
Photographs of heavy drinking or other misbehavior were literally non-existent.

52 *Zhatva*, 1945, Tretyakov Gallery, Moscow.

53 *Otets*, 1962–1964.

54 *Semya v puti, s.a.*

55 *Svadba na zavtrashnei ulitse*, 1962, Tretyakov Gallery, Moscow.

56 The Russian word *byt*, which describes everyday life, does not translate directly
into English. Aside from referring to everyday life, it also relates to the conduct
of everyday life and the whole lifestyle of man (Buchli 1997: 161–176).

57 Instead of Western bourgeoisie, vulgarity was instead connected more to
the past of Stalin's era. The ideal of everyday design sought to skip Stalin's era
and continue where the constructivism of the 1920s had left off. The ideals
of design and architecture of Khrushchev's era can be seen as the circle closing:
in turning toward Western minimalism, Soviet design took a step toward its
own roots, because it was in fact Russian Constructivism that had been the
ideal of Western functionalism, Bauhaus and the so-called "international style"
in the 1920s and 1930s (Heinonen 1986: 28).

58 This was a peculiar phenomenon connected to the Soviet housing shortage.
In the early years of the Revolution, people had been placed into large
apartments forcibly seized from the former elite. In addition to actual
homelessness, millions of people had to live in such cramped and unsatisfactory
conditions, sharing a home with several other families. In these so-called
kommunalka flats, a large family might have only one room at its disposal,
and the kitchen, toilet, and bathroom were shared with other inhabitants.
Moving to a new home increased living comfort. People are still living in dingy
multiple family flats; in 2003, in St. Petersburg alone over half a million people
were queuing for a municipal home (Panchenko 2003; Utehin 2001).

59 The exhibition was part of a cultural exchange between the East and West. The United States had hosted a similar Soviet exhibition a few months earlier in New York (Oldenziel and Zachmann 2009: 1–29).

60 Both cosmonauts-in-training and those that had already flown lived (live) in Star City (*Zvyozdnyi gorodok*). Located near Moscow, Star City was not marked on maps during the Soviet period and ordinary people did not have any opportunity to visit there. Such closed cities could be found around the Soviet Union and they were generally connected with the war industry.

61 The same impatient order was repeated after Gagarin's flight when Khrushchev ordered another manned spaceflight right after the first one. Gherman Titov's flight was a success. It also drew the world's attention away from the building of the Berlin wall, a relatively awkward subject for Khrushchev (Kohonen 2009: 122).

62 All of the public ones came back alive.

63 VDNKh, or the Exhibition of Achievements of the People's Economy (*Vystavka dostizheniy narodnogo khozyaystva*), is today the All-Russia Exhibition Centre, an area located in Moscow that included numerous exhibition pavilions. Since 1966, there has been a space pavilion in the area.

64 This is clearly evident in the case of Alexei Leonov, described in the previous chapter. The role defined by the cybernetics as a "living link" between man and technology turned out to be strong in Leonov's case. The capacity to take risks and imagination saved his life.

65 *I.V. Stalin i K.E. Vorošilov v Kremle*, 1938, Tretyakov's Gallery, Moscow.

66 In Propp's function 12, the hero is tested and he gets a helper.

67 The Curiosity photo gallery can be viewed here: http://go.nasa. gov/1PZToN3; the photo of Obama speaking on the phone is found here: http://go.nasa.gov/1OQVmyC.

68 Perestroika ("restructuring") means the political and economic reforms
 undertaken by the last General Secretary of the Soviet Union, Mikhail
 Gorbachev. Glasnost ("openness") refers to the endeavors of the same era to
 increase administrative transparency and freedom of speech, which was seen,
 for instance, in the historic liberation of the press.

69 This is a reference to the US space program, whose re-entry capsules landed
 in the sea.

70 *Uzhin traktoristov*, 1951, The Art Museum of Irkutsk.

71 The early origins of the star symbol are not known. The fairy tale that
 describes a good red star is found in a leaflet recruiting people to the Red
 Army in 1918. "[…] all need to join the Red Army and put a red star on their
 forehead and fight against the supporters of evil: the czars, princes, landowners
 and bourgeoisie!" (Tumarkin 1983: 70–72). In the fairy tale the five-pronged
 star represented universal goodness, which with its light drives away lies and
 absolute evil. Richard Stites holds Alexander Bogdanov's early science-fiction
 book *Red Star* (*Krasnaya Zvezda*, 1908) as the most likely source of inspiration
 for the symbol. Bogdanov's book is a Communist utopia located on the
 planet Mars (Stites 1989: 85–86).

73 This brings to mind Propp's function 23 of the unidentified return: the hero
 returns home, but he is not recognized. Another pictorial analogy to this
 function is a photo of Gagarin as an anonymous citizen at the Tomb before
 his departure (Figure 65).

SOURCES AND LITERATURE

Archival Material

Rossiisky gosudarstvennyi arkhiv nauchno-tekhnicheskoi dokumentatsii,
RGANTD, Moskva

Magazines and Newspapers

Hudozhnik

Helsingin Sanomat

Life

Neuvostoliitto Tänään

Ogonyok

Pravda

Sovetskoe Foto

Films

Alov, A., Naumov, V. 1957. *Pavel Korchagin.* Kievskaya Kinostudiya: Kiev.

Barashev, P., Salnikov, Yu. 1969. *Yuri Gagarin.* Tvorcheskoe Obedinenie "Ekran", Tsentralnoe televidenie.

Bogolepov, D., Kopalin, I., Kosenko G. 1961. *Pervyi reys k zvezdam.* Mosnautchfilm: Moscow.

Danilevskaya, M., Yakovlev, N. 2007. *On mog byt pervim. Drama kosmonavta Nelyubov.* Teleradiostudiya Roskosmos: Moscow.

Kalatozov, M. 1941. *Valeri Chkalov.* Lenfilm: Leningrad.

Kaufman, Philip 1983. *The Right Stuff.* The Ladd Company: Holywood, CA.

Klushantsev, Pavel 1951. *Vselennaya.* Lennauchfilm: Leningrad.

Klushantsev, Pavel 1957. *Doroga k zvezdam.* Lennauchfilm: Leningrad.

Klushantsev, Pavel 1965. *Luna.* Lennauchfilm: Leningrad.

Kubrick, Stanley 1968. *2001: A Space Odyssey.* MGM: Hollywood, CA

Zhuravlov, Vasili 1936. *Kosmicheskiy reis.* Mosfilm: Moscow.

Bibliography and Sources

Abramov, Aleksey 2005. *Pravda i vymysly o Kremlevskom nekropole i Mavzolee.* Eksmo & Algoritm: Moscow.

Alekseyev, M. 1961. Kogda emu bylo shestnatsat… – *Ogonyok,* 18/1961: 30–31.

Anderson, Benedict 1983. *Imagined Communities: Reflections on the Origin and Spread of Nationalism.* Verso: London.

Anon, "First pictures of Russian astronauts" 1959. *Life* 19/1959 (Nov. 9): 26.

Anon. 1961. Transactions of the IAU: Volume XIB. *Proceedings of the Eleventh General Assembly* 1961, Berkeley.

Anon. 1970. Transactions of the IAU: Volume XIVB. *Proceedings of the Fourteenth General Assembly* 1970, Brighton.

Antimonov, B. S. and Fleiyshits, E. A. 1957. *Aftorskoe Pravo.* Gosudarstvennoe izdatelstvo yuridicheskoj literatury: Moscow.

Anttila, Lauri 1989. In Search of the Earth. – Timo Valjakka (ed.) *Synnyt – Sources of Contemporary Art.* Museum of Contemporary Art: Helsinki, 79–96.

Autio-Sarasmo, Sari 2005. An Illusion of the Endless Forests? Timber and Soviet Industrialization in the 1930s. – Autio-Sarasmo, Sari, Rosenholm, Arja (eds.) *Understanding Russian Nature: Representations, Values and Concepts.* Aleksanteri-papers 4/2005. Gummerrus: Saarijärvi, 125–145.

Autio-Sarasmo, Sari 2011. Khrushchev and the Challenge of Technological Progress. – Smith, Jeremy, Ilic, Melanie (eds.) *Khrushchev in the Kremlin: Policy and Government in the Soviet Union 1953–1964.* Routledge: Abingdon, New York, 133–149.

Autio-Sarasmo, Sari, Miklóssy, Katalin 2011. Introduction: The Cold War from a New Perspective. – Autio-Sarasmo, Sari, Miklóssy, Katalin (eds.) *Reassessing Cold War Europe.* Routledge: New York, 1–15.

Bailes, Kendall 1977. Alexei Gastev and the Soviet Controversy over Taylorism 1918–24. – *Soviet Studies,* 3/1977: 373–394.

Bailes, Kendall 1978. *Technology and Society under Lenin and Stalin: Origins of the Soviet Technological Intelligentsia 1917–1941.* Princeton University Press: Princeton.

Barabashov, N. P. 1961. *Atlas of the Other Side of the Moon.* Pergamon Press: Oxford, London, New York, Paris.

Barthes, Roland 1985. *Valoisa huone.* Kansankulttuuri ja Suomen valokuvataiteen museon säätiö: Jyväskylä.

Bassin, Mark 2000. "I Object to Rain That Is Cheerless": Landscape Art and the Stalinist Aesthetic Imagination. – *Cultural Geographies,* 7/2000: 313–336.

Batchen, Geoffrey 2008. Snapshots: Art History and the Ethnographic Turn. – *Photographies,* 2/2008: 121–142.

Belin, Laura Ruth 1991. *Secret Agents 301, 329, and 345: The Introduction of Hybrid Seed Corn in the USSR.* Harvard University Press: Cambridge, MA.

Belotserkovsky, Sergei 1992. *Gibel Gagarina. Fakty i domysly.* Mashinostroenie: Moscow.

Berman, Marshall 1982. *All That Is Solid Melts into Air.* Verso: London, New York.

Bespalov, L. 1964. S dvuh negativov. – *Sovetskoe Foto* 4/1964: 36

Blagonravov, A. 1957. "Mechanix Illustrated" zajavljajet pravo na Lunu. – *Ogonyok* 29/1957: 29.

Blagonravov, A. 1960. Avaruusaluksen hytti odottaa ihmistä. – *Neuvostoliitto Tänään* 12/1960: 10–11, 20.

Bolotova, Alla 2005. The State, Geology and Nature in the USSR: The Experiences of Colonizing the Russian Far North. – Rosenholm, Arja, Autio-Sarasmo, Sari (eds.) *Understanding Russian Nature: Representations, Values and Concepts.* Aleksanteri-papers 4: 2005. Saarijärvi: Gummerus, 99–124.

Bolotova, Alla 2010. Luonnon kolonisaatio Neuvostoliitossa. – *Idäntutkimus* 4/10. Venäjän ja Itä-Euroopan tutkimuksen seura ry: Helsinki, 17–30.

Bolshaya *Sovetskaya Entsiklopediya* 1955. Gosudarstvennoe nauchnoe izdatelstvo, "Bolshaya Sovetskaya Entsiklopediya": Moscow.

Bonestell, Chesley, Ley, Willy 1952. *Avaruuden valloitus.* WSOY: Porvoo

Bonnell, Victoria E. 1997. *Iconography of Power: Soviet Political Posters under Lenin and Stalin.* University California Press: Berkeley.

Bown, Matthew Cullerne (ed.) 1993. *Art of the Soviets: Painting, Sculpture and Architecture in a One-Party State 1917–1992.* Manchester University Press: Manchester.

Bown, Matthew Cullerne 1998. *Socialist Realist Painting.* Yale University Press: New Haven, London.

Boym, Svetlana, Bartos, Adam 2001. *Kosmos: Remembrances of the Future.* Architectural Press: Princeton.

Brugioni, Dino A. 1999. *Photo Fakery: The History and Techniques of Photographic Deception and Manipulation.* Brassey's: Virginia.

Bryld, Mette, Lykke, Nina 2000. *Cosmodolphins: Feminist Cultural Studies of Technology, Animals and the Sacred.* Zed Books: New York, London.

Buchli, Victor 1997. Khrushchev, Modernism, and the Fight against Petit-bourgeois Consciousness in the Soviet Home. – *Journal of Design History* 2/1997: 161–176.

Buchli, Victor 1999. *An Archaeology of Socialism: The Narkomfin Communal House, Moscow.* Berg Publishers: Oxford.

Buckland, Gail 1980. *First Photographs: People, Places and Phenomena as Captured for the First Time by the Camera.* Robert Hale Limited: London.

Buck-Morss, Susan 2000. *Dreamworld and Catastrophe: The Passing of Mass Utopia in East and West.* The MIT Press: Cambridge, MA.

Bulkeley, Rip 2000. The Sputniks and the IGY. – Launius, Roger D. (ed.)
Reconsidering Sputnik: Forty Years since the Soviet Satellite. Harwood Academic
Publishers: Amsterdam, 125–160.

Burgess, Colin, Hall, Rex 2009. *The First Soviet Cosmonaut Team: Their Lives,
Legacy, and Historical Impact.* Praxis Publishing: Chester.

Burgess, Colin, Dubbs, Chris 2007. *Animals in Space: From Research Rockets
to the Space Shuttle.* Springer-Praxis: Berlin, Heidelberg, New York.

Buzek, Anthony 1964. *How the Communist Press Works.* London: Pall Mall Press.

Campbell, Joseph [1949] 1973. *Hero with a Thousand Faces.* Princeton University
Press: Princeton.

Carr, David 1986. *Time, Narrative and History.* Indiana University Press:
Bloomington, IN.

Cherenov, K. 1965. Sluchay na granitse. – *Ogonyok* 13/1965: 26.

Clark, Katerina 1990. The Changing Image of Science and Technology in Soviet
Literature. – Loren R. Graham (ed.) *Science and Soviet Social Order.*
Harvard University Press: Cambridge, MA, 259–298.

Clark, Katerina 2000a [1981]. *The Soviet Novel: History as Ritual.* University
of Chicago Press: Bloomington, IL.

Clark, Katerina 2000b. Sotstealism i sakralizatsiya prostranstva. – Günther, Hans,
Dobrenko, Evgeny (eds.) *Sotsrealisticheskiy kanon.* Akademicheskiy projekt:
St. Petersburg, 119–127.

Clark, Katerina 2000c. Stalinskiy mif o "velikoi seme". – Günther, Hans, Dobrenko,
Evgeny (eds.) *Sotsrealisticheskiy kanon.* Akademicheskiy projekt:
St. Petersburg, 785–795.

Clark, Katerina 2003. Socialist Realism and the Sacralizing of Space. – Dobrenko,
Evgeny, Naiman, Eric (eds.) *The Landscape of Stalinism: The Art and Ideology
of Soviet Space.* University of Washington Press: Seattle, WA, 3–18.

Clark, Phillip 1988. *The Soviet Manned Space Programme.* Salamander Books: London, New York.

Cosgrove, Denis 1994. Contested Global Visions: One-World, Whole-Earth, and the Apollo Space Photographs. – *Annals of the Association of American Geographers* 84(2)/1994: 270–294.

Cosgrove, Denis 2001. *Apollo's Eye: A Cartographic Genealogy of the Earth in the Western Imagination.* John Hopkins University Press: Baltimore and London.

Couldry, Nick 2003. *Media Rituals: A Critical Approach.* Routledge: London, New York.

D'Antonio, Michael 2007. *A Ball, a Dog, and a Monkey: 1957 – The Space Race Begins.* Simon & Schuster: New York.

Dick, Steven J., Launius, Roger D. (eds.) *Societal Impact of Spaceflight* (NASA SP-2007-4801).

Dligatch, Lev 1934. Pamjati K. E. Tsiolkovskogo. – *Ogonyok* 28/1937: 7.

Dobronravov, V. 1958. Ihmisen tie avaruuteen. – *Neuvostoliitto Tänään* 18/1958: 4–5.

Douglas, Mary 1970. *Natural Symbols.* Routledge: New York.

Doyle, Arthur Conan 2006 [1892]. *The Adventures of Sherlock Holmes: The Greatest Detective of Them All.* Headline Publishing Group: London, 72–73.

Dubbs, Chris 2003. *Space Dogs: Pioneers of Space Travel.* Writers Showcase: New York, Lincoln, Shanghai.

Dunham, Vera S. 1976. *In Stalin's Time: Middle Class Values in Soviet Fiction.* Cambridge University Press: Cambridge, UK.

Ehrenburg, Ilja 1963. *Suojasää.* Karisto: Hämeenlinna.

Ekonen, Kirsti, Turoma, Sanna 2011. *Venäläisen kirjallisuuden historia.* Gaudeamus Helsinki University Press: Helsinki.

Elo, Mika 2005. *Valokuvan medium.* Tutkijaliitto: Helsinki.

Ensimmäinen *ihminen avaruudessa* 1961. Kansankulttuuri Oy: Helsinki

Ensimmäinen *vuosi tekokuiden historiaa* 1958. – *Neuvostoliitto Tänään* 18/1958: 3.

Epstein, Mikhail 2003. Russo-Soviet Topoi. – Dobrenko, Evgeny, Naiman, Eric (eds.) *The Landscape of Stalinism: The Art and Ideology of Soviet Space.* University Washington Press: Seattle, WA, 279–282.

Field, Deborah A. 2004. Mothers and Fathers and the Problem of Selfishness in the Khrushchev Period. – Ilic, Melanie, Reid, Susan E., Attwood, Lynne (eds.) *Women in the Khrushchev Era.* Palgrave MacMillan: New York, 96–113.

Filtzer, Donald 2004. Women Workers in the Khrushchev Era. – Ilic, Melanie, Reid, Susan E., Attwood, Lynne (eds.) *Women in the Khrushchev Era.* Palgrave MacMillan: New York, 29–51.

Fitzpatrick, Sheila 1999. *Everyday Stalinism. Ordinary Life in Extraordinary Times: Soviet Russia in the 1930s.* Oxford University Press: New York, Oxford.

Fitzpatrick, Sheila 2008. *The Russian Revolution.* Oxford University Press: New York, Oxford.

Flammarion, Camille 1865. *Mnogochislennost obitaemyh mirov.* Izdanie knigoprodavtsa i tipografa M. O. Volfa: St. Petersburg.

Flammarion, Camille 1877. *Les Terres du Ciel.* Librarie Académique Didier et Cie: Paris

Flammarion, Camille 1881. *Astronomie Populaire. Description Générale de Ciel.* C. Marpon et E. Flammarion: Paris.

Flammarion, Camille 1908a. *Razskazy o beskonechnom.* Moscow.

Flammarion, Camille 1908b. *Popularnaya astronomiya.* Moscow.

Friedman, Jonathan 1992. The Past in the Future: History and the Politics of Identity. – *American Anthropologist* 94:4/1992: 837–859.

Frigård, Johanna 2008. *Alastomuuden oikeutus. Julkistettujen alastonkuvien moderneja ideaaleja Suomessa 1900–1940.* SKS: Helsinki.

Gagarin, Yuri 1961. *Doroga v kosmos.* Izdatelstvo Pravda: Moscow.

Gavrilin, V. 1961. Herman Titov urheilijana. – *Neuvostoliitto Tänään* 18/1961: 31.

Geertz, Clifford 1983. *Local Knowledge: Further Essays in Interpretive Anthropology.* Basic Books: New York.

Geim, Stefan 1959. Vek kosmosa I. – *Ogonyok* 2/1959: 20–23.

Geim, Stefan 1961. Novye gorizonty veka. – *Ogonyok* 18/1961: 22–23.

Geldern, James von, Stites, Richard (eds.) 1995. *Mass Culture in Soviet Russia.* Indiana University Press: Bloomington, IN.

General Assembly. Official Records, 1958. *Resolution adopted by the General Assembly: Resolution 1348* (XIII). Question of the peaceful use of outer space. 792nd plenary meeting, December 13, 1958.

General Assembly. Official Records, 1966. *Resolution adopted by the General Assembly: Resolution 2222* (XXI). Treaty on Principles Governing the Activities of States in the Exploration and Use of Outer Space, including the Moon and Other Celestial Bodies.

Gennep, Arnold van 1960 [1908]. *Rites of Passage.* Routledge: London.

Geppert, Alexander C. T. 2008. Space *Personae.* Cosmopolitan Networks of Peripheral Knowledge. – *Journal of Modern European History.* 2/2008. C. H. Beck: Munich, 262–286.

Gerovitch, Slava 2002. Love-Hate for Man-Machine Metaphors in Soviet Physiology: From Pavlov to "Physiological Cybernetics." – *Science in Context,* 15(2)/2002: 339–374.

Gerovitch, Slava 2007. "New Soviet Man" Inside Machine: Human Engineering, Spacecraft Design, and the Construction of Communism. – *OSIRIS* 22/2007: 135–157.

Gerovitch, Slava 2008. Creating Memories: Myth, Identity, and Culture in the Russian Space Age. – Steven J. Dick (ed.) *Remembering the Space Age.* NASA: Washington DC, 203–236.

Gerovitch, Slava 2015. Memories of Space and Spaces of Memory: Remembering Sergei Korolev. – Maurer, Eva, Richers, Julia, Rüthers, Monica, Scheide, Carmen (eds.) *Soviet Space Culture: Cosmic Enthusiasm in Socialist Societies.* Palgrave MacMillan: Basingstoke, 85–102.

Ginzburg, Carlo 1996. *Johtolankoja. Kirjoituksia mikrohistoriasta ja historiallisesta metodista.* Gaudeamus: Helsinki.

Golikov, A. 1959. Na doroge bolshih vysot. – *Ogonyok* 42/1959: 4–5.

Golikov, A. 1962. Sokoly letayut vysoko. – *Ogonyok* 34/1962: 22–23.

Golikov, A. 1963a. Ja – "Chaika". – *Ogonyok* 26/1963: 6–7.

Golikov, A. 1963b. Doch kosmonavta. – *Ogonyok* 40/1963: 3.

Golikov, A. 1963c. Bolshogo vam Schastya!. – *Ogonyok* 46/1963: 6–7.

Golikov, A. 1968. 24 marta 1968 goda. Poslednee intervyu. – *Ogonyok* 15/1968: 31–34.

Golovanov, Yaroslav 1978. *Our Gagarin.* Progress Publishers: Moscow.

Golovanov, Yaroslav 2001. *Zametki vashego sovremennika. Tom 1 1953–1970.* Izdatelstvo "Dobroe Slovo": Moscow.

Gorin, Peter A. 2000. Rising from the Cradle: Soviet Perceptions of Space Flight before Sputnik. – Launius, Roger D. (ed.) *Reconsidering Sputnik: Forty Years since the Soviet Satellite.* Harwood Academic Publishers: Amsterdam, 11–42.

Gorokhoff, Boris I. 1959. *Publishing in the U.S.S.R.* Indiana University Press: Bloomington, IN.

Günther, Hans 2003. The Heroic Myth in Socialist Realism. – Groys, Boris, Hollein, Max (eds.) *The Dream Factory Communism: The Visual Culture of the Stalin Era.* Hatje Cantz Verlag: Ostfildern-Ruit, 106–124.

Hagemeister, Michael 1997. Russian Cosmism in the 1920s and Today. – Glatzer Rosenthal, Bernice (eds.) *The Occult in Russian and Soviet Culture.* Cornell University Press: Ithaca, NY, 185–202.

Hagemeister, Michael 2011. The Conquest of Space and the Bliss of the Atoms: Konstantin Tsiolkovskii. – Maurer, Eva, Richers, Julia, Rüthers, Monica, Scheide, Carmen (eds.) *Soviet Space Culture: Cosmic Enthusiasm in Socialist Societies.* Palgrave MacMillan: Basingstoke, UK, 27–41.

Harford, James 1997. *Korolev: How One Man Masterminded the Soviet Drive to Beat America to the Moon.* John Wiley & Sons, Inc.: New York.

Harford, James J. 2000. Korolev's Triple Play: Sputniks 1, 2, and 3. – Launius, Roger D. (ed.) *Reconsidering Sputnik: Forty Years since the Soviet Satellite.* Harwood Academic Publishers: Amsterdam, 73–94.

Hariman, Robert, Lucaites, John Louis 2007. *No Caption Needed: Iconic Photographs, Public Culture, and Liberal Democracy.* University Chicago Press: Chicago.

Harley, J. B. 1989. Maps, Knowledge, and Power. – Cosgrove, Denis, Daniels, Stephen (eds.) *The Iconography of Landscape.* Cambridge University Press: Cambridge, UK, 277–312.

Hartmann, William K. 1990. Beginnings. – Hartmann, William K (ed.) *In the Stream of Stars: The Soviet/American Space Art Book.* Workman Publishing: New York, 12–15.

Haynes, John 2003. *New Soviet Man: Gender and Masculinity in Stalinist Soviet Cinema.* Manchester University Press: Manchester, UK.

Heinonen, Raija-Liisa 1986. *Funktionalismin läpimurto Suomessa.* Suomen Rakennustaiteen museo: Helsinki.

Heppenheimer, T. A. 1997. *Countdown: A History of Space Flight.* John Wiley & Sons: New York.

Hersch, Matthew H. 2012. *Inventing the American Astronaut.* Palgrave MacMillan: New York.

Hobsbawm, Eric 1978. Man and Woman in Socialist Iconography. – *History Workshop Journal* 1/1978: 121–138.

Hobsbawm, Eric, Ranger, Terence (eds.) 1983. *The Invention of Tradition.* Cambridge University Press: Cambridge, UK.

Holmes, Richard 2008. *The Age of Wonder: How the Romantic Generation Discovered the Beauty and Terror of Science.* Pantheon Books: New York.

Howell, Yvonne 2015. *From "Sots-Romanticism" to Rom-Com: The Strugatskys "Monday Begins in Saturday" as a Film Comedy.* Languages, Literatures, and Cultures Faculty Publications. Paper 66, 127–143.

Jacobs, Michael 1995. *The Painted Voyage: Art, Travel and Exploration 1564–1875.* The Trustees of British Museum: London.

Jager, C. de, Jappel, A. (trans.) 1971. *Proceedings of the Fourteenth General Assembly Brighton, UK, August 18–27, 1970.* D. Reidel: Dordrecht.

Jameson, Fredric 2008. The Square Peg in the Round Hole or the History of Spaceflight. – *Critical Inquiry* 5/2008. Chicago University Press: Chicago, 172–183.

Jenks, Andrew L. 2012. *The Cosmonaut Who Couldn't Stop Smiling. The Life and Legend of Yuri Gagarin.* Northern Illinois University Press: DeKalb.

Johansson, Hanna 2009. Musta peili ja tirkistysaukko – maisemakuvien käänteiset kertomukset. – Kari Soinio. *Maisemasta paikkaan.* Maahenki: Helsinki, 32–47.

K Zvezdam. *Risunki lyochika-kosmonavta A. Leonova i hudozhnika-fantasta A. Sokolova* 1970. Izdatelstvo "Avrora": Leningrad.

Kachosvily, L. 1958. Sputnik III Moskovan yllä. – *Neuvostoliitto Tänään* 11–12/1958: 19.

Kachosvily, L., ja Bulushev, J. 1961. Yuri Gagarinin tie avaruuteen. – *Neuvostoliitto Tänään* 9/1961: 8–13.

Kaganovsky, Lilya 2008. *How the Soviet Man Was Unmade: Cultural Fantasy and Male Subjectivity under Stalin.* University of Pittsburg Press: Pittsburg.

Kamanin, Nikolai 1964. *Skrytyj kosmos: 2 kniga.*
http://militera.lib.ru/db/kamanin_np/index.html (tarkistettu: 25.5.2012)

Kant, Immanuel 2007 [1790]. *Critique of Judgement.* Cosimo: New York.

Keghel Isabelle de 2010. Western in Style, Socialist in Content? Visual Representations of GDR Consumer Culture in the "Neue Berliner Illustrierte" (1953–64). – Autio-Sarasmo, Sari, Humphreys, Brendan (eds.) *Winter Kept Us Warm: Cold War Interactions Reconsidered.* Kikimora: Helsinki, 76–106.

Kemppainen, Ilona, Peltonen, Ulla-Maija 2011. Muuttuva sankaruus.
– Peltonen, Ulla-Maija, Kemppainen, Ilona (eds.), *Kirjoituksia sankaruudesta.* SKS: Helsinki, 9–46.

Kendrick, Gregory M. 2010. *The Heroic Ideal: Western Archetypes from Greeks to the Present.* McFarland & Company Publishers: London.

Khrushchev, Nikita 1961a. Hrushchevin puhe Punaisella torilla 14.4.1961.
– *Neuvostoliitto Tänään* 9/1961: 18–21, 30–31.

Khrushchev, Nikita 1961b. Neuvostoliiton kommunistisen puolueen ohjelmasta. Alustus Neuvostoliiton kommunistisen puolueen XXII edustajakokouksessa.
– *Tie kommunismiin. Kokoelma NKP:n XXII edustajakokouksen aineistoa 1961.* Vieraskielisen kirjallisuuden kustannusliike: Moscow, 171–323.

King, David 1997. *The Commissar Vanishes: Falsification of Photographs and Art in Stalin's Russia.* Metropolitan Books: New York.

Koerner, Joseph Leo 1990. *Caspar David Friedrich and the Subject of Landscape.* Reaktion books: London.

Kohonen, Iina 2009. The Space Race and Soviet Utopian Thinking. – Bell, David, Parker, Martin (eds.) *Space Travel and Culture: From Apollo to Space Tourism.* Wiley-Blackwell: Oxford, 114–131.

Kohonen, Iina 2011. The Heroic and the Ordinary: Photographic Representations of Soviet Cosmonauts in the Early 1960s. – Maurer, Eva, Richers, Julia, Rüthers, Monica, Scheide, Carmen (eds.) *Soviet Space Culture: Cosmic Enthusiasm in Socialist Societies.* Palgrave MacMillan: Basingstoke, 103–120.

Korolev, Yu. 1957. Za fotoocherk bez instsenirovki – *Sovetskoe Foto* 2/1957: 19–23.

Kozhevnikov, V. A. 1906. Predlisloviye. – Fedorov, N. F. (ed.) *Filosofiya Obshchego Dela. Stati, Mysli i Pisma.* Tom I. Moskva, Vernyi, i–iv.

Kozlov, Alexei 1966. Lunnyj "Internatsional" – *Ogonyok* 15/1966: 1.

KPSS v rezoljutsiiyah VII, 373–495. – Hodnett, Grey 1974 (ed.) *Resolutions and Decisions of the Communist Party of the Soviet Union, Volume 4. The Khrushchev Years 1953–1964.* University of Toronto Press: Toronto, 124–132.

KPSS v rezoljutsiyah VIII, 173–325. – Hodnett, Grey 1974 (ed.) *Resolutions and Decisions of the Communist Party of the Soviet Union, Volume 4. The Khrushchev Years 1953–1964.* University of Toronto Press: Toronto, 281–282.

Krukovsky, V. 1963. Trudnye Metry. *Ogonyok* 12/1963: 16–20.

Krupneshy ucheny, talantlivyi konstruktor 1966 – *Ogonyok* 4/1966: 4.

Krylov, Yu 1959. Mezhplanetnaya trassa prolozhena… – *Ogonyok* 39/1959: 6.

Kuchment, Mark 1990. Bridging the Two Cultures: The Emergence of Scientific Prose. – Loren R. Graham (ed.) *Science and the Soviet Social Order.* Harvard University Press: Cambridge, MA, 325–340.

Kuznetskiy, M. 2001. *Gagarin na kosmodrome Baikonur.* Vladi: Krasnozamensk.

Kuusinen, Otto W. 1961 *Fundamentals of Marxism-Leninism.* Lawrence & Wishart: London.

Lane, Christel 1981. *The Rites of Rulers: Ritual in Industrial Society – The Soviet Case.* Cambridge University Press: Cambridge, UK.

Larionov, E. 1960. Kak smotret peiyzazh. – *Hudozhnik.* Ezhemesyachnyi zhurnal soyuza hudozhnikov PSFSR, 9/1960: 41–45.

Latour, Bruno 2002. What is Iconoclash? Or is there a World beyond Image Wars? – Latour, Bruno, Weibel, Peter (eds.) *Iconoclash – Beyond Image Wars in Science, Religion and Art.* MIT Press: Cambridge, UK.

Launius, Roger D. 2000. (ed.) *Reconsidering Sputnik: Forty Years since the Soviet Satellite.* Harwood Academic Publishers: Amsterdam.

Launius, Roger D. 2005. *Heroes in a Vacuum: The Apollo Astronaut as Cultural Icon.* 43rd AIAA Aerospace Sciences Meeting and Exhibit, 10–13 January 2005, Reno, Nevada.

Lefebvre, Henri 2008 [1974]. *The Production of Space.* Blackwell Publishing: Oxford.

Leonov, Alexei, Scott, David 2004. *Two Sides of the Moon: Our Story of the Cold War Space Race.* Simon & Schuster: London.

Leonov, L. 1961. Ponnahdus taivaalle. – *Neuvostoliitto Tänään* 9: 4–5, 8.

Lewis, Cathleen S. 2008. *The Red Stuff: A History of the Public and Material Culture of Early Human Spaceflight in the* U.S.S.R. Ph.D. diss., History, George Washington University.

Lovell, Stephen 1996. "Ogonek": The Crisis of a Genre. – *Europe-Asia Studies,* Sept/1996: 989–1006.

Lund, Nils-Ole 1998. Modernism as a Vehicle for Social Change in the Nordic Welfare States. – Ola, Wedebrunn (ed.) *Modern Movement Scandinavia: Vision and Reality.* Fonden til udgivelse af arkitekturtidsskrift: Århus, 7–11.

Lyapunov, B. 1958. Nachalo kosmicheskoi ery – *Ogonyok* 41: 6–7.

Maddrell, Paul 2006. *Spying on Science: Western Intelligence in Divided Germany 1945–1961.* Oxford University Press: New York.

Malahov, N. 1970. Dolog i truden put… – *K Zvezdam. Risunki lyochika-kosmonavta A. Leonova i hudozhnika-fantasta A. Sokolova.* Izdatelstvo 'Avrora': Leningrad, 5–11.

Marek, Roman 2009. Weltraumhunde im Kalten Krieg: Laika als Versuchstier, Propagandawaffe und Heldin – Pöppinghege, Rainer (ed.) *Tiere im Krieg. Von der Antike bis zur Gegenwart.* Ferdinand Schöningh Verlag: Paderborn, 251–268.

Marxismi-leninismin perusteet 1960. Karjalan ASNT: n valtion kustannusliike: Petroskoi.

Masevich, A. G. 1959. Skazka stala bylju! – *Ogonyok* 40/1959: 8.

McCannon, John 1997. Positive Heroes at the Pole: Celebrity Status, Socialist-Realist Ideals and the Soviet Myth of the Arctic, 1932–39. – *The Russian Review.* July/1997: 346–365.

Mihailov, Galaktion 1961. Ihmisen avaruuslento. – *Neuvostoliitto Tänään* 8/1961: 6–9.

Miller, Ron 1990. The History of Space Art. – Hartmann, William K. (ed.) *In the Stream of Stars: The Soviet/American Space Art Book.* Workman Publishing: New York, 24–53.

Mitchell, W. J. T. (ed.) 2002. *Landscape and Power.* University of Chicago Press: Chicago.

Mitchell, W. J. T. 1992. *The Reconfigured Eye: Visual Truth in the Post-Photographic Era.* The MIT Press: Cambridge, MA.

Mozzhorin, Yuri 2000. *Tak eto bylo.* ZAO, Mezhdunarodnaya programma obrazovaniya: Moscow. http://epizodsspace.airbase.ru/bibl/mozjorin/tak/obl.html

Mulvey, Laura 1989. Visual Pleasure and Narrative Cinema. – Mulvey, Laura (ed.) *Visual and Other Pleasures.* Palgrave Macmillan: Basingstoke, New York, 14–26.

Murayev, A. I., Kochovalova, E. K., Kvashuk, L. P. 1961. *Sovetskiy lyochik – pervyi kosmonavt.* Voennoe Izdatelstvo Ministerstva oborony: Moscow.

Naiman, Eric 1997. *Sex in Public: The Incarnation of Early Soviet Ideology.* Princeton University Press: Princeton.

Naiman, Eric 2003. Introduction. – Dobrenko, Evgeny, Naiman, Eric (eds.) *The Landscape of Stalinism: The Art and Ideology of Soviet Space.* University of Washington Press: London, Seattle, xi–xvii.

Narskiy, I., Nagornaja, O., Nikonova, O., Hmelevskaya, Yu. (eds.) *Oche-vidnaja istoriya. Problemy vizualnoi istorii Rossii xx stoletiya.* Kamennyi poyas: Cheljabinsk.

Nesterov, V. F. 1987, *Pervye v mire.* Planeta: Moscow.

Neufeld, Michael J. 2012. *Spacefarers: Images of Astronaut and Cosmonauts in the Heroic Era of Space Flight.* Smithsonian Institution Scholarly Press: Washington DC.

Nikolayev, A. 1961. Naedine so vselennoi. Rasskazy o novyh naukah. – *Ogonyok* 16/1961: 8.

Nivat, Georges 2003. The Russian Landscape as Myth. – *Russian Studies in Literature* 39: 51–70.

Nye, David E. 1994. *American Technological Sublime.* MIT Press: Cambridge, MA.

Oldenziel, Ruth, Zachmann, Karin 2009. Kitchens as Technology and Politics: An Introduction – Oldenziel, Ruth, Zachmann, Karin (eds.) *Cold War Kitchen: Americanization, Technology, and European Users.* MIT Press: Cambridge, MA, 1–29.

Ordway, Frederick I. 1992. Dreams of Space Travel from Antiquity to Verne. – Ordway, Frederick I., Liebermann, Randy, Bova, Ben (eds.) *Blueprint for Space: Science Fiction to Science Fact.* Smithsonian Institution Press: Washington, London, 35–48.

Orwell, George 1978 [1949]. *Vuonna 1984.* WSOY: Porvoo.

Ostrovski, Nikolai 1974 [1930–1934]. *Kuinka teräs karaistui.* Kansankulttuuri: Helsinki.

Panchenko, Leonid 2003. Krugi kommunalnogo raja – *Novaya Gaseta* 83/2003. http://www.novayagazeta.spb.ru/2003/83/1 (tarkistettu: 25.5.2012)

Papanin, Ivan 1981. *Elämää jäälautalla.* Progress: Moskova.

Peoples, Columba 2008. Sputnik and 'Skill Thinking' Revisited: Technological Determinism in American Responses to the Soviet Missile Threat. – *Cold War History* 1/2008: 55–75.

Petrone, Karen 2000. *Life Has Become More Joyous, Comrades: Celebrations in the Time of Stalin.* Indiana University Press: Bloomington.

Petrushenko, V. 1961. Samiy luchshiy…! – *Ogonyok* 34/1961: 12.

Pipko, D., Chernikova, V. 1961. Sinun uusi "kotisi", ihminen 2. (Oleg Gashenkon kertomuksen mukaan) – *Neuvostoliitto Tänään* 12/1961: 10–11, 20–21.

Pisarzhevsky, Oleg 1958. Novaya geografiya nauki. – *Ogonyok* 46/1958: 5–6.

Plamper, Jan 2008. Prostranstvennaya poetika kulta lichnost: "krugi" vokrug Stalina. – Narskiy, I., Nagornaja, O., Nikonova, O., Hmelevskaya, Yu. (eds.) *Oche-vidnaya istoriya. Problemy vizualnoi istorii Rossii xx stoletiya.* Kamennyi pojas: Cheljabinsk, 339–364.

Pokrovsky, G. 1961. Ihmisälyn voitto. – *Neuvostoliitto Tänään* 9/1961: 14–15; 26–27.

Pollock, Griselda 1988. *Vision & Difference: Femininity, Feminism and the Histories of Art.* Routledge: New York.

Porter, Cathy 1990. Introduction. – Korotich, Vitaly, Porter, Cathy (eds.) *The Best of Ogonyok: The New Journalism of Glasnost.* London: Heinenman, 2–6.

Portree, David S. F., Trevino, Robert C. 1997. *Walking to Olympus: An EVA Chronology.* Monographs in Aerospace History Series. NASA: Washington DC.

Programma *KPSS* 1961. Pravda: Moscow.

Propp, Vladimir 1968. *Morphology of the Folktale.* Indiana University Press: Bloomington.

Prozorov, Boris 1969. "Zond-7" – Kosmicheskiy issledovatel i fotokorrespondent. – *Ogonyok* 35/1969: 1.

Rabinovich, Eugene 1967. Igor Kurchatov 1903–1960. An Introduction. – *Bulletin of the Atomic Scientists: A Journal of Science and Public Affairs.* Dec/1967: 8–9.

Radetsky, Peter 2007. *The Soviet Image: A Hundred Year of Photography from Inside the TASS Archives.* Chronicle Books: San Francisco.

Rauschenbach, B. V., Vetrov, G. S. 1998. *S.P. Korolev i ego delo. Svet i teni v istorii kosmonavtiki. Izbrannyje trudy i dokumenty.* Nauka: Moscow.

Reichhardt, Tony 2006. The First Photo from Space. – *Air & Space Magazine,* http://www.airspacemag.com/

Reid, Susan E. 1994. Photography in the Thaw: Contemporary Russian Art Photography. – *Art Journal,* Summer/1994: 33–39.

Reid, Susan E. 1997. Destalinization and Taste, 1953–1963. – *Journal of Design History* 2/1997: 177–201.

Reid, Susan E. 1999. Masters of the Earth: Gender and Destalinisation in Soviet Reformist Painting of the Khrushchev Thaw. – *Gender and History* 11/2 1999: 276–312.

Reid, Susan E. 2004. Women in the Home. – Ilic, Melanie, Reid, Susan E., Attwood, Lynne (eds.) *Women in the Khrushchev Era.* Palgrave MacMillan: New York, 149–176.

Reid, Susan E. 2005. The Khrushchev Kitchen: Domesticating the Scientific-Technological Revolution. – *Journal of Contemporary History* 40/2005: 289–316.

Reid, Susan E. 2009a. Happy Housewarming! Moving into Khrushchev-era Apartments. – Balina, Marina, Dobrenko, Evgeny (eds.) *Petrified Utopia: Happiness Soviet Style.* Anthem Press: London, 133–161.

Reid, Susan E. 2009b. Communist Comfort: Socialist Modernism and the Making of Cozy Homes in the Khrushchev Era. – *Gender and History,* 3/2009: 465–498.

Rockwell, Trevor 2012. They May Remake our Image of Mankind: Representations of Cosmonauts and Astronauts in Soviet and American Propaganda Magazines 1961–1981. – Neufeld, Michael J. (ed.) *Spacefarers: Images of Astronaut and Cosmonauts in the Heroic Era of Space Flight.* Smithsonian Institution Scholarly Press: Washington DC.

Rogatchevski, Andrei 2011. Space Exploration in Russian and Western Popular Culture: Wishful thinking, Conspiracy Theories and Other Related Issues. – Maurer, Eva, Richers, Julia, Rüthers, Monica, Scheide, Carmen (eds.) *Soviet Space Culture: Cosmic Enthusiasm in Socialist Societies.* Palgrave MacMillan: Basingstoke, 251–265.

Romanov, A. 1961. Vostok-2 letit k zvedzdam. – *Ogonyok* 37/1961: 16–17.

Roth-Ey, Kirstin 2007. Finding a Home for Television in the USSR, 1950–1970. – *Slavic Review: Interdisciplinary Quarterly of Russian, Eurasian, and East-European Studies,* Summer/2007: 278–306.

Rudaux, Lucien 1948. *Astronomie: les Asters, l'Univers.* Librairie Larousse: Paris.

Rudim, V. 1961. Reportash o serdtsah chelovecheskih. – *Ogonyok* 52/1961: 8–11.

Ryan, James R. 1997. *Picturing Empire: Photography and the Visualization of the British Empire.* Reaktion Books: London.

Sala, Charles 1993. *Caspar David Friedrich and Romantic Painting.* Terrail: Paris.

Samuel, Raphael 1994. *Theatres of Memory. Vol. 1: Past and Present in Contemporary Culture.* Verso: London, New York.

Sartorti, Rosalinde 1987. Photography and the State between the Wars. The Soviet Union. – Lemagny, Jean-Claude, Rouille, Andre (eds.) *History of Photography: Social and Cultural Perspectives.* Cambridge University Press: Cambridge, UK, 127–135.

Sartorti, Rosalinde 1995. On the Making of Heroes, Heroines, and Saints. – Stites, Richard (ed.) *Culture and Entertainment in Wartime Russia.* Indiana University Press: Bloomington, IN, 176–193.

Schama, Simon 1995. *Landscape and Memory.* HarperCollins Publishers: London.

Schwartz, Joan M. 1996. The Geography Lesson: Photography and the Construction of Imaginative Geographies. – *Journal of Historical Geography,* 22/1996: 16–45.

Schwartz, Joan M., Ryan, James R. 2006. Introduction: Photography and the Geographical Imagination. – Schwartz, Joan M., Ryan, James R. (eds.) *Picturing Place: Photography and the Geographical Imagination.* I.B. Tauris & Co Ltd: London, 1–18.

Scott, James C. 1998. *Seeing Like a State: How Certain Schemes to Improve the Human Condition Have Failed.* Yale University Press: New Haven, London.

Sekula, Allan 2003. Reading an Archive: Photography between Labour and Capital. – Wells, Liz (ed.) *Photography Reader.* London: Routledge, 2003: 443–452;

Sharonov, V. 1959. K Solntsu! K Zvezdam!. – *Ogonyok* 3/1959: 2–3.

Shelton, William 1968. *Soviet Space Exploration: The First Decade.* Lowe & Brydone: London.

Siddiqi, Asif A. 2011. Cosmic Contradictions: Enthusiasm and Secrecy in the Soviet Space Program. – Andrews, James T., Siddiqi, Asif A. (eds.) *Into the Cosmos: Space Exploration and Soviet Culture.* University of Pittsburgh Press: Pittsburgh, 47–76.

Siddiqi, Asif A. 2014. *The Red Rockets' Glare: Spaceflight and the Russian Imagination, 1857–1957*. Cambridge University Press: Cambridge, UK.

Siukonen, Jyrki 2001. *Uplifted Spirits, Earthbound Machines: Studies on Artists and the Dream of Flight*. SKS: Helsinki.

Siukonen, Jyrki 2003. *Muissa maailmoissa. Maapallon ulkopuolisten olentojen kulttuurihistoriaa*. Gaudeamus: Helsinki.

Sokolov, A. 2008. Tekst, obraz, interpretatsiya: visualnyj povorot v sovremennoiy istoriografii. – Narskiy, I., Nagornaya, O., Nikonova, O., Hmelevskaya, Yu. (eds.) *Oche-vidnaya istoriya. Problemy vizualnoi istorii Rossii xx stoletiya*. Kamennyi pojas: Cheljabinsk, 10–24.

Sokolov, A., Lavrenyuk, V. 2001. Kosmicheskiy miry Andreja Sokolova. – *Zhurnal Voin Rossii*. Ministerstvo Oborony Rossiskoy Federatsiy. 4/2001: 94–96.

Soluri, Michael 2008. Examining the Iconic and Rediscovering the Photography of Space Exploration in Context to History of Photography. – Steven J. Dick (ed.) *Remembering the Space Age*. NASA: Washington DC, 271–340.

Sommar, Ingrid 2003. *Scandinavian Style: Classic and Modern Scandinavian Design and Its Influence on the World*. Carlton Books: London.

Sovetskoe *Fotoiskusstvo* 1939. Goskinoizdat: Moscow.

Sperling, Valerie 2015. *Sex, Politics, and Putin: Political Legitimacy in Russia*. Oxford University Press: New York.

Starr, Frederick S. 1978. *Melnikov: Solo Architect in a Mass Society*. Princeton University Press: Princeton.

Stites, Richard 1989. *Revolutionary Dreams: Utopian Vision and Experimental Life in the Russian Revolution*. Oxford University Press: New York.

Sytin, Viktor 1957. Chelovek realnoj mechty. – *Ogonyok* 38: 12–13.

Tagg, John 1988. *The Burden of Representation: Essays on Photographies and Histories*. MacMillan Education: London.

Taubman, William 2003. *Khrushchev: The Man and His Era.* Simon & Schuster: London.

Thomas, Nicholas 1992. The Inversion of Tradition. – *American Ethnologist,* 2/1992: 213–232.

Tie kommunismiin. NKP:n XXII *edustajakokouksen aineistoa.* 1961 Vieraskielisen kirjallisuuden kustannusliike: Moscow.

Titov, German 1961. *700000 kilometrov v kosmose. Rasskaz lyochika-kosmonavta SSSR.* Izdatelstvo Pravda: Moscow.

Topchev, Aleksander 1957. Tieteen kaikkien alojen kehitys loi perustan tekokuun lähettämiselle. – *Neuvostoliitto Tänään,* 21/1957: 6–7.

Trachtenberg, Alan 1989. *Reading American Photographs: Images as History, Mathew Brady to Walker Evans.* Hill and Wang: New York.

Tsiolkovsky, Konstantin 1928. *Volja vselennoi: Neizvestnye razumnye sily.* Kaluga.

Tsiolkovsky, Konstantin 1960. Moya zhizn. – *Ogonyok,* 37/1960: 4–5, 10.

Tsiolkovsky, Konstantin 1962. Zhizn v mezhzvezdnoj srede. – *Ogonyok* 32/1967: 24–25.

Tsiolkovsky, Konstantin 1970. Chelovechestvo ne ostanetsya vechno na Zemle… – *K Zvezdam. Risunki lyochika-kosmonavta A. Leonova i hudozhnika-fantasta A. Sokolova.* Izdatelstvo "Avrora": Moscow, 5.

Tully, Carol (ed.) 2000. *The Romantic Fairy Tales.* Penguin Books: London.

Tumarkin, Nina 1983. *Lenin Lives! The Lenin Cult in Soviet Russia.* Harvard University Press: Cambridge, MA.

Turner, Victor 1997. *The Ritual Process: Structure and Anti Structure.* Aldine de Gruyter: New York.

Udarnikam – luchie kvartiry, obraztsovye stolovye. – *Ogonyok* 7/1934.

Ulivi, Paolo, Harland, David 2004. *Lunar Exploration: Human Pioneers and Robotic Surveyors*. Springer-Praxis: Berlin, Heidelberg, New York.

Utehin, Ilya 2001. *Ocherki kommunalnogo byta*. O.G.I: Moscow.

Vail, Peter, Genis, Aleksandr 1988. *60-ye: Mir sovetskogo cheloveka*. Adris: USA.

Vasilev, Sergei 1957. Razvedchikam nebesnyh glubin – *Pravda* 6.10.1957: 1.

Vaughan, William 1994. *Romanticism and Art*. Thames and Hudson: London.

Vernov, S. N. 1957. Razvedka glubin kosmosa – *Ogonyok* 44/1957: 5.

Vihavainen, Timo 2003. *O. W. Kuusinen ja Neuvostoliiton ideologinen kriisi vuosina 1957–64*. SKS: Helsinki.

Virilio, Paul 2007. *The Original Accident*. Polity Press: Cambridge, UK.

Vyazemsky, B. A. 1957. Illjustratsiya v gasete. – *Voprosy Partiyno-Sovetskoi pechati*. Izdatelstvo Leningradskogo Universiteta: Leningrad, 150–164.

Westad, Odd Arne 2000. The New International History of the Cold War: Three (Possible) Paradigms – *Diplomatic History* 4/2000: 551–565.

Whitaker, Ewen A. 1999. *Mapping and Naming the Moon: A History of Lunar Cartography and Nomenclature*. Cambridge University Press: Cambridge, UK.

White, Hayden 1973. *Metahistory: The Historical Imagination in Nineteenth-Century Europe*. Johns Hopkins University Press: Baltimore.

Widdis, Emma 2003a. *Visions of a New Land: Soviet Film from the Revolution to the Second World War*. Yale University Press: New Haven, London.

Widdis, Emma 2003b. To Explore or to Conquer? Mobile Perspectives on the Soviet Cultural Revolution. – Dobrenko, Evgeny, Naiman, Eric (eds.) *The Landscape of Stalinism: The Art and Ideology of Soviet Space*. University of Washington Press: Seattle, London, 219–240.

Widdis, Emma 2005. Muratova's Clothes, Muratova's Textures, Muratova's Skin. *KinoKultura* 8/2005. http://www.kinokultura.com/articles/apr05-widdis.html

Widdis, Emma 2009. Sew Yourself Soviet: The Pleasures of Texture in the Machine Age. – Balina, Marina, Dobrenko, Evgeny (eds.) *Petrified Utopia. Happiness Soviet Style.* Anthem Press: London, 115–132.

Wilks, Guntram 2005. *Das Motiv der Rückenfigur.* Tectum Verlag: Marburg.

Wilson, Tuzo J. 1961. IGY *the Year of the New Moons.* Michael Joseph: London.

Winter, F. H. 1990. *Rockets into Space.* Harvard University Press: Cambridge, MA.

Yegorov, B. F. 2007. *Rossiiskie Utopii. Istoricheskiy Putevoditel.* Isskustvo – SPB: St. Petersburg.

Yevtushenko, Yevgeny 1962. *Olen vaiti ja huudan.* Kirjayhtymä: Helsinki.

Zdravomyslova, E., Tyomkina, A. 2007. Sovetskiy etakraticheskiy poryadok. – Zdravomyslova, E., Tyomkina, A. (eds.) *Rossiyskiy Gendernyi Poryadok. Sociologicheskiy Podkhod.* Evropejskiy universitet: Sankt-Petersburg, 96–137.

Zenkovsky, V. V. 1953. *A History of Russian Philosophy. Vol. two.* Routledge: London.

Zvonkov, V. 1961. Liikenne Kuussa. – *Neuvostoliitto Tänään* 3/1961: 22–23.

Names in the sources and literature reflect the format in the original document.

List of Figures

26 RGANTD 1–2192, photographer not credited

27 P. Barashev, *Ogonyok* 43/1967

28 *Ogonyok* 7/1966, photographer not credited

29 *Ogonyok* 45/1959, photographer not credited

30 RGANTD 1–19596, photographer not credited

31 *Ogonyok* 45/1959, photographer not credited

32 *Ogonyok* 45/1959, photographer not credited

33 *Ogonyok* 1/1958, illustrator not credited

34 German Titov, *Ogonyok* 37/1961

35 German Titov, *Ogonyok* 37/1961

36 *Ogonyok* 39/1969, photographer not credited

37 *Ogonyok* 35/1969, photographer not credited

38 A. Sokolov, *Ogonyok* 32/1962

39 A. Sokolov, *Ogonyok* 32/1962

40 A. Sokolov, *Ogonyok* 32/1962

41 RGANTD 1–15269, photographer not credited

42 Aleksey Leonov 1970, illustration from *K Zvezdam. Risunki lyochika-kosmonavta A. Leonova i hudozhnika-fantasta A. Sokolova.*

43 *Ogonyok* 12/1965, photographer not credited

44 Camille Flammarion 1908

45 C. D. Friedrich 1818

46 C. D. Friedrich 1819

47 Chesley Bonestell 1949, reproduced courtesy of Bonestell LLC

48 Andrei A. Tutunov 1964

49 Mikhail Kugach 1969

50 RGANTD 1–15013, photographer not credited

51 *Ogonyok* 30/1969, photographer not credited

52 *Ogonyok* 16/1961, photographer not credited

53 Photo from Borodin, G. I. 1972 *Pokorenie Kosmosa,* photographer not credited

54 Photo from Clark, Phillip 1988. *The Soviet Manned Space Programme,* photographer not credited

55 RGANTD 1–13525, photographer not credited

56 Photo from *Utro kosmicheskoij ery,* 1961, photographer not credited

57 RGANTD 2–383, photographer not credited

58 RGANTD 0–3251, photographer not credited

59 I. Tunkel and B. Kuzminin, *Ogonyok* 33/1961

60 L. Borodulin, G. Koposov, Yu. Krivonosov, S. Raskin, M. Skurihina, E. Haldei, I. Tunkel, V. Cheredintsev *Ogonyok* 35/1962

61 L. Borodulin, G. Koposov, Yu. Krivonosov, S. Raskin, M. Skurihina, E. Haldei, I. Tunkel, V. Cheredintsev *Ogonyok* 35/1962

62 G. Koposov, E. Umnov, A. Gostev, Yu. Krivonosov, B. Vdovenko, D. Ukhtomsky, *Ogonyok* 27/1963

63 G. Koposov, E. Umnov, A. Gostev, Yu. Krivonosov, B. Vdovenko, D. Ukhtomsky, *Ogonyok* 27/1963

64 Photo from: Murayev A. I, Kochovalova E. K, Kvashuk L. P. 1961, *Sovetskiy lyochik – pervyi kosmonavt,* photographer not credited

65 A. Ustinov, *Ogonyok* 15/1963

66 Photo from *700000 kilometrov v kosmose,* photographer not credited

67 V. Bashkatov and A. Samelyak *Ogonyok* 40/1962

68 O. Knorring *Ogonyok* 16/1961

69 Photo from *Utro Kosmicheskiy ery,* 1961, photographer not credited

70 Photo from *Utro Kosmicheskiy ery,* 1961, photographer not credited

71 V. Volodkin, M. Skurihin, L. Derzhavich, *Ogonyok* 33/1961

72 G. Trofimov, *Ogonyok* 34/1962

73 *Ogonyok* 26/1963, photographer not credited

74 L. Derzhavich, RGANTD 0–391

75 A. Sergeyev, RGANTD 1–2211

76 V. Cheredintsev, RGANTD 1–14924

77 RGANTD: 0–874, photographer not credited

78 RGANTD: 0–160, photographer not credited

79 D. Sashin, *Ogonyok* 27/1961

80 V. Cheredintsev, *Ogonyok*43/1964

81 V. Cheredintsev, A. Monkletsov, *Ogonyok* 4/1969

82 *Ogonyok* 34/1962, photographer not credited

83 V. Bazanov, Vera Zhiharenka, G. Omelchuk, B. Smirnov, *Ogonyok* 35/1962

84 *Ogonyok* 18/1961, photographer not credited

85 V. Makarov, RGANTD 1–13074

86 Vladimir Kostetsky 1947

87 A. Romanov, *Ogonyok* 26/1963

88 Yu. Krivonosov, A. Ustinov, *Ogonyok* 46/1963

89 V. Cheredintsev, RGANTD 1–16642

90 RGANTD 0–949, photographer not credited

91 RGANTD 0–594, photographer not credited

92 V. Cheredintsev, RGANTD 1–16645

93 V. Cheredintsev, RGANTD 1–16625

94 *Ogonyok* 26/1963, photographer not credited

95 V. Cheredintsev, *Ogonyok* 13/1964

96 V. Cheredintsev, *Ogonyok* 43/1964

97 RGANTD I–2126, photographer not credited

98 V. Cheredintsev, RGANTD I–15243

99 V. Cheredintsev, RGANTD I–16648

100 Arkadi Plastov 1945

101 M. Kugach, *Ogonyok* 15/1968

102 D. Ukhtomsky, *Ogonyok* 15/1968

103 I. Snegirev, *Ogonyok* 32/1962

104 E. Umnov, *Ogonyok* 32/1959

105 V. Cheredintsev, *Ogonyok*43/1964

106 V. Cheredintsev, A. Monkletsov, *Ogonyok* 4/1969

107 RGANTD I–14829, photographer not credited

108 D. Ukhtomsky, *Ogonyok* 15/1968

109 *Ogonyok* 47/1957, photographer not credited

110 N. Filippov, *Ogonyok* 46/1957

111 http://ujkey.tumblr.com/post/14728076802/may-you-forever-be-remembered

112 *Ogonyok* 32/1962, photographer not credited

113 A. Monkletsov, V. Cheredintsev, *Ogonyok* 4/1969

114 *Ogonyok* 4/1969, photographer not credited

115 L. Borodulin, A. Bochinin, A. Uzlyan, D. Ukhtomsky, *Ogonyok* 44/1967

116 D. Baltermants, *Ogonyok* 32/1960

117 *Ogonyok* 16/1964, photographer not credited

118 *Ogonyok* 15/1968, photographer not credited

119 A. Gostev, A. Bochinin, A. Ustinov, *Ogonyok* 15/1968

120 A. Gostev, A. Bochinin, A. Ustinov, *Ogonyok* 15/1968

121 A. Gostev, A. Bochinin, A. Ustinov, *Ogonyok* 15/1968

122 RGANTD 0–483, photographer not credited

123 RGANTD I–5756, photographer not credited

124 Andrei Sokolov 1970, illustration from *K Zvezdam. Risunki lyochika-kosmonavta A. Leonova i hudozhnika-fantasta A. Sokolova.*

125 RGANTD 0–878, photographer not credited

First published in the UK in 2017 by
Intellect, The Mill, Parnall Road, Fishponds, Bristol, BS16 3JG, UK

First published in the USA in 2017 by
Intellect, The University of Chicago Press, 1427 E. 60th Street,
Chicago, IL 60637, USA

A catalogue record for this book is available from the
British Library.

Copy-editor: MPS Technologies
Cover designer: Jyri Konttinen
Production manager: Richard Kerr and Faith Newcombe
Typesetting: Jyri Konttinen

Print ISBN: 978-1-78320-742-8
ePDF ISBN: 978-1-78320-743-5
ePUB ISBN: 978-1-78320-744-2

Printed and bound by CPI Corporate, UK

This is a peer-reviewed publication.